THEORY
FOR
ART HISTORY

theory4

A book series from
ROUTLEDGE

Theory for Religious Studies
William E. Deal and Timothy K. Beal

THEORY
FOR
ART HISTORY

Jae Emerling

ROUTLEDGE New York • London

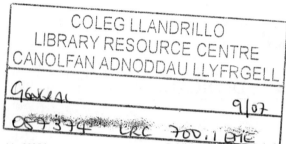
Published in 2005 by
Routledge
Taylor & Francis Group
270 Madison Avenue
New York, NY 10016

Published in Great Britain by
Routledge
Taylor & Francis Group
2 Park Square
Milton Park, Abingdon
Oxon OX14 4RN

© 2005 by Taylor & Francis Group, LLC
Routledge is an imprint of Taylor & Francis Group

Printed in the United States of America on acid-free paper
10 9 8 7 6 5 4 3

International Standard Book Number-10: 0-415-97363-5 (Hardcover) 0-415-97364-3 (Softcover)
International Standard Book Number-13: 978-0-415-97363-2 (Hardcover) 978-0-415-97364-9 (Softcover)

Library of Congress Cataloging-in-Publication Data

Emerling, Jae.
 Theory for art history / Jae Emerling.
 p. cm. -- (Theory4)
 Includes bibliographical references.
 ISBN 0-415-97363-5 (hardback : alk. paper) -- ISBN 0-415-97364-3 (pbk. : alk. paper)
 1. Art--Historiography. 2. Art criticism--History. 3. Art--Philosophy. I. Title. II. Series.

N7480.E46 2005
701'.18--dc22 2005011243

Taylor & Francis Group
is the Academic Division of T&F Informa plc.

Visit the Taylor & Francis Web site at
http://www.taylorandfrancis.com

and the Routledge Web site at
http://www.routledge-ny.com

for Vito Anthony Disciglio

Er wird Dich
bedecken mit
seinem Gefieder
&
unter seinem
Flügel dann
ruhest Du aus

—W. G. Sebald

CONTENTS

ACKOWLEDGMENTS

I am grateful to many colleagues, friends, and family members for their help and encouragement with this project. First, I would like to thank Donald Preziosi and Claire Farago for their continued support and encouragement as well as for many conversations around the dinner table in Boulder, Colorado. Second, I'm thankful to William Germano at Routledge for giving me the opportunity to write this book and to Linda Manis for all her editorial help. There are many people at the University of California, Los Angeles, who have helped me, but I would like to acknowledge only a few: Sean Anderson, Doris Chon, Ken Reinhard, and Ali Behdad, whose advice and friendship I rely on more than he knows. In addition, I'm indebted to Giorgio Agamben not only for his guidance and his time, but for providing me with an example of an engaged intellectual that I will not soon forget. My thinking about theory, culture, ethics, and politics owes much to his work. In addition, I am grateful to my parents, Geraldine Disciglio Emerling and James Emerling, for their continued support and for being genuinely nonplussed about how they produced a son who is at once so different and yet so similar to them. I would like to express my warm gratitude to Robin Morris and Earle Smith for many hours spent traveling, talking about anything and everything, and for reminding me that family is the relationships built as much as the ones given. Above all, I am indebted to my wife, Nora Ryan, not only for her invaluable help and support, but also because without her my life would be unrecognizable. This book is dedicated to the memory of my grandfather, Vito Anthony Disciglio, whom I think about every day.

INTRODUCTION

This volume is an introduction to critical theory, with particular emphasis on how and why it has not only informed, but transformed art history. Questions central to art historical discourse concern the ontology and meaning of a work of art, its status as a thing or as an inflection of a preexisting discourse (whether historical, stylistic, or political), its reception by an intended or ideal viewer, and the role art plays in society. These questions were first voiced by aesthetics, which, along with ontology and ethics, is one of the founding principles of Western philosophy. From its inception, aesthetics has been premised on the Greek concept of *aisthesis*, the sensory perception of an artwork by the viewer. However, traditional notions of aesthetic beauty, truth, and conceptual experience have been challenged by critical theory. The reliance upon language and phenomenology that motivates critical theory has necessitated a radical rethinking of the very subject matter of art history: the work of art, the viewer, and the sociopolitical consequences of the production and consumption of art.

In recent decades, many art historians have moved beyond their traditional disciplinary boundaries. Theories of language and gender, previously absent from art history, are becoming more and more central. This is due in large part to critical theory, which tethers the discipline of art history to philosophy, linguistics, sociology, literary studies, and anthropology. The practice of interdisciplinarity has proven indispensable to the most intriguing and innovative work not only in art history, but in the humanities and social sciences in general. *Theory for Art History* presents some of the key thinkers and ideas that have had and continue to have a considerable impact on thinking and writing in the humanities and social sciences in general, and in the field of art history in particular. As an introduction to the intersection between critical theory and art history, it provides a concise introduction to the theories of scholars outside art historical discourse proper whose work has proven invaluable to the conceptual, ethical, and political reorientation of the field.

Art history initially received critical theory as a new set of interpretative tools that were applied to the traditional study of art. Critical theory provided a conceptual framework through which it became possible not only to formalize and criticize modern and contemporary art, but also to rethink the premises of art history. By drawing serious attention to the position of the art historian within a preexisting matrix of institutional and individual subject-positions, critical theory initiated a critique of the study of non-Western art by Euro-American scholars that seeks to address and even redress the imbalance of power inherent in such study. In general, critical theory asks innovative questions and reveals other possibilities for studying and interpreting art and its histories.

However, it would be a disservice to the reader not to mention the often contentious history of this intersection between critical theory and art history. Simply put, this is an introduction to a body of work that many art historians would like to see slip into a quiet oblivion. The infiltration of critical theory proved quite startling to traditional art historical practice. The emphasis on language, subjectivity (individual and collective), and politics (racial, gender, and sexuality) were considered by some to be extraneous to the core concerns of an often masculinist, elitist endeavor that fueled connoisseurship and an insatiable art market. Critical theory marked the arrival of the excluded, the marginal riffraff, who were conceived as usurpers bent on undermining tradition and denying any claim to aesthetic or historical truth. Aside from an often palpable xenophobia, the reception of critical theory in art history has been characterized by both a tinge of conservative hysteria *and* a clamoring for its radical liberating presence.

One could say that critical theory changed everything and yet changed nothing because it never actually "arrived." How could it since it has always been here? Critical theory is not external to art history; it is not a second-order discourse of mastery and meaning. The relation between the two is not one of transcendence, but one of immanence. Because of their shared genealogy in aesthetics, critical theory and art history are siblings. From this perspective, its "reception" begins to look more and more like the parable of the prodigal son than any kind of foreign intrusion. What theory provides art history is an ethical suspension, a critical self-reflexivity that returns unannounced to interrupt the status quo

practice of art history. Herein lies the danger. Is critical theory merely a passing phase of art history—an interpretative fashion that has passed out of style? Or does its presence at the heart of art history not irremediably alter the very practice of art history?

No matter what heading or watchword you place the contents of *Theory for Art History* under—whether postmodernism, poststructuralism, continental philosophy, or post-Marxism— what remains undeniable is that the work explained in this text constitutes a rigorous, manifold, often poetic thinking on the work of art and our historical and contemporary experience of it. To ignore this thinking is not only to refuse the potentiality of critical theory as contemplative thought, as a necessary self-reflexivity, but also to make inoperable the very act of rethinking art history. If we foreclose on one, the other becomes unrecognizable.

This book was written with three audiences in mind. First, it is for undergraduate students in courses on the theory and methodology of art history. Second, this book is for graduate students seeking an introduction to critical theory that will prepare them to engage the primary sources and enter into larger, ongoing discussions. Finally, *Theory for Art History* is intended for teachers and scholars of art history who introduce students to contemporary theoretical perspectives and who are themselves interested in how these perspectives inflect art historical practice. The present volume could serve as a supplement to any course on critical theory.

This text focuses on bodies of thought that arose primarily in postwar Europe, but what we have come to term critical theory developed in conversation with the philosophic and aesthetic thought that preceded it. The importance of Plato, Aristotle, Immanuel Kant, and G.W.F. Hegel for art historical discourse is indisputable. Their absence from this volume is not to downplay their significance, which is asserted nonetheless through the many references to their work in what follows. The parameters of this text are such that the thinkers termed predecessors are nineteenth-century figures without whose work critical theory as such would not exist. Each of the four theoretical predecessors included in this volume— Sigmund Freud, Karl Marx, Friedrich Nietzsche, and Ferdinand Saussure—serves as a hinge to the earlier thinkers. In addition, these four thinkers initiate the major discourses that drove late twentieth-century critical theory (e.g., Marxism and psychoanalysis). Indeed,

their questions, concepts, and discourses continue to set the agenda for critical theory today. Whether one embraces them or not, one must have a basic understanding of their contributions in order to enter the conversation between critical theory and art history.

This book is designed to be a useful resource. Most readers, it is assumed, will not read it from cover to cover, but will go to it for help with particular theorists and theories. The four predecessors introduced in the opening section are presented in alphabetical order by last name, as are the twenty-six chapters in the main section. Every chapter on an individual thinker has three main parts: a list of Key Concepts, the main body of the text, and a Further Reading section.

At the beginning of each chapter is a short bulleted list of Key Concepts that I have identified as particularly important for students of art history to understand. These concepts are listed in the order of their appearance in the main text.

The main body of each chapter begins with a brief biographical sketch. In the discussion that follows the names of other thinkers included in the volume are cross-referenced. Key Concepts are highlighted where they are most thoroughly explained; thus, a reader interested in one particular Key Concept can quickly scan the chapter for the discussion of it. Each chapter also offers a discussion of some possible implications for art history. It is impossible to indicate all of the possible implications for art history, but a suggestion of the ways in which a certain thinker's work has been used is given, as well as how it may be used in the future.

Finally, each entry has a Further Reading section which includes two subsections: first, a "By" subsection listing those primary texts essential for a more complete understanding of a thinker; second, an "About" subsection listing texts about the theorist as well as texts on art history that include a significant discussion of the theorist or application of the theorist's ideas. In the body of each entry, when a particular text by a theorist is mentioned the date given in parenthesis indicates the year that work was originally published.

Theory for Art History presents multiple ways that we might come to understand art history. What follows will require some effort on the part of the reader, not so much in reading the chapters as in following up on what is presented here and becoming better versed in critical theory. The goal is to provide initial access to the

scholars' work, to explain their key concepts, and to give direction for further study. As readers move beyond the introductions to the primary texts, it is the hope of the author that they will develop a more complex and subtle understanding of the necessity of critical theory for the study of art history.

PREDECESSORS

PREDECESSORS

SIGMUND FREUD

Key Concepts

- unconscious
- repression
- psychoanalysis
- sublimation
- pathography

Sigmund Freud (1856–1939), the founder of psychoanalysis, was born into an assimilated, secular Jewish family in the Moravian town of Freiburg. However, the most formative place in Freud's development was not Freiburg, but fin de siècle Vienna. He earned a medical degree at the University of Vienna in 1881. After winning a modest medical scholarship, proceeded to work with Jean-Martin Charcot at the Salpêtrière Hospital in Paris from 1885 to 1886. Freud was intrigued by Charcot's work on hysteria, which Charcot diagnosed as a disease and treated with hypnotism. In 1886, Freud began his practice as a physician in Vienna, where he focused on nervous disorders. Freud's method differed from Charcot's in that Freud abandoned hypnotism in favor of allowing his patients to freely narrate their experiences. It was in Vienna that he initially proposed and refined his psychoanalytic discourse, presented in the landmark publication of *The Interpretation of Dreams* (1900). In 1938, he fled to London to escape the advancing Nazis and he died there in 1939.

The intellectual and theoretical legacy of Freud's work in the humanities, especially literature, art history, and philosophy, is arguably one of the most important in the tradition of modernity. In addition to his assertion of the unconscious, his thesis that dreams must possess an underlying logic discernible through a method of psychoanalytic interpretation, remains a centerpiece of Western cultural discourse. In 1922, Freud presented a lecture at the International Congress of Psychoanalysis in Berlin, entitled "Some Remarks on the Unconscious," which provided three definitions of psychoanalysis: first, a discipline focused on investigating the unconscious; second, a therapeutic method for treating nervous disorders; and third, a growing body of research on several aspects of culture, including literature and art history. Freud often termed this last facet of psychoanalysis a metapsychology.

Freudian terms such as the **unconscious** and **repression** have become commonplace, but in contemporary usage their precise meanings within Freud's system are often lost. These two terms form a dynamic system that defines the very structure of Freudian psychoanalysis. Freud argues:

> We have learnt from psycho-analysis that the essence of the process of repression lies, not in putting it to an end, in annihilating the idea which represents an instinct, but in preventing it from becoming conscious … the repressed is a part of the unconscious.… How are we to arrive at a knowledge of the unconscious? It is of course only as something conscious that we know it, after it has undergone transformation or translation into something conscious. (1915, p. 573)

The unconscious is, therefore, the nonconscious part of the mind and as such it affects conscious thought and behavior but is not directly accessible for interpretation. What the analyst must decipher is the various compromise formations—the distortions caused by the opposing forces of unconscious desire and repression—that become evident through an analysand's retelling. For Freud, the unconscious (id, primal instincts) is not static. It is bound in a series of complex mechanisms with the superego ("a special agency … self-criticism"), that is, rational thought, reason, or one's conscience (1919, p. 211). The site of conflict, and negotiation is the ego (*das Ich*). It is the dynamic tension or play between these

forces that distorts or disguises unconscious desire. The task of the analyst is to locate these compromise formations and decipher them. Freud writes that

> almost everywhere there can be found striking omissions, disturbing repetitions, palpable contradictions, signs of things the communication of which was never intended.... One could wish to give the word "distortion" the double meaning to which it has a right, although it is no longer used in this sense. It should mean not only "to change the appearance of," but also "to wrench apart," "to put in another place." (1939, p. 52)

What makes Freud's work extraordinary is his attempt to develop a systematic means to access and interpret the unconscious. In the passage quoted here he explicitly elides the actions of psychical processes with those of textual interpretation (one influenced by the Jewish rabbinical practice of midrash), in a gesture that renders one's conscious life, the life history of the ego, a text littered with "suppressed and abnegated material," that is, the traces of another origin (p. 52).

Psychoanalysis is an act of interpretation "concerned with laying bare these hidden forces," one that from its inception, Freud desired to raise to the status of a science, what he called "an impartial instrument" (1919, p. 220). By investigating his patients' life history, Freud sought to objectively demonstrate his contention that "in mental life nothing which has once been formed can perish—that everything is somehow preserved and that in suitable circumstances ... it can once more be brought to light" (1930, p. 16). The presence of these hidden forces is made evident through everyday occurrences, such as forgetting proper names, slips of the tongue (i.e., Freudian slips or parapraxes), bungled actions, and most importantly, dreams. Collectively all of these elements comprise the psychopathology that Freud is keen on identifying and interpreting. It is the analyst's task, he argues, to pinpoint these slips, these inabilities, the unsaid within discourse, so as to help the patient attain knowledge of the repressed experiences that cause neuroses.

It was primarily with his identification of the constitutive elements of dreams, the dream-work as Freud terms it, that psychoanalysis stakes its claim to our attention. Dreams, Freud

believed, represent the fulfillment of unconscious wishes that the conscious mind censors because they are socially taboo, unpleasurable, or a threat to the integrity of the self (the ego). What has been repressed is re-presented in dream imagery. This re-presentation or distortion (*Entstehung*) is brought about by condensation, displacement, pictorial arrangement, and secondary revision. Condensation is the process whereby a number of people, events, or meanings are combined and reduced to a single image in a dream. Displacement, on the other hand, is the process by which one person or event is dispersed into many linked associations, whether it is a similar sounding word or a symbolic substitution. The remaining elements of pictorial arrangement and secondary revision are the means by which the dream is finalized; together they arrange the dream content in such a way that the manifest content (the dream as the dreamer experiences it, i.e., the literal text of the dream), does not completely hide the latent content (the repressed unconscious material). It is this opening in the otherwise seamless construction of the dream-work that allows Freud to intervene.

Freud's intervention, his "talking cure" as one of his early patients phrased it, a therapeutic method for treating nervous disorders, requires the analysand to narrate his or her life history. Lying on a couch, the analysand recounts his or her life history with little interruption from the analyst, who sits behind the patient listening for subtle manifestations of unconscious processes that indicate neurosis. In this more or less uninterrupted, free association by the patient, language is not taken at face value. Rather Freud's self-imposed task is to sift through the language of the conscious mind for traces of the unconscious, that is, traces that indicate the presence of latent or repressed content. In the act of recounting one's life history certain elements pique the analyst's curiosity, such as an odd turn of phrase, a mishandled image, the repetition of a certain word. These elements hint at the faulty areas of the construction, that which indicates the absent presence of what has been repressed, the little thread, which if pulled unravels the entire fiction. This is why the ego, one's conscious sense of self—what you presume to be self-evident and noncontradictory—is, in fact, a fiction.

In psychoanalysis, the speaking human subject is approached as a divided subject, a site of conflict between conscious and un-

conscious drives that do not form a single, integrated, whole self. Therefore, the enunciations of the "I" of language are not to be accepted without hesitation because more often than not they represent only the alibis of the ego. What Freud is after is a trace of the origin: the alibi (literally, what is in another place).

Freud borrows his model of psychic preservation, the presence of the past in the present, from archaeology. In *Civilization and Its Discontents* (1930), Freud posits an analogy between psychic preservation and an archaeological model, specifically Rome, the Eternal City. He explains how the topography of Rome is shot through with ruins and remnants of the past; they are found "dovetailed into the jumble of the great metropolis which has grown up in the last few centuries since the Renaissance" (p. 17). Freud takes this archaeological model (the tell or site) and maps it onto human consciousness because this is how the past is preserved in the present; it is a model of immanence. He argues that we should compare the past of a city with that of the mind. He asks us to "suppose that Rome is not a human habitation but a psychical entity with a similarly long and copious past" (p. 17). In both models, what Freud posits is a spectral palimpsest that recalls his explanation of the *Wunderblock*, wherein all that has been written on the tabula rasa is preserved in the wax on which it rests. This model of immanence is important because it provides a spatial metaphor that enables one to read the traces or residual effects of the past in the present. Moreover, it helps us to understand Freud's insistence when it comes to the constant action required to repress an unconscious desire. He is adamant when he asserts that the "process of repression is not to be regarded as an event which takes place once, the results of which are permanent, as when some living thing has been killed and from that time onward is dead; repression demands a persistent expenditure of force … the maintenance of a repression involves an uninterrupted expenditure of force" ("Repression," p. 572).

From Freud's first major text *The Interpretation of Dreams* (1900) through *Totem and Taboo* (1913), and even in later work such as *Civilization and Its Discontents* (1930), a conception of the human being is given. It posits that humans are driven by two primal instincts: self-preservation and libidinal satisfaction. These instincts follow no normative social laws besides satisfaction. This drive toward satisfaction is a destructive force. Unchecked, only violence

and death would result from our march toward unabashedly selfish fulfillment. Thus, Freud argues that there is a need for civilization and social order to repress these instincts; to make civilization as such possible these instincts must be addressed. One of the primary means for dealing with these instincts that Freud identifies is **sublimation**.

In sublimation, he argues, repressed material is "promoted" into something grander or is disguised as something "noble." For example, sexual urges may be given sublimated expression in the form of intense religious experiences or longings. Art is a primary form of sublimation. Freud writes, "Sublimation of instinct is an especially conspicuous feature of cultural development; it is what makes it possible for higher psychical activities, scientific, artistic or ideological, to play such an important role in civilized life" (1930, p. 44). Substitutive satisfactions like art are illusions in contrast with reality because what we desire is satisfaction and yet "there is no possibility at all of its being carried through; all the regulations of the universe run counter to it" (p. 23). Thus, we are made to derive enjoyment in illusory, second-tier forms. However, sublimation provides Freud with a means to further investigate how repressed material continues to exert a determining influence over conscious life, how and why primal instincts are perpetually present, always threatening to take over. This potential for desublimation occurs not only on the individual level, but on the collective level as well because sublimatory ventures like religion and art are social illusions. Often overlooked here is the politics implicit in Freud's model. He argues that sociopolitical life can be improved only if the mass of repressed material (in both the individual and collective spheres) is addressed in a systematic fashion. Importantly, it is myth, literature, and art that provide the opportunity to diagnose "the wishful phantasies of whole nations," their "secular dreams" (1908, p. 442).

His interest in (de-)sublimation—the uncensored articulation of psychic fantasy—along with the "aesthetic yield of pleasure" this offers, can help introduce Freud's engagement with literature and art history. Throughout his career Freud consistently turned his attention to literature and art to aid his development of psycho-analytic methodology. These areas of study greatly impacted how he thought of interpretation and its ends. Inversely, the

importance of Freudian thought to the study of literature and art history cannot be underestimated. It fundamentally changed the way in which we relate to, read, and interpret cultural production.

Freud's position vis-à-vis works of art is comprised of two interrelated motivations. First, he presents an artist-as-patient model, in which **pathography** is the central and much disputed term. Second, Freud's writings on art are astute examinations of how readers or viewers experience artworks. This is the pole of reception wherein what matters most is the emotive effect—the yield of pleasure—a work has on the viewer. One example of how these terms are inextricable is provided by Freud's own experience. Freud was an avid collector of antiquities. His interest in them arose upon the death of his father, an event that also spurred his desire to complete *The Interpretation of Dreams*. This collection of artifacts served as an index of the passing of Freud's father and as the material presence of the Western cultural past that played a role in the construction of psychoanalysis: a method of unearthing an individual's forgotten past, the very one that dictates the shape of the future. In his essay "'Mille e tre': Freud and Collecting" (1994), John Forrester writes that "Freud's collection of antiquities, and the very idea of psychoanalysis itself … was a compendium of his version of civilization, as opposed to its diffusion and fragmentation in the world of everyday life—a world that nonetheless could be measured and weighed in the scales of the analytic method" (p. 242). With Freud's antiquities collection, the difficulty of separating manifest and latent content, the autobiographical as opposed to the impersonal construction of a work for others to enjoy, becomes evident. But it is precisely with this difficulty that the future import of Freud's work for art historical discourse rests.

Let us turn to the concept of pathography. It is in his famous essay "Leonardo Da Vinci and a Memory of Childhood" (1910) that Freud deploys this term. In the broadest sense it refers to a method of interpretation that relies upon the biography of an artist. But Freud is more precise in his phrasing. He refers to the manner in which the pathology, the unconscious repetitions and preoccupations of an artist, are written (*grapha*) in the produced work. It is a translation of selected aspects of a life history, more often than not those concerned with traumatic experiences,

repressed desires, and other symptoms. Put another way, Freud's essay is "an attempt to exhibit—not, of course, to prove, but like the clinical case histories, to exhibit—the dependence of the adult capacities and proclivities on the infantile and in particular on infantile sexuality" (Wollheim, 1985, p. 214). This method of art historical practice is one in which the decipherment of the artist's original intention is the ultimate goal. But, and herein lies the paradox, it is psychoanalytic discourse that undermines any claim to uncovering a pure intention. More than merely indicating its distance from other schools of thought like empiricism and phenomenology, what psychoanalysis insists upon is a radical rethinking of notions like artistic intent and any art historical approach that claims to arrive at a direct expression of latent content through an interpretation of the manifest. However, this is not to deny that Freud's text does not posit something like artistic intent. The argument here is simply that the myriad critiques of his pathographic reading of Leonardo must be tempered with his comments on the other pole of art historical work: reception.

Freud's thoughts on reception stem from the simple question he sets out to answer in his essay on the sculpture of Moses by Michelangelo. In the essay published in 1914, Freud asks why a viewer can be "so powerfully affected," so compelled (which includes both the poles of attraction and repulsion) by works of art (p. 123). Unlike in the essay on Leonardo, Freud completely avoids any discussion of Michelangelo's pathography, instead he focuses on the work of art itself and how it can be read by a viewer. In a related text published five years later, "The 'Uncanny,'" Freud states: "It is only rarely that a psycho-analyst feels impelled to investigate the subject of aesthetics, even when aesthetics is understood to mean not merely the theory of beauty but the theory of the qualities of feeling" (p. 193). What Freud tacitly posits here is a return to the Greek origin of the concept of aesthetics, one that traverses the discourse that began with Alexander Baumgarten's proposition of the aesthetic as a complement to rational thinking. It is Baumgarten's colonialist opposition of aesthetic and fetish —itself symptomatic of the role of Enlightenment thought in the foundation of the aesthetic sphere—that is reversed in Freud's desire to return to the Greek concept of *aisthesis*, which referred to feeling or sense perception. Freud sets out to utilize his theory of repression, especially its corollary concepts of fetishism

and sublimation, to interpret the work of art as an index of an intransitive state; that is, the uncanny effect produced by one's compulsion before certain works of art. This compulsion suggests not merely the inversion of rational thinking, but it indicates the presence of an absence (the Freudian logic of the fetish). Additionally, the deferred temporality of repression, the way in which an event in the past that has been repressed only becomes known as such through its citation by something that occurs in the present, foregrounds the undecipherability of artistic intention and reception as such. Freud's system emphasizes temporality.

In terms of the reception of artworks, the addition of time as well as the potentiality of an artwork to trigger a psychic effect in the viewer (one that creates a situation of empathy and a loosening of the constraints on unconscious desire) suggests how Freud saw aesthetics through a psychoanalytic lens. There is no simple call for an interpretation of intention (even an unconscious one), but rather there is a call for a methodology that can articulate the threshold between an artist's desire and ability to create a work and the reception of said work by a viewer. Freud contends that aesthetic space is an interpsychic one in which the "yield of pleasure" a viewer receives—a result of the viewer's empathetic and desirous relation to the artist—emboldens us to enjoy our own fantasies and desires without shame. He argues that this "yield of pleasure" may "liberate the tensions in our minds"(1908, p. 443). Artworks can loosen the reign of the superego and draw us into a situation in which the very structure of subjectivity—our relation to repressed material and the fiction we weave around its traces—becomes contingent and mutable.

Aesthetic experience, therefore, is simultaneously one of pleasure and anxiety, pathography and reception. In the threshold between the two resides the potentiality to become otherwise. As Neil Hertz writes: "It is in this context—of being brought to a standstill by the unconscious arousal of repressed affect, usually but not exclusively attached to sexual anxieties—that we can best engage the question of how Freud imagines the reception of works of art" (1997, p. xvii). Moreover, this interruption of the system, bringing it to a standstill, is a cause of anxiety for criticism. How are we to locate this point where the poetic speech of the dream-work stops. Is it possible to utilize Freud's call for interpretative attention to "the significance of minor details" so as to make present the

death of the artist's intention (which is re-presented over and over again in the yet again of reception), which simultaneously marks the beginning of its *Nachleben* (afterlife)? The *Nachleben* of works is the terrain of art historians and critics wherein one must work through discourse (whether it is historicist, formalist, theoretical) in order to return the viewer to the artwork.

And what of the *Nachleben* of psychoanalysis? The one in which psychoanalysis is irreducible to Freud's intent. This is because Freud is not the author of psychoanalysis; he is the initiator of the discourse of psychoanalysis. It is the *Nachleben* of psychoanalysis, more so than the figure of Freud himself, that serves as a precursor for many twentieth-century critical theorists. The importance of this discourse lies in its being a system of thought that conceits to work through the vagaries of language and the seductiveness of the image-repertoires of modernity in order to arrive at the very bedrock of individual and collective life. The discourse of psychoanalysis provides critical theory with an enabling-limit, an interpretative horizon. As an interpretative discourse, psychoanalysis has proven both problematic and invaluable in explicating such areas as identity politics, literary texts, or political ethics. In the field of art history, psychoanalysis has changed the very contours of the practice, regardless of whether or not one is for or against its premises. The simple fact that the aesthetic sphere is no longer considered a space of disinterested aesthetic pleasure as Kant argued, but is one laced with individual and collective mythic, sexual, and political anxiety is a central argument for the continued engagement with the discourse of psychoanalysis.

The aesthetic sphere as redefined by Freud presents art historians and critics with a standing offer: to come to an understanding of artworks (in both their production and reception) and to derive a method of interpretation that does not foreclose upon the potentiality of the aesthetic situation to induce an individual to become otherwise—to take up a new relation to the past, to desire as such. This is also a system of thought that seeks to tie our aesthetic life to our political life. The life history that Freudian psychoanalysis collects and interprets is an aesthetic–political life that must be narrated. In the same manner, the relation between psychoanalysis and contemporary art historical practice must be narrated anew. This narration must not be afraid to radically

critique even the most central concepts of psychoanalytic discourse. Whether it is the anachronistic theories of gender and sexuality, or the ethnocentric focus of Freud's historical perspective, the discourse of psychoanalysis must continue to be rethought from within art historical discourse, starting from the twin poles of pathography and reception.

Further Reading

By Freud

1900. *The Interpretation of Dreams*. Vol. 4 of *The Standard Edition of the Complete Psychological Works of Sigmund Freud*, edited and translated by James Strachey. London: Hogarth Press, 1953.

1908. "Creative Writers and Daydreaming." In *The Freud Reader*, edited by Peter Gay. New York: W.W. Norton, 1989.

1910. "Leonardo da Vinci and a Memory of His Childhood." In *The Freud Reader*, edited by Peter Gay. New York: W.W. Norton, 1989.

1914. "The Moses of Michelangelo." In *Writings on Art and Literature*. Stanford, CA: Stanford Univ. Press, 1997.

1915. "Repression." In *The Freud Reader*, edited by Peter Gay. New York: W.W. Norton, 1989.

1915. "The Unconscious." In *The Freud Reader*, edited by Peter Gay. New York: W.W. Norton, 1989.

1916–1917. *Introductory Lectures on Psycho-Analysis*. Vols. 15, 16 of *The Standard Edition of the Complete Psychological Works of Sigmund Freud*, edited and translated by James Strachey. London: Hogarth Press, 1961.

1919. "The 'Uncanny.'" In *Writings on Art and Literature*. Stanford, CA: Stanford Univ. Press, 1997.

1930. *Civilization and Its Discontents*, edited and translated by James Strachey. New York: W.W. Norton, 1962.

1939. *Moses and Monotheism*, translated by Katherine Jones. New York: Vintage Books, 1967.

About Freud

Bowie, Malcolm. "Freud and Art, or What Will Michelangelo's Moses Do Next?" In *Psychoanalysis and the Future of Theory*. Oxford: Blackwell, 1993.

Forrester, John. "'Mille e tre': Freud and Collecting." In *The Cultures of Collecting*, edited by John Elsner and Roger Cardinal. Cambridge, MA: Harvard Univ. Press, 1994.

Gay, Peter. *Freud: A Life for Our Times*. New York: W.W. Norton, 1988.

Gombrich, E.H. "Freud's Aesthetics." In *Reflections on the History of Art*, edited by R. Woodfield. Berkeley: Univ. of California Press, 1987.

Hertz, Neil. "Foreword." In *Writings on Art and Literature by Sigmund Freud*. Stanford, CA: Stanford Univ. Press, 1997.

Kofman, Sarah. *The Childhood of Art: An Interpretation of Freud's Aesthetics*, translated by Winifred Woodhull. New York: Columbia Univ. Press, 1988.

Meisel, Perry, ed. *Freud: A Collection of Critical Essays*. Englewood Cliffs, NJ: Prentice Hall, 1981.

Ricoeur, Paul. *Freud and Philosophy: An Essay on Interpretation*, translated by Denis Savage. New Haven: Yale Univ. Press, 1970.

Shapiro, Meyer. "Leonardo and Freud: An Art Historical Study." *Journal of the History of Ideas* 17 (1956): 147–178.

Spitz, Ellen Handler. *Image and Insight: Essays in Psychoanalysis and the Arts*. New York: Columbia Univ. Press, 1991.

Wollheim, Richard. *Sigmund Freud*. New York: Viking Press, 1971.

Wollheim, Richard. "Freud and the Understanding of Art." In *Sigmund Freud*, edited by Harold Bloom. New York: Chelsea House, 1985.

KARL MARX

Key Concepts

- historical materialism
- dialectic
- modes of production
- proletariat, capitalists, bourgeoisie
- base/superstructure
- alienation
- ideology
- commodity fetishism

Karl Marx (1818–1883) was a German political philosopher. He was born in Trier, Germany, to liberal Jewish parents who had converted to Protestantism in order to advance the law career of his father. In 1836, after a year at the University of Bonn, Marx entered the University of Berlin, where he concentrated on philosophy. Deeply influenced by Hegelian thought, he was a member of a student group known as the Young Hegelians who espoused a radical, atheistic version of Hegel's *The Phenomenology of the Spirit* (1807).

Marx's doctoral thesis on Greek philosophy was accepted in 1841. Unable to find a university position, he became a journalist for the liberal newspaper the *Rhenish Gazette*. He wrote articles on a wide range of topics, touching especially on political and social concerns, and served briefly as the paper's editor before it was censored by the Prussian government for, among other things, articles about workers' conditions.

In 1843 Marx, newly married, moved to Paris to take a position as coeditor of a new publication, the *German-French Annals*. This journal expressed communist ideas, but failed to draw the interest of French readers. Deemed subversive by the Prussian government, the publication was confiscated and its editors sought for arrest. Once again unemployed and now unable to return to Germany, Marx devoted his energy to writing a work of political philosophy that would express his socialist views. At this same time (1844), Marx befriended Friedrich Engels, son of a German industrialist, who became Marx's lifelong collaborator and benefactor.

At the insistence of the Prussian government, the French expelled Marx and other German communists from Paris. Marx moved to Brussels, supported financially by Engels. They both attended the Congress of the Communist League in London in 1847. It was here that Marx asserted his views about how to bring about a communist revolution. As a result, he and Engels were commissioned to articulate the League's working doctrines, which resulted in the publication of *The Communist Manifesto* (published in German) in 1848.

After the 1848 French Revolution, Marx moved first to Paris, then to Cologne, then back to Paris as conservative factions regained control of Germany, and then, late in the summer of 1849, to London where he remained throughout the rest of his life. Marx lived in poverty for a time, but with Engel's support and his own family inheritances, he eventually enjoyed a comfortable lifestyle in London with his family. He continued to organize social movements and to write. In 1852, and continuing for a decade, he became a regular contributor to the *New York Tribune*. Marx published the first volume of *Das Kapital*, a critique of capitalist economics, in 1867. *Das Kapital* brought attention once again to Marx's ideas and a second edition was published in 1871. Translations into other languages soon followed, though an English translation did not appear until after Marx's death. Two subsequent volumes of *Das Kapital* remained unfinished at the time of his death but were later completed by Engels.

Marxism, or Marxist theory, is based on the ideas formulated by Marx and Engels as a critique of industrial capitalism. It focuses attention on social history in relation to political economy, especially class struggle. From a Marxist perspective, history is not driven by ideas, values, or some overarching spirit. Rather, it is a

record of struggle, rooted in material existence, for food, shelter, products of labor, and control over the means of production. Marx's ideas—disseminated in part through various interpretations of Marxism—exerted a tremendous impact on twentieth-century politics as well as on critical theory, literary theory, cultural studies, philosophy, sociology, and the arts.

We can conceive of Marxist theory in at least two ways. First, Marxist theory is a revolutionary critique of capitalist society. Marx was personally concerned with the need for social change in light of what he saw as the injustice and oppression caused by nineteenth-century industrial capitalism and the economic relations it engendered. His analyses of how industrial capitalism operated and how it caused oppression were directed at changing this system and thereby ending the human suffering that it produced. Second, and more important for our purposes, Marxist theory is a way to analyze not only economic relations (the base in Marx's terms), but also those values and viewpoints created by industrial capitalism that impact ostensibly nonpolitical endeavors such as religion, literature, and other cultural products (the superstructure). Marxist theory underscores the ideological nature of all human enterprises.

Central to Marxist thought is a philosophy of history known as **historical materialism**, which views historical change as a result of the actions of human beings within the material world, and not of the hand of God or some other extrahuman force. In this materialist view of history, Marx was influenced by Ludwig Feuerbach, who criticized the idealism of Hegelian thinking, which stressed ideas and the spiritual nature of the universe and historical teleology, by emphasizing the material conditions of the world. For Marx, what propels history is a **dialectic** expressing economic and other conflicts between social classes. Hegel, too, had understood history as dialectical, with change taking place through a series of successive movements from thesis to antithesis to synthesis. But whereas Hegel saw this as a history of a divinely inspired human spirit, Marx saw it as a history of human struggle over material goods and their production. This is why Marx is said to have stood Hegel on his head: material circumstances shape ideas, not vice versa.

Marxism describes the historical development of different **modes of production**, a concept referring to the ways societies organize economic relations in order to allow for the production of goods. The Marxist characterization of capitalism as an oppressive and

unjust system of labor and production focuses on social relations and the tools used in the production of goods. Labor is not formed in isolation, but within larger human networks. Therefore, the alienation of a worker from his or her labor defines the means by which humanity has been divested of its very being—its social being. From its earliest articulation, Marxism is presented as a discourse that is always already political *and* ontological.

Although modes of production differ across historical periods, Marxist cultural analysis is especially focused on industrial capitalism, viewing it as an economic system that depends on and promotes an unequal and therefore unjust mode of production. Marx's discussion of class struggle in capitalist society presupposes that economic development progresses from primitive to feudal to capitalist, and that class struggle corresponds to the dominant mode of production in each society. Inevitably, Marx argues, contradictions between those in control and those controlled result in class conflict. It is this dialectic of class confrontations that creates a new society. It is only with the development of a socialist mode of production that class distinctions and conflicts end. Historical change is possible only within the context of dialectical conflicts between classes. The ultimate goal being, of course, a classless, socialist state.

Before reaching this goal the agents within capitalist society must be identified. In a capitalist mode of production, the relations of production are such that workers labor to turn raw materials into finished goods (commodities) and owners control the sale and distribution of these products, collecting their surplus value. Such a system, Marx argues, inevitably results in the creation of class inequality in which the **proletariat**—workers who sell their labor power for a wage in order to make a living—enables the **capitalists** who own and control the means of production (i.e., natural resources, factories, machines, and other material resources) to recover a profit at the expense of the workers. A third class, the **bourgeoisie**, is made up of neither owners nor workers, but service providers such as doctors and teachers. Although they provide services to both other classes, they are usually identified as capitalists.

For Marx, economic organization shapes other aspects of society. The concepts of **base** and **superstructure** explain this relationship. Base refers to a society's economic mode of production, which

determines its superstructure, that is, its political, social, religious, moral, scientific, and other cultural productions. From this perspective, artworks, for instance, are not an independent or autonomous mode of human activity but are conditioned and determined by a society's mode of production and the relations it constructs. Marxism is a materialist theory that views artistic production as a part of society's superstructure, which includes universities and museums. It is Marxism that first presented us with the vocabulary of art institutions.

Additionally, Marxism draws our attention to the processes of **alienation**, especially that caused by the stratification of society into different classes, where the upper classes have privileged access to the goods produced by the lower classes. Alienation occurs in two ways. First, a capitalist mode of production is a system in which workers produce goods from which only capitalist owners profit. This is a labor alienated from its own efforts. Second, workers are alienated from themselves in a capitalist system. According to Marx, this occurs because workers become commodities when they must sell their alienated labor in the marketplace, just as other goods are sold. Thus, the workers become alienated from their own humanity and that of others. It is for this reason that Marx describes his goal of a classless, communistic society as:

> the positive supersession [*Aufhebung*] of private property as human self-estrangement, and hence the true appropriation of the human essence through and for man; it is the complete restoration of man to himself as a social, i.e. human, being, a restoration which has become conscious and which takes place within the entire wealth of previous periods of development. (1844, p. 212)

Marx's thought forwards a progressive, dialectical overcoming of capitalist modes of production that is informed by the struggles and inequalities of the past. It is only through the dialectic that humanity can free itself from alienation and its attendant ideology.

Ideology, Marx contends, is a false consciousness that distorts social and material reality, thereby functioning to keep people in their place within the capitalist system. This distortion prevents people from viewing the relations of production as they really are. Therefore ideology is an aspect of superstructure: it is produced by the economic base and functions to legitimate that base. Ideologies

determine what can be thought and believed about politics, religion, and literature. But ideologies are not autonomous; they depend, Marx explains, on the prevailing economic mode of production and serve as a justification for its continued existence.

In this Marxist light, the practices of art history and museology— elements of the superstructure—are not innocent endeavors, but rather are ideologically implicated in larger political and economic processes. There is a long-standing tradition within art history of Marxist thinkers who have sought to foreground the ideology inherent in various approaches to the study of art. Within art historical practice, Marxist thought foregrounds the social and human origins of any cultural production; any reading of an artwork must be grounded in the logic of the base/superstructure relation. Included in this perspective is the importance of questions concerning the ways in which technology alters the production and reception of artworks, patronage, and even social inequality (for example, feminism).

In terms of art history, a key idea is Marx's insistence upon conceiving of form as content. This is intentionally meant to mirror the base/superstructure relation. This way of thinking demands an approach to art history that begins not with the disembodied, disinterested perspective of Kantian aesthetics, but from an embodied, politically engaged perspective that desires to understand how art can be both the symptom of ideology and indicative of its overcoming. Although art is a product of the superstructure, Marx never espoused a position that has today become known as "vulgar Marxism," wherein art, as an example of a cultural product, is merely a passive, mechanical reflection of the base. From its inception, Marxist thought has contained a more nuanced, even radical, notion of art. Marx argued that some cultural productions (he often gives Shakespeare as an example) can transcend ideology; thus, the superstructure can, in certain instances, alter the base. Artworks have the potential to affect and even change how we view material (social and historical) reality. This more dynamic reading of Marx has been developed further by late twentieth-century Marxist thinkers, such as Louis Althusser, who have been able to draw on psychoanalysis and poststructuralist thought. Nonetheless, the concept of art as both a symptom of ideology and as that which can be more than a mere

political instrument is present in Marx's thought even in its earliest forms. This artistic and political tension was dramatically played out immediately after the Russian Revolution (October 1917) in the debates between the artistic avant-garde (for example, Constructivists such as Alexander Rodchenko) and the growing centralization of the socialist state under Stalin.

Art is given this curious potentiality because it refracts the alienation of a humanity severed from its very ontological status; that is, the debasement of the public realm in bourgeois capitalist society. Under the reign of capitalism, there are no longer relations between human beings. The social sphere is defined by **commodity fetishism** in which there is only "a social relation between the products" (1867, p. 43). Products become commodities because they are endowed with qualities symbolizing exchange value and the remnants of social interaction. A commodity is an intriguing "social hieroglyphic" that must be deciphered in order to reveal the presence of another economy: the absent exchange of social relations between persons as opposed to things (p. 45). This attests to the importance of art history. Despite the artwork's inescapable status as a commodity and the inherent commodity fetishism involved in art historical practice, there is a call for an interpretation that can explicate the means by which the production of art is more than a mere reflection of the mode of production (see **ADORNO** and **BENJAMIN**). An artwork is addressed to an audience, and although an artwork is received individually, it can induce the viewer/listener/reader into an awareness of others, an awareness of the larger social sphere. Moreover, Marx reasons, because art is not produced in immediate response to any biological need (such as hunger, shelter, and so on), it is an expression, a labor of desire, aimed at speaking with others—at constructing a *socius*. This is why Marx writes: "My own existence is social activity. Therefore what I create from myself I create for society, conscious of myself as a social being" (1844, p. 213). The production of art objects can be a praxis addressed to an audience of others that aids in the overcoming of alienation by making humanity conscious of itself as an object amongst other objects, rather than as a human being. In other words, it can make evident the logic and the consequences of capitalist modernity. Marx argues that man's "expression of life is his alienation of life, and that this realization is a loss of reality, an

alien reality, so that the positive supersession of private property, i.e., the sensuous appropriation of the human essence and human life" becomes possible (p. 214).

In conclusion, it is essential that the radical humanism Marx proposes—the very redefinition of our "species-being"—be understood as inseparable from his thoughts on the production and reception of art. His calls for a materialistic art history, that is, his insistence on the role played by the social and historical context in the production and interpretation of artworks, is one of the determining frameworks of art historical practice, one that deserves to be rethought even as we find ourselves culturally and politically in the twilight of Marxism. As the late Jacques DERRIDA astutely observed in *Specters of Marx* (1993): "I believe in the political virtue of the contretemps [because] … it will always be a fault not to read and reread and discuss Marx…. There will be no future without this … without the memory and inheritance of Marx: in any case of a certain Marx, of his genius, of at least one of his spirits. For this will be our hypothesis or rather our bias: there is more than one of them, there must be more than one of them" (pp. 88, 13).

Further Reading

By Marx

1844. "Private Property and Communism." In *The Continental Aesthetics Reader*, edited by Clive Cazeaux. London and New York: Routledge, 2000.

1848. *The Communist Manifesto: A Modern Edition.* New York: Verso, 1998.

1867. *Capital: An Abridged Edition*, edited by David McLellan. Oxford: Oxford Univ. Press, 1999.

About 1939–1941. *The Grundrisse*, edited and translated by David McLellan. New York: Harper & Row, 1972.

Marx and Engels on Literature and Art: A Selection of Writings, edited by Lee Baxandall and Stefan Morawski. New York: International General, 1973.

The Marx-Engels Reader, edited by Robert C. Tucker. 2nd ed. New York: W.W. Norton, 1978.

Karl Marx: A Reader, edited by John Elster. Cambridge, UK: Cambridge Univ. Press, 1986.

Early Writings, translated by Rodney Livingstone and Gregor Benton. London: Penguin, 1992.

About Marx

Althusser, Louis. *For Marx*, translated by Ben Brewster. New York: Pantheon, 1969.

Baxandall, Lee. *Marxism and Aesthetics: A Selected Annotated Bibliography*. New York: Humanities Press, 1968.

Carver, Terrell, ed. *The Cambridge Companion to Marx*. Cambridge, UK: Cambridge Univ. Press, 1992.

Derrida, Jacques. *Specters of Marx: The State of Debt, the Work of Mourning, and the New International*, translated by Peggy Kamuf. London and New York: Routledge, 1994.

Elster, Jon. *Making Sense of Marx*. Cambridge, UK: Cambridge Univ. Press, 1985.

Larsen, Neil. *Modernism and Hegemony: A Materialist Critique of Aesthetic Agencies*. Minneapolis: Univ. of Minnesota Press, 1990.

Lukács, Georg. *Studies in European Realism*, translated by Edith Bone. New York: Grosset & Dunlap, 1964.

Macherey, Pierre. *A Theory of Literary Production*, translated by Geoffrey Wall. London and New York: Routledge, 1978.

McLellan, David. *Karl Marx: His Life and Thought*. New York: Harper & Row, 1973.

Negri, Antonio. *Marx Beyond Marx*, translated by Harry Cleaver, Michael Ryan, and Maurizio Viano. South Hadley, MA: Bergin & Garvey, 1984.

Singer, Peter. *Marx: A Very Short Introduction*. Oxford: Oxford Univ. Press, 2000.

Wolff, Jonathan. *Why Read Marx Today?* Oxford: Oxford Univ. Press, 2002.

FRIEDRICH NIETZSCHE

Key Concepts

- Dionysian and Apollonian
- aesthetic relation
- tragic culture

Friedrich Wilhelm Nietzsche (1844–1900) was born in Röcken, Prussia. He was the eldest of three children. His father and both grandfathers were ordained Lutheran ministers, and early on he seemed destined for the ministry (other children called him the "little pastor"). His father died at thirty-six, when Friedrich was only five. About five months later his youngest brother Joseph also died.

Nietzsche received an excellent education. From the ages of fourteen to nineteen he studied at Schulpforta, an elite boarding school. In 1864, he entered the University of Bonn to study theology and philology, but a year later he moved to the University of Leipzig to focus exclusively on philology. In 1867 he took leave of his studies to serve for a year in the Prussian military as an officer. In 1869, at twenty-four, he was appointed professor of classical philology at the University of Basel. At the time of his appointment he had yet to complete his exams and dissertation, but the University of Leipzig waived those requirements and awarded him the doctoral degree.

As a result of failing health, Nietzsche took leave of his professorate in 1876, and then resigned in 1879. Having given up his Prussian

citizenship without being granted Swiss citizenship, he remained "stateless" for the rest of his life. For the next decade, he wrote prolifically while traveling and visiting friends throughout Europe and elsewhere.

In January 1889, while in Turin, he suffered a mental breakdown from which he never recovered. The apocryphal story is that he collapsed after wrapping his arms around the neck of a horse that had just been brutally whipped by a coachman. After spending a year in a sanitarium in Jena, he went to live with his mother until her death in 1897. He spent his last years in the care of his sister, Elizabeth, a devout anti-Semite who published *The Will to Power* (based on his 1880s notebooks) and who later brought his works to the attention of influential fascists, including Hitler and Mussolini. Despite certain passages in his writings that easily support the anti-Jewish ideology of the Nazis, Nietzsche railed against German nationalism and was alienated from his sister on account of her anti-Semitism.

Nietzsche described his work as philosophizing "with a hammer." Trained in classical philology, he is best known as a critic of prevailing Western European cultural values. In particular, he challenged the Christian foundations of those values. But his philosophy was not simply negative or destructive, which is a common misreading. On the contrary, his critical eye on Western civilization was inspired by a desire to affirm what he understood to be the source of life—a kind of primordial, creative energy beyond rationality and beyond moral categorization as good or evil. He argued that Western civilization was in decline because it had drained that life force, ceding power and authority to those who fear it.

Art is central to Nietzsche's thoughts on the decline of Western civilization. For him, art is capable of suggesting an alternative to this demur, rational life of decline; it represents, he argues in *The Birth of Tragedy* (1872), "the highest task and the truly metaphysical activity of this life"—the very life of the will he outlines throughout his works (p. 31). This first text describes a primordial, emotive, and rhythmic life force, which he terms **Dionysian**, after the ancient gender-bending god of wine, masquerade, violence, and orgy. Contrary to the prevailing view of ancient Greece as a world of noble harmony and rational order, Nietzsche argues that Greek culture existed in the tension between

two opposing forces: on the one hand, the Dionysian forces of amoral desire and intoxicated "blissful ecstasy"; and on the other, the Apollonian forces of moral order and sober rationality. The **Apollonian** force is order; the Dionysian is the chaotic life force that precedes the order of civilization and is its creative source. Nietzsche believes that in the centuries since ancient Greece, Western civilization has gradually repressed the Dionysian, leaving modern society predominantly Apollonian, starved of creative energy and in poor health. "Modern man," he avers, "is merely a counterfeit of the sum of cultural illusions that are allegedly nature" (1872, p. 62). To correct this situation Nietzsche explains that pre-Socratic Attic tragedy was, in fact, equally Apollonian and Dionysian; thus, his prescription for modern (specifically, nineteenth-century Western Europe) society is a radical transformation of the aesthetic sphere aimed at understanding the dialectical development of art.

Two important philosophical positions underlie Nietzsche's redefinition of "the science of aesthetics" (p. 33). First, following on the work of Immanuel Kant and Arthur Schopenhauer, Nietzsche argues that there is no facile opposition between appearance and truth. Rather, he insists that the world is constructed through representation. In other words, because self-consciousness constructs reality, there is no representation of a thing-in-itself. Because of humanity's reliance on language we are condemned, Nietzsche argues, to a life of metaphor, an endless contemplation of images. This is characterized as an anthropocentric existence wherein there is no possibility of bridging the gulf "between this real truth of nature [Dionysian] and the lie of culture [Apollonian] that poses as if it were the only reality that is similar to that between the eternal core of things, the thing-in-itself, and the whole world of appearances" (p. 61).

Nietzsche's second philosophical position, which allows us to understand the first more fully, is a call for the inversion of Kantian aesthetics. In *On the Genealogy of Morals* (1887) he offers the following:

> Kant thought he was honoring art when among the predicates of beauty he emphasized and gave prominence to those which established the honor of knowledge: impersonality and universality. This is not the place to inquire whether this was essentially a mistake; all I wish to underline is that Kant, like all philosophers, instead of envisaging the aesthetic

> problem from the point of view of the artist (the creator), considered art and the beautiful purely from that of the "spectator," and unconsciously introduced the "spectator" into the concept "beautiful"…"That is beautiful," said Kant, "which gives pleasure without interest." (pp. 104–105)

Here it is easy to see that the poles of creator and spectator correspond to those of the Dionysian and the Apollonian. Moreover, this call for an inversion of Kantian aesthetics is an extension of Nietzsche's overarching conception of the immanence of the Apollonian and Dionysian. More than simply calling for the substitution of the latter for the former, his definition of art is contingent upon an ever-changing dynamic relation between the Apollonian forces of restraint, disinterest, and dissimulation, and the Dionysian forces of intoxication (the dissolution of the individual into the sphere of the collective), intuition, and the delimitation of the human subject. The artist maintains a relation to the "primordial artist of the world" and in this relation the artist is revealed to be both "subject and object, at once poet, actor, and spectator" (p. 52). Because he also considers external "reality" to be valid only as an aesthetic phenomenon, Nietzsche defines aesthetic experience as not what occurs in an isolated, privileged sphere of existence, but as the very founding experience of life. It is in and through art that life as such can be experienced.

The aspect of this system of thought most interesting to the study of art history is how Nietzsche theorizes the interdependence of these opposing poles. The gulf that separates subject and object, appearance and truth, Apollonian and Dionysian, is traversed by what he terms "an **aesthetic relation**" [*ein ästhetisches Verhalten*] (1873, p. 58). It is art that moves between the spheres of Apollo and Dionysos; it is art that keeps the possibility of "continual rebirths" in play (1872, p. 66). This is accomplished by the reticence of the aesthetic, which does not conceit to know the external world on its own terms. On the contrary, the aesthetic sphere, for Nietzsche, is determined by the Dionysian motives of the artist as opposed to spectator; that is, the "true artist" who refuses to deny the intuition that there exists something beyond the world of appearance and self-consciousness. Although the aesthetic cannot represent the thing-in-itself, it is able to construct a relation with "the mysterious X of the thing in itself" (1873, p. 55). This "mysterious X" must remain inaccessible and unrepresentable but, through art, it makes

its presence felt, thereby undermining the concept of experience that Western civilization has inherited from Platonic idealism. It is a nihilistic "playing with seriousness" that allows Nietzsche to present the aesthetic relation between the Apollonian and the Dionysian as that which has the ability to affect "redemption in illusion" (1873, p. 61; 1872, p. 61). Just as the world is conceived by an artist, Nietzsche redefines art as a drive, a force, or rhythm, that "continually manifests an ardent desire to refashion the world which presents itself to waking man, so that it will be as colorful, irregular, lacking in results and coherence, charming and eternally new as the world of dreams" (1873, p. 59). Simply put, the metaphysical is the aesthetic in Nietzsche's work only insofar as there is no simple binary opposition of appearance and truth. The truth appears through the rhythm of intuition and language, music and image.

It should be noted that Nietzsche privileges music over the plastic arts. Music, for him, is closest to metaphysics; it is what "allows the symbolic image to emerge in its highest significance" (1872, p. 103). However, as the Dionysian needs the Apollonian, so music needs the plastic arts. It is in the translation between the spheres that the immanence of the two poles of cultural production becomes evident. In fact, the plastic arts as representations of phenomena are crucial to Nietzsche's system because he believes that an organism translates external stimulation into an image. This means that the image is an immediate translation of external stimuli (perceptions as such). This point helps to explain why toward the end of *The Birth of Tragedy* Nietzsche finally articulates his basic points of departure: "what aesthetic effect results when the essentially separate art-forces, the Apollonian and the Dionysian, enter into simultaneous activity? Or more briefly: "how is music related to image and concept?" (p. 101). This intimacy between intuition (music) and image (plastic arts) affords him the opportunity to declare that "art is worth more than truth" and that "we possess art lest we perish of the truth" (1901, pp. 453, 435).

Nietzsche's work is invaluable for art historical practice not only because his thinking has shaped the discourse of modernism and postmodernism, but also because his work insists that the reception of an artwork is irreducible to formalistic-linguistic concepts and mere appreciation of "beauty." Rather than continuing on the dead-end street of a viewer's sensuous apprehension (*aisthesis*)

of an artwork, Nietzsche's work radically departs from Kant. As Giorgio Agamben explains in *The Man Without Content* (1994):

> The problem of art, as such, does not present itself within Nietzsche's thought because all his thought is about art. There is no such thing as Nietzsche's aesthetics because Nietzsche never thought of art starting from … the spectator's sensuous apprehension—and yet it is in Nietzsche's thought that the aesthetic idea of art … as a creative-formal principle, attains the furthest point of its metaphysical itinerary. (p. 85)

Nietzsche calls for a shift in focus from the spectator and the perception of the work of art to the artist and the work of art because he wants to replace Kantian aesthetics (which expresses only a will to decline, a stoic resignation) with "an aesthetic relation" that asserts the will to life that is the nucleus of his philosophy. With this substitution, he bequeaths art history the extraordinary challenge of recognizing art as the "highest metaphysical task of man." The first step toward this acknowledgment would be for art history to move "far beyond the phraseology of our usual aesthetics" (1872, p. 101).

This requires the art historian to take on an aspect of the artist rather than remaining merely the appreciative, even politicized, "theoretical man" who maintains the estrangement between what Nietzsche calls "true art" and culture, instead of transforming "the desert of our exhausted culture" by allowing it to touch its Dionysian foundation (1872, p. 123). Art history, therefore, is less about categorization, formal appreciation, or even social historical work, than it is about disclosing the ways in which art is vital to individual and collective experience. (The difficulty arises because the criteria by which one would judge or arrive at what constitutes this category of "true art" are yet to be determined.) Art exists, for Nietzsche, within the flux of the Apollonian and the Dionysian, that is, within the sphere of tragedy. He concludes his first text with a call for a rebirth of what he calls **tragic culture**, which can "'live resolutely' in wholeness and fullness" because "the tragic man of such a culture" is not afraid "to desire a new art, the art of metaphysical comfort, to desire tragedy as his own proper Helen" (1872, p. 113). It remains to be seen whether or not art history can live up to a conception of art that must pass through

the suffering of life before it can attain its ultimate goal of *"une promesse de bonheur."*

Lastly, there is no better summation than Nietzsche's own poetic words: "Thus the aesthetically sensitive man stands in the same relation to the reality of dreams as the philosopher does to the reality of existence; he is a close and willing observer, for these images afford him an interpretation of life, and by reflecting on these processes he trains himself for life" (1872, p. 34).

Further Reading

By Nietzsche

1872. *The Birth of Tragedy and The Case of Wagner*, translated by Walter Kaufmann. New York: Vintage Books, 1967.

1873. "On Truth and Lie in the Extra-Moral Sense." In *The Continental Aesthetics Reader*, edited by Clive Cazeaux. London and New York: Routledge, 2000.

1883–1891. *Thus Spoke Zarathustra*, translated by Walter Kaufmann. New York: Viking, 1968.

1886. *Beyond Good and Evil*, translated by Walter Kaufmann. New York: Random House, 1966.

1887. *On the Genealogy of Morals*, translated by Walter Kaufmann. New York: Vintage Books, 1967.

1887. *The Will to Power*, translated by Walter Kaufmann. New York: Random House, 1967.

About Nietzsche

Agamben, Giorgio. *The Man Without Content*, translated by Georgia Albert. Stanford, CA: Stanford Univ. Press, 1999.

Bataille, Georges. *On Nietzsche*, translated by Bruce Boone. New York: Paragon, 1992.

Deleuze, Gilles. *Nietzsche and Philosophy*, translated by Hugh Tomlinson. New York: Columbia Univ. Press, 1983.

Ferry, Luc. "The Nietzschean Moment: The Shattered Subject and the Onset of Contemporary Aesthetics." In *Homo Aestheticus: The Invention of Taste in the Democratic Age*, translated by Robert De Loaiza. Chicago: Univ. of Chicago Press, 1993.

Heidegger, Martin. "The Word of Nietzsche: 'God is Dead.'" In *The Question Concerning Technology and Other Essays*, edited by William Lovitt. New York: Harper & Row, 1977.

Kaufmann, Walter. *Nietzsche: Philosopher, Psychologist, Antichrist*. Princeton, NJ: Princeton Univ. Press, 1950.

Kofman, Sarah. *Nietzsche and Metaphor*, translated by Duncan Large. Stanford, CA: Stanford Univ. Press, 1993.

Nehamas, Alexander. *Nietzsche: Life as Literature*. Cambridge, MA: Harvard Univ. Press, 1985.

Shapiro, Gary. *Archaeologies of Vision: Foucault and Nietzsche on Seeing and Saying*. Chicago: Univ. of Chicago Press, 2003.

Vattimo, Gianni. *Nietzsche: An Introduction*, translated by Nicholas Martin. Stanford, CA: Stanford Univ. Press, 2002.

FERDINAND DE SAUSSURE

Key Concepts

- structural linguistics/structuralism
- semiotics
- langue/parole
- synchronic/diachronic
- sign (signifier and signified)
- arbitrariness of the sign
- binary opposition (meaning as difference)

Ferdinand de Saussure (1857–1913) was a Swiss linguist whose posthumously published *Course in General Linguistics* (1916) became a catalyst for the development of structuralism. Saussure was born in Geneva, Switzerland, into a family with a lineage of noted academics dating back to the eighteenth century. Saussure himself displayed a gift for languages from an early age. At the University of Geneva, he studied not only linguistics but also theology, law, and chemistry. In 1878, at twenty-one years of age, he published *Memoir on the Original System of Vowels* in the Indo-European Languages, a comparative study of vowel usage in proto-Indo-European languages.

Saussure received his doctorate from the University of Leipzig in 1880. From 1881 to 1891 he taught linguistics at the École des hautes études in Paris. In 1891, he returned to the University of Geneva where he taught courses on Sanskrit and general linguistics for the remainder of his career. Although he published very little,

his students at the University of Geneva compiled and transcribed their notes from his general linguistics course lectures and had them published under the title *Course in General Linguistics*.

Saussure's perspective on language had an impact on all fields of cultural study. The decisive element in his work is the assertion that linguistic meaning resides in the relationships between words. This philosophy of language is commonly referred to as **structural linguistics or structuralism** because its strategy for examining language and meaning centers on investigating structures within a system. Structuralism brought about a major shift in twentieth-century thought by initiating the "linguistic turn," which has become shorthand for the conviction that meaning does not exist outside the system of language.

In the *Course on General Linguistics*, Saussure advocates the scientific study of language, which for him, concerns "the life of signs within society." This method departs from historical linguistics as practiced by European philologists in the late nineteenth and early twentieth centuries, who sought to trace Indo-European languages back to a common origin. Saussure called his new linguistic science semiology, a term derived from the Greek word for "sign" (*semeîon*). Semiology, also called **semiotics**, the science of signs; that is, the study of the structure of language as a system of signification rather than the study of the history of language.

In order to study language as a system of signs, Saussure makes a distinction between ***langue*** and ***parole***. *Langue* (language) refers to language as a structured system operating at a particular time and place, and to the linguistic rules that determine how a language can be used in practice. In contrast, *parole* (speech) refers to particular instances of speech within the system. Without *langue*, *parole*—what individuals say, language in use or semantics—would be impossible. For Saussure, the object of inquiry, then, is *langue*, which constitutes the overarching linguistic system that makes specific utterances possible.

As the terms *langue* and *parole* suggest, the study of language as a system requires a **synchronic** ("at the same time") rather than a **diachronic** ("through time") approach. Synchrony refers to the study of language—especially spoken language—as it is used at a particular moment in time. Diachrony refers to the study of language over time. Nineteenth-century philology employed a diachronic methodology that derived from a central assumption

that language could only be understood through a study of its historical changes. By tracing a word back to its etymological origin, one would then be able to follow the path back to its present meaning.

Saussure advocates a synchronic approach to language as a system. Instead of etymology as the conveyor of the word's meaning, he asserts that meaning is produced by a word's relationship to other words occurring at a particular time, within a particular system of relationships. For instance, the contemporary word "dog" means something not because of its historical derivation from the Middle English *dogge*, which is in turn derived from the Old English *docga*, but rather because of the current relationship of dog to other words like puppy and cat. In Saussure's analysis, all of these terms are part of a differential system, and their meanings and significance derive synchronically from relationships with other signs within that system.

As illustrated by the previous example, a central claim made by Saussure's semiotics is that words do not have an inherent significance because meaning resides in relationships of difference and similarity within a larger linguistic system. Simply put, words are not units of self-contained meaning. A related concern— whether language is natural or conventional—also plays an important role in Saussure's linguistic analysis. A natural view of language proposes that language names things in the world because there is some intrinsic relationship between a word and a thing named. On the other hand, if language is conventional, as Saussure maintains, both concrete things and abstract concepts are named on the basis of an arbitrary decision to use a certain sound to represent a certain idea.

How does Saussure arrive at the conclusion that language is primarily conventional? He begins with the idea of a linguistic **sign**. A sign may be a word or some other form; he often refers to a sign as an "acoustic-image." Regardless of its particular form, however, every sign consists of a **signifier** and a **signified**.

$$sign = \frac{signifier}{signified}$$

A linguistic sign comprises an acoustic image, such as the letters d-o-g spoken or written (the signifier) and the object or concept associated with the acoustic image (the signified). What determines the

meaning of a sign is not its acoustic image or linguistic origin, but its place within the larger network of interrelationships, that is, within the larger linguistic structure. Thus a structuralist approach focuses on the relationship of individual parts to the larger whole (the structure) within which significance is determined.

One of Saussure's crucial insights, then, is that the sign is fundamentally relational. In other words, the relationship between the signifier and signified is **arbitrary**. That is, there is no a priori relationship between a signifier and a signified. The fact that dog signifies a four-legged domestic animal in English, while *chien* and *inu* point to this same animal in French and Japanese, respectively, is evidence that there is no necessary, predetermined relationship between the letters d-o-g and a common pet. The word dog is an arbitrary designation. We could call dogs by some other term as long as we agree culturally on that usage. There is no particular dog designated by the word, nor is there some inherent quality ("dogness") contained in or conveyed by the acoustic-image dog.

Because signs are arbitrary, the meaning of any particular sign is determined in terms of similarity and difference in relation to other signs. Language is a differential system of meaning. Meaning is founded on **binary oppositions**, such as light/dark, inside/outside, margin/center, male/female, and so on. Within these binary pairs, the meaning of one is basically the opposite of the other. Meaning is predicated on difference. Saussure argues:

> In language there are only differences. Even more important:
> a difference generally implies positive terms between which
> the difference is set up; but in language there are only
> differences without positive terms ... [Moreover] the idea or
> phonic substance that a sign contains is of less importance
> than the other signs that surround it. (1916, p. 120)

This insight on the differential function of meaning in language has serious implications for the concepts, identities, and cultural articulations that take place in and through language.

The consequences of Saussure's insights are fundamental to twentieth-century thought, in part because semiotics, by definition, is an interdisciplinary venture. By asserting the "arbitrariness of the sign," Saussure's work draws attention to the problematic of intent in any spoken or written text. There is no guarantee that

an author's intended meaning can be inscribed in the speech he or she uses. The system of language cannot be pinned down to insure the conveyance of a particular meaning. In addition, the idea of context, used as a means to devise the parameters which narrow the possibilities of the potential meaning of any given sign, can no longer be taken as a given. A context does not preexist an accumulation of signs or a text, rather the context is constructed anew with each use of language, with each utterance, each text. This fact problematizes the traditional notion of a "natural" relationship between an author/artist and his or her works.

Within art history, Saussure's work has had a somewhat problematic reception, but its influence has nonetheless been remarkable. Saussure's semiotics enters art historical discourse as soon as he calls the signifier an acoustic image. In his terms a sign is, by definition, antirealist, which suggests an affinity between his work and the turn to abstraction in early twentieth-century art. One need only think of the Belgian Surrealist René Magritte's famous painting *The Betrayal of Images* (1928–1929). This seemingly simple representation of a pipe is irremediably complicated by the inclusion of the words: "*Ceci n'est pas une pipe* [This is not a pipe]." The arbitrariness of the sign is made evident here, but there is also another turn of the screw. The visual image—the painting—bears no "natural" relation to neither the acoustic image "pipe" nor the signified (a wooden instrument one uses to smoke tobacco). But Magritte's work begs a further question concerning whether or not visual language is something altogether different from either *langue* or *parole*.

The intersection between visual image and text also plays an important role in postwar Conceptual art practice, especially in the work of the Art and Language group. In many ways, the work of this group is indicative of how critical theory, beginning in the 1960s and armed with structuralism, informs contemporary cultural production and the critical reception of artworks. The work of many scholars and critics falls under the large umbrella of visual semiotics, a field unthinkable without Saussure.

The differential manner in which binary oppositions work to define one another, that is, how meaning is structurally negotiated, opened the door for the "linguistic turn" of poststructuralism in the late twentieth century. In poststructuralist thought, binary oppositions like black/white, male/female, straight/queer, colonizer/colonized

are pressed to reveal a fundamental denotive instability. There is no structure that guarantees the meaning of either term. This insight, in turn, allows for a critique of the inherent paradoxes of larger discourses such as racism, which are premised on a denial of the interdependence of binary terms such as these.

Saussure's work instigates a fundamental rethinking of the nature of representation. This includes the representation of the subject—the constitution of all subjects (individual and collective) in and through language—as well as the notion of the representation of "reality." Beyond changing how art historians must read their objects of study and raising questions about the very nature of visual representation, semiotics, by raising the status of the text and discourse, implicates the very activity of the art historian in the production or performance of his or her object of study. This is because there can be no simple binary opposition of art object and historian/critic. The centrality of Saussure's work to critical theory as a whole rests in large part on his theory of language, but also on the consequences of that theory, the most important of which may very well be self-reflexivity, which begins not with how we wield language but how it constitutes us.

Further Reading

By Saussure

1916. *Course in General Linguistics*, translated by Wade Baskin. New York: McGraw-Hill, 1959.

About Saussure

Bal, Mieke, and Norman Bryson. "Semiotics and Art History: A Discussion of Context and Senders." In *The Art of Art History: A Critical Anthology*, edited by Donald Preziosi. Oxford: Oxford Univ. Press, 1998.

Belsey, Catherine. *Poststructuralism: A Very Short Introduction*. Oxford: Oxford Univ. Press, 2002.

Culler, Jonathan. *The Pursuit of Signs: Semiotics, Literature, Deconstruction*. Ithaca, NY: Cornell Univ. Press, 1981.

Culler, Jonathan. *Ferdinand de Saussure*. Rev. ed. Ithaca, NY: Cornell Univ. Press, 1986.

Lévi-Strauss, Claude. "The Structural Study of Myth." In *Structural Anthropology*. New York: Basic Books, 1963.

Mitchell, W.J.T. *Iconology: Image, Text, Ideology*. Chicago: Univ. of Chicago Press, 1986.

THEORY FOR ART HISTORY

THEODOR W. ADORNO

Key Concepts

- culture industry
- autonomy of art
- dialectics of appearance

Theodor Wiesengrund Adorno (1903–1969) was born in Frankfurt am Main, Germany. His academic career is marked by a series of remarkable and influential encounters. While at the University of Frankfurt, in addition to music composition, Adorno studied sociology and psychology with Siegfried Kracauer. Music remained a lifelong interest for Adorno, who even trained as a concert pianist under Alban Berg. His first published essays were on the modernist composer and pioneer of atonalism, Arnold Schönberg. In 1926, Adorno's first attempt at the *Habilitationsschrift* (a document required for promotion to a university position), titled *The Concept of the Unconscious or The Transcendental Theory of the Mind* was rejected. But his second attempt, which has become a widely influential work, *Kierkegaard: The Construction of the Aesthetic* (1933), was successful. Adorno established the Institut für Sozialforschung in Frankfurt with his longtime friend and collaborator Max Horkheimer in 1931. With the rise of Nazism in Germany, Adorno and other Jewish intellectuals were expelled from their university posts. As a result, he went into exile in Oxford, England, before departing to the United States, where he lived and worked in New York City, Los Angeles, and Berkeley. Adorno returned to Frankfurt after the

war, where he reestablished the Institute of Social Research in 1949. The intellectuals, economists, and sociologists associated with the Institute included Horkheimer, Herbert Marcuse, and Jürgen Habermas, among others. It is this group of thinkers who comprise the first generation of what has been termed "critical theory." Upon Horkheimer's retirement in 1959, Adorno assumed the role of director and held that post until the late 1960s. The student uprisings and social unrest in Paris during May 1968 spilled into West Germany, where students occupied the Institute's buildings. Adorno's comments on the protests were widely ridiculed and he fled to Switzerland, where he died in 1969 while working on his unfinished magnum opus *Aesthetic Theory* (1970).

Adorno's work has been central to discussions of modernism. His work bears the influence of his friendship with Walter **BENJAMIN**, who encouraged Adorno's interest in the work of Karl **MARX**. The published correspondence between Adorno and Benjamin constitutes one of the most intriguing and important intellectual documents of the twentieth century. Texts such as *The Dialectic of the Enlightenment* (1947), cowritten with Horkheimer, *Negative Dialectics* (1966), and *The Philosophy of Modern Music* (1958), serve as touchstones of postwar critical thought. Adorno's work, however, has been criticized for being elitist, Eurocentric, and too reliant upon a dialectical method associated with high modernism. Nonetheless, his interdisciplinary approach to the study of the "culture industry" and his argument for the autonomy of art have played a considerable role in the manifold discourses bearing the prefix 'post': postmodernism, poststructuralism, post-Marxism, and even postcolonialism. In this regard it is significant that Adorno's major works were written during his exile in the United States, where the importance of his work to many American scholars and activists, including Angela Davis, who studied with Adorno, is inestimable. Moreover, his aphoristic, performative writing style shares something with the poststructuralist writing practices of Jacques **DERRIDA**, who shared Adorno's contention that no thought—even critical theory itself—escapes the pull of the marketplace, nor does it exist as a kind of second-order language that transcends the discourse it critiques. Their paratactical style of writing is meant to undermine the traditional authoritative voice

of the scholar as it constructs a space from which to critique the exchange economy of advanced capitalism.

Adorno's discussions of the culture industry began with his disagreements with Benjamin over the latter's belief in the transformative potential of film and radio to radicalize the masses. In his early essay "On the Fetish-Character in Music and the Regression of Listening" (1938), Adorno insists that technology denies artistic innovation by promoting a passive viewer, thereby stunting political consciousness. (It should be noted that Benjamin's thought underwent a crisis that caused him to abandon this early position.)

Adorno develops his position further in the chapter titled "Culture Industry: Enlightenment as Mass Deception" in *The Dialectic of the Enlightenment*, which serves as an excellent introduction to his work. Drawing on the work of Friedrich NIETZSCHE and Marxist thinkers such as Georg Lukács, Adorno analyzes the advent of the culture industry in late capitalist societies. In responding to what he calls "the darkening of the world" brought about by fascism, Stalinism, and the Holocaust, Adorno argues that the world has retreated into myth and barbarism, which are dialectically present in the Enlightenment origins of modern society. The concept of the **culture industry** refers not only to popular culture, but to the entire sphere of popular media and culture that produces commodities for mass consumption. In late capitalism, the culture industry even renders art a mere commodity. For Adorno, a commodity is defined in Marxist terms: it is a mass-produced object whose exchange value is its only use value. In this system, the consumer is passive, politically apathetic, and objectified.

The illusory pleasures offered by the culture industry only serve the ends of profit and the further exploitation of the masses, Adorno argues. The "standardization" of culture is accomplished in the name of a unified economic and political power. (These issues have only become more pressing with globalization and its attendant entertainment industry.) To counter this rather pessimistic diagnosis of the current state of affairs, Adorno posits "true art" as the diametric opposite of popular media and culture. This concept of art that Adorno forwards is problematic in its claims of universality, but it marks one of the most extended and complex meditations on the role of art in contemporary society.

Art, for Adorno, is related to genuine happiness as opposed to the illusory, fleeting sensual gratification of the culture industry. Here, he has in mind modernist avant-garde art and music, which attempts to resist commercialization and homogeneity. The task Adorno sets art is to counter the vagaries of capitalist exchange value; to preserve a form of subjectivity that is not one of degradation and objectification. In these terms, art must recognize social relations as negative, as alienated and reified, in order to represent and criticize them. This argument has been central to the debates surrounding the notion of the avant-garde in modern Western art historical discourse. One of the primary texts of that debate, Peter Bürger's *Theory of the Avant-Garde* (1974), is very much informed by Adorno's position.

Adorno's argument is grounded in a complex understanding of the **autonomy of art** that runs throughout his works. With the fusion of economic and political power in late capitalism, art is alienated; it is presented as a mere commodity. However, and here Adorno differs from Marxist thinkers such as Bertolt Brecht, Jean-Paul Sartre, and the New Left, art maintains an autonomy that gives it a critical distance from which it can observe and critique the socioeconomic sphere. It is not a product of society in any direct manner. Contrary to Sartre's famous calls for a "committed" art, for instance, Adorno demures: "This is not the time for political works of art" ("Commitment" in *Notes to Literature*, 1974, p. 93). There is no doubt that this conception of autonomy is one of Adorno's more contentious, yet it is essential to his masterful rethinking of Kantian and Hegelian aesthetics as well as to his understanding of how the political intersects with the philosophic and the aesthetic. Furthermore, he asserts that modernist avant-garde art movements continue to use this autonomy (a concept perhaps better explained by Pierre **Bourdieu**'s notion of the "field of cultural production," which more easily accounts for art's autonomy and its extenuating circumstances) to grasp the critical "truth content" available to us. It is this "truth content" of the work of art that Adorno posits as a proleptic necessity to any possible revolutionary transformation of society.

The attempt to synthesize these ideas on commodity fetishism, the culture industry, and the autonomy of art into a general theory of aesthetics is to be found in Adorno's posthumously published *Aesthetic Theory*. It is a wide-ranging text that references Cimabue,

Paul Gauguin, and Eugène Atget in a single breath, in which Adorno attempts a radical examination of classical aesthetics (notions of beauty, nature) and modern aesthetics (he returns to Benjamin's concept of the aura and the notion of the "beautiful semblance"). Martin Jay has characterized this singular and often provocative text as "Western Marxism, aesthetic modernism, mandarin cultural despair, and Jewish self-identification," swayed by the "pull of deconstruction" (Jay, 1984, p. 22). Only recently has the achievement this work represents begun to be fully appreciated. For many years it was overshadowed by Hans-Georg Gadamer's thoughts on aesthetics in *Truth and Method* (1960), which evinces the centrality of Martin **HEIDEGGER** to continental philosophy.

In what is not so much a continuation as a refinement of his earlier thinking, Adorno posits art as a site of struggle against conformity and passivity. He addresses what he terms the **"dialectics of appearance"** (*Dialektik des Scheins*). For Adorno, the aesthetic is not a realm of mere appearance or illusion, rather it is the medium of truth. Aesthetic appearance is an index of "truth content." What he is arguing against is clearly stated in an excerpt from *Minima Moralia: Reflections from Damaged Life* (1951):

> Cultivated philistines are in the habit of requiring that a work of art "give" them something. They no longer take umbrage at works that are radical, but fall back on the shamelessly modest assertion that they do not understand. This eliminates even opposition, their last negative relationship to truth, and the offending object is smilingly catalogued among its kind, consumer commodities that can be chosen or refused without even having to take responsibility for doing so. (p. 216)

It is against this neutralization of art that Adorno constructs the constellation of his argument. A primary claim of *Aesthetic Theory* is that the dialectical goal of the autonomy of art is to question appearance, to dissolve the closed, illusory realm of appearance into a "caesura" or "riddle." Thus, the autonomy of art enables it to resist its classification and domestication within the exchange economy. In doing so, however, it denies the existence of any stable, locatable truth as such. What Adorno presents here is an aesthetic theory in which avant-garde art, literature, and music can index "truth content" through their "enigmatic character."

Adorno connects his late thoughts on aesthetics here with his often solemn contemplation of suffering and the weight of the past, which are summarized in his dictum, "to write lyric poetry after Auschwitz is barbaric."

> In comparison with past art and the art of the present it [the form of art in a changed society] will probably again be something else; but it would be preferable that some fine day art vanish altogether than it forget the suffering that is its expression and in which form has its substance. This suffering is the humane content that unfreedom counterfeits as positivity. If in fulfillment of the wish a future art were once again to become positive, then the suspicion that negativity were in actuality persisting would become acute; this suspicion is ever present, regression threatens unremittingly, and freedom—surely freedom from the principle of possession—cannot be possessed. But then what would art be, as the writing of history, if it shook off the memory of accumulated suffering. (1970, pp. 260–261)

This simultaneous fear of regression and his desire to believe in the potentiality of art to effect political change hinges on a conception of memory colored by Benjamin's late texts. As with the reception of Benjamin, which has for too long been stalled in discussions of the dissolution of the artwork's aura, Adorno's thoughts on the aesthetic deserve to be revisited. But this time they deserved to be revisited less with an eye toward placing them within a larger tradition of Marxist cultural criticism and more with an eye toward how this work can illuminate the terrain of the work of art, which remains aimless in the *terra aesthetica* of the contemporary.

To date, Adorno's work has been central to discussions of Marxist art history, especially in an ancillary role of explaining Benjamin's *The Arcades Project*. Further ties to the discourse of modern and contemporary art are to be found in Adorno's privileging of abstract art. He does this to avoid the traps of representational or mimetic art, but also to emphasize that art is not an imitation of reality, rather it is the radical other of reality. The assertion that art is autonomous and must resist the incursions of mass-produced culture (kitsch) put forth by Adorno played a crucial role in Clement Greenberg's theory of modernist painting. Greenberg's

notion of each artistic medium's "area of competence" echoes aspects of Adorno's argument. However, Adorno's concept of the autonomy of art—as site of resistance that indexes "truth content" in aesthetic form—retains a more pointed ethical outrage and commitment to the memory of the past and the abuses of state and economic power:

> Art, which even in its opposition to society remains a part of it, must close its eyes and ears to it: it cannot escape the shadow of irrationality. But when art itself appeals to this unreason, making it a raison d'être, it converts its own male-diction into a theodicy.... The content of works of art is never the amount of intellect pumped into them: if anything it is the opposite. (1974, 93; translation emended)

Further Reading

By Adorno

1933. Kierkegaard: *Construction of the Aesthetic*, translated by Robert Hullot-Kentor. Minneapolis: Univ. of Minnesota Press, 1989.

1938. "On the Fetish-Character in Music and the Regression of Listening." In *The Essential Frankfurt School Reader*, edited by Andrew Arato and Eike Gebhardt. New York: Continuum, 1982.

1947. Adorno and Max Horkheimer. *Dialectic of the Enlightenment*. New York: Continuum, 1972.

1949. *The Philosophy of Modern Music*, translated by Anne G. Mitchell and Wesley V. Blomster. New York: Seabury Press, 1973.

1951. *Minima Moralia: Reflections from Damaged Life*, translated by E.F.N. Jephcott. London: Verso, 1974.

1955. *Prisms*, translated by Samuel and Shierry Weber. Cambridge, MA: MIT Press, 1981.

1965. *The Jargon of Authenticity*, translated by Knut Tarnowski and Frederic Will. London and New York: Routledge, 1973.

1966. *Negative Dialectics*, translated by E.B. Ashton. London and New York: Routledge, 1973.

1970. *Aesthetic Theory*, translated by Robert Hullot-Kentor. Minneapolis: Univ. of Minnesota Press, 1997.

Theodor W. Adorno and Walter Benjamin: The Complete Correspondence 1928–1940, edited by Henri Lonitz, translated by Nicholas Walker. Cambridge, MA: Harvard Univ. Press, 2001.

1974. *Notes to Literature*, 2 vols., edited by Rolf Tiedemann, translated by Shierry Weber Nicholsen. New York: Columbia Univ. Press, 1991–1992.

About Adorno

Bernstein, J.M. *The Fate of Art: Aesthetic Alienation from Kant to Derrida and Adorno*. University Park: Pennsylvania State Univ. Press, 1992.

Buck-Morss, Susan. *The Origin of Negative Dialectics: Theodor W. Adorno, Walter Benjamin, and the Frankfurt Institute*. New York: Free Press, 1977.

Bürger, Peter. *Theory of the Avant-Garde*, translated by Michael Shaw. Minneapolis: Univ. of Minnesota Press, 1984.

Gibson, Nigel, and Andrew Rubin. *Adorno: A Critical Reader*. Oxford: Blackwell, 2002.

Greenberg, Clement. *The Collected Essays and Criticism I: Perceptions and Judgments 1939–1944*. Chicago: Univ. of Chicago Press, 1986.

Huhn, Tom, and Lambert Zuidervaart, eds. *The Semblance of Subjectivity: Essays in Adorno's Aesthetic Theory*. Cambridge, MA: MIT Press, 1997.

Hullot-Kentor, Robert. "Translator's Introduction." In *Aesthetic Theory*. Minneapolis: Univ. of Minnesota Press, 1997.

Jameson, Frederic. *Late Marxism: Adorno, or, the Persistence of the Dialectic*. London and New York: Routledge, 1990.

Jay, Martin. *Adorno*. Cambridge, MA: Harvard Univ. Press, 1984.

Osborne, Peter. "Adorno and the Metaphysics of Modernism: The Problem of 'Postmodern' Art." In *The Problems of Modernity: Adorno and Benjamin*, edited by Andrew Benjamin. London and New York: Routledge, 1988.

Rose, Gillian. *The Melancholy Science: An Introduction to the Thought of Theodor W. Adorno*. New York: Columbia Univ. Press, 1978.

Wellmer, Albrecht. *The Persistence of Modernity: Essays on Aesthetics, Ethics, and Postmodernism*, translated by David Midgley. Cambridge, MA: MIT Press, 1991.

Wiggerhaus, Rolf. *The Frankfurt School: Its History, Theories, and Political Significance*, translated by Michael Robertson. Cambridge, MA: MIT Press, 1994.

Wolin, Richard. "Utopia, Mimesis, and Reconciliation: A Redemptive Critique of Adorno's Aesthetic Theory." *Representations* 32 (1990): 33–49.

Zuidervaart, Lambert. *Adorno's Aesthetic Theory: The Redemption of Illusion*. Cambridge, MA: MIT Press, 1991.

GIORGIO AGAMBEN

Key Concepts

- *experimentum linguae*
- original structure of the work of art
- potentiality
- whatever being
- bare life

Giorgio Agamben (b. 1942) was born in Rome. He studied law at the University of Rome and received his degree in 1965 with a thesis on the political thought of Simone Weil. In 1966 and 1968 he participated in seminars at Le Thor with Martin HEIDEGGER on Heraclitus and on Hegel. His friendships with the major figures of the postwar Italian intelligentsia—Italo Calvino, Pier Paolo Pasolini, and Elsa Morante—remain an influence on his work. From 1974 to 1994, Agamben served as the editor of the Italian edition of the works of Walter BENJAMIN. Agamben is currently a professor of aesthetics at the University of Venice. He has also taught at the University of Siena and the University of Macerata. In addition, he has held international teaching posts at the École des hautes études en sciences sociales, Collège international de philosophie, Northwestern University, and the University of California, Los Angeles.

Agamben's work deploys a complex philosophy of language colored by the work of Benjamin, Heidegger, and Ludwig Wittgenstein. This philosophy of language centers on the being-in-language-of-the-non-linguistic, which Agamben terms the ***experimentum linguae***,

an experience of humanity's historical-epochal opening to language. From this linguistic basis Agamben's work constructs an erudite meditation on ontology, ethics, politics, and representation.

Between 1974 and 1975, he worked with Frances Yates at the Warburg Institute in London on the relation between language and "phantasm" in the medieval concept of melancholia, which resulted in his book *Stanzas: Word and Phantasm in Western Culture* (1977). In this text, Agamben explicates the concept of the phantasm in relation to classical philosophical and iconological concerns with representation. This, in turn, inflects the discourse on language initiated by poststructuralism. Despite being an early study, *Stanzas* presents the gesture that defines the entirety of Agamben's work: to reproach the myopia of contemporary critical thought through a philological and conceptual genealogy of the history of philosophy. In *Stanzas*, for instance, the phantasm, although initially addressed by Aristotle, returns as a paradigm in medieval psychology (including discourse on love), in Sigmund **FREUD**'s theories of melancholy and fetishism, and in Jacques **DERRIDA**'s concept of the trace. In defining the phantasm in "its most general outlines," Agamben writes that "sensible objects impress their forms on the senses, and this sensible impression, or image, or phantasm (as the medieval philosophers prefer, in the wake of Aristotle) is then received by the phantasy, or imaginative virtue, which conserves it even in the absence of the object that has produced it" (p. 71). Agamben asserts the immanence of this concept to linguistics, seventeenth-century emblematics, troubadour poetry, and philosophical theories of memory in a work that has repercussions for not only philosophy, but also medieval studies, psychoanalysis, poetics, and art history.

Agamben continues to develop his theory of representation in *The Idea of Prose* (1985). Made up of short prose fragments that circle around Hegel's statement that since we live in an "age of prose" art is no longer our highest value, Agamben's text extends Benjamin's meditation on the "idea of prose" in relation to language and the philosophy of history. In early texts such as this and *Infancy and History: Essays on the Destruction of Experience* (1978), Agamben presents a question that remains the focal point of his philosophical project: are we capable of "thinking the groundlessness and emptiness of language and its representations without any negativity" so as

to reconceive the very idea of socio-political community through a serious meditation on the nature of representation? He writes:

> At issue here is whether the form of representation and reflection can still be maintained beyond representation and reflection, as contemporary thought, in its somnambulant nihilism, seems determined to maintain; or whether a realm is not instead opened here for a task and a decision of an entirely different kind. The fulfillment of the form of presupposition and the decline of the power of representation imply a poetic task and an ethical decision. (1999, p. 115)

Through a transformation of the idea of representation—the idea of prose as such—Agamben posits a linguistic, ontological, and political concept of community in his *The Coming Community* (1990). This concept is crucial to understanding his thesis that the "**original structure of the work of art**" is the ethical space of our world wherein we are capable of action and knowledge.

The most extended presentation of Agamben's thoughts on art is his *The Man Without Content* (1994). Here he argues that "the original structure of the work of art is now obscured" because it has become a "self-annihilating nothing" wandering in the *terra aesthetica*. By surveying the history of aesthetics from Plato's idea of art as "divine terror" to the work of NIETZSCHE and MARX, Agamben wagers that our alienation in modernity is mirrored in the alienation of the work of art: "In the work of art man risks losing not simply a piece of cultural wealth, however precious, and not even the privileged expression of his creative energy: it is the very space of his world, in which and only in which he can find himself as man and as being capable of action and knowledge" (p. 102). To this end he calls for a destruction of traditional aesthetics.

> Perhaps nothing is more urgent—if we really want to engage the problem of art in our time—than a *destruction* of aesthetics that would, by clearing away what is usually taken for granted, allow us to bring into question the very meaning of aesthetics as the science of the work of art.... But perhaps just such a loss and such an abyss are what we most need if we want the work of art to reacquire its original stature. (p. 6)

This destruction is actually a survey of the ruins of the Western aesthetic project that seeks to conceive of the work of art as potentiality.

The concept of **potentiality** is central to Agamben's thought. Drawing on Aristotle's distinction between potentiality and actuality, *dynamis* and *energeia*, Agamben defines potentiality as "not simply the potential to do this or that but potential to not-do, potentiality not to pass into actuality" (1999, p. 180). In *The Man Without Content* Agamben titles a chapter on the crisis of art in our time "Privation Is Like a Face," a phrase from Aristotle's discussion of potentiality. He explains: "What Artistotle wants to posit is the existence of potentiality: that there is a presence and a face of potentiality. He literally states as much in a passage in the *Physics*: 'privation [*sterēsis*] is like a face, a form [*eidos*]'" (1994, p. 180). What Agamben forwards here is a potentiality that "creates its own ontology" by "emancipating itself from Being and non-Being alike"; potentiality is not merely a matter of will or necessity, it is an experience of "the threshold between Being and non-Being, between sensible and intelligible, between word and thing" which is "not the colorless abyss of the Nothing but the luminous spiral of the possible" (1999, pp. 259, 257). Potentiality is the ontology of the **"whatever being"** (*l'essere qualunque*), the being no longer split between essence and existence, but rather "a pure, singular and yet perfectly whatever existence," that is, *as such* (1990, p. 94).

The face of Agamben's 'coming community' is the face of the "whatever being," i.e., the face of potentiality, the face of a humanity that is irreparably its *experimentum linguae*. For him, this is the face of a redeemable humanity.

What is so pressing about Agamben's thoughts on art (including his collaboration with Gilles **Deleuze**, *Bartleby: La formula della creazione* [1993], which makes Herman Melville's famous story "Bartleby the Scrivener" into the centerpiece of an extended meditation on the idea of creation) is the manner in which they are inextricably tied to his work on politics. This is most evident in his *Means Without End: Notes on Politics* (1996), where he makes sense of one of Benjamin's most enigmatic ideas: that of a "politics of pure means." Here Benjamin's influence on Agamben is particularly felt, especially in terms of political theory and messianic theology. This book includes an essay on Guy Debord and the French Situationists, a group founded in 1957 that combined Marxism with avant-garde artistic practice. Debord's

diagnosis of our epochal situation as one of spectacle, atemporality, and commodification in his 1967 work *Society of Spectacle* is central to Agamben's political thought. Rather than understanding Debord's text as a negative, Agamben asserts that it is only from within this debased, mediated situation that, paradoxically, we are exposed to the potentiality of a political community to come. What is at stake politically in the concepts of potentiality, whatever being, and language becomes evident in the following statement from *The Coming Community*: "the era in which we live is also that in which for the first time it is possible for humans to experience their own linguistic being—not this or that content of language, but language itself … the very fact the one speaks. Contemporary politics is this devastating *experimentum linguae*" (p. 83). For Agamben, an experience of our very linguistic being is the only hope left to us.

Although Agamben's work seemingly shifts through a series of distinct issues (theology, linguistics, poetry, ethics), these issues are all, in fact, intimately related. For example, his work on community (*The Coming Community*) is related to his ethical proposition that the concentration camp, not the Greek polis, is the basis of modern Western society (see *Means Without End*). What founds Western juridical and political society, therefore, is an act of exclusion, an exception. Agamben's most recent work turns to the enigmatic figure of the "homo sacer" in archaic Roman law and the paradoxical notion of the "state of exception" that founds the Western democratic juridical order. He develops Michel **FOUCAULT**'s concept of biopolitical power in order to define a relation between sovereignty and **bare life** (*la nuda vita*). In many ways, the entirety of Agamben's work is about the concept of modern life; aesthetic *and* political. It is between the Greek notions of *zoē* (the concept of physiological life common to all living beings) and *bios* (a way of living proper to a particular group; biography, spirit) that Agamben situates his extended meditation on the human condition—"bare life." It is in the threshold between the two, amidst the paradoxes of modern state politics or rule through biopower, that Agamben argues for the linking of *zoē* and *bios*, voice and language. In place of Western political life, Agamben calls for "a completely new politics—that is, a politics no longer founded on the *exceptio* of bare life" (1995, p. 11).

Agamben never takes the concerns he addresses as independent objects of study; rather—and this is what makes his work so compelling and urgent—culture, politics, law, and theology are components of the ethics of being he articulates throughout his work as a whole. This ongoing discussion is what Agamben refers to as "the absent work" because it "constitutes the written work as *prolegomena* or *paralipomena* of a non-existent text ... the counterfeit of a book which cannot be written" (1978, p. 3).

Further Reading
By Agamben

1977. *Stanzas: Word and Phantasm in Western Culture*, translated by Ronald L. Martinez. Minneapolis: Univ. of Minnesota Press, 1993.

1978. *Infancy and History: Essays on the Destruction of Experience*, translated by Liz Heron. London and New York: Verso, 1993.

1985. *Idea of Prose*, translated by Michael Sullivan and Sam Whitsitt. Albany: State Univ. of New York Press, 1995.

1990. *The Coming Community*, translated by Michael Hardt. Minneapolis: Univ. of Minnesota Press, 1993.

1990. *Potentialities: Collected Essays in Philosophy*, translated by Daniel Heller-Roazen. Stanford, CA: Stanford Univ. Press, 1999.

1994. *The Man Without Content*, translated by Georgia Albert. Stanford, CA: Stanford Univ. Press, 1999.

1995. *Homo Sacer: Sovereign Power and Bare Life*, translated by Daniel Heller-Roazen. Stanford, CA: Stanford Univ. Press, 1998.

1996. *Means Without End: Notes on Politics*, translated by Vicenzo Binetti and Cesare Casarino. Minneapolis: Univ. of Minnesota Press, 2000.

1998. *Remnants of Auschwitz: The Witness and the Archive*, translated by Daniel Heller-Roazen. New York: Zone Books, 1999.

1998. "Difference and Repetition: On Guy Debord's Films." In *Guy Debord and the Situationist International: Texts and Documents*, edited by Tom McDonough. Cambridge, MA: MIT Press, 2002.

About Agamben

Dillon, Brian, ed. *Paragraph: A Journal of Modern Critical Theory* 25:2 (July 2002). Special edition dedicated entirely to Agamben's work.

Heller-Roazen, Daniel. "Editor's Introduction: 'To Read What Was Never Written.'" In *Potentialities: Collected Essays in Philosophy*. Stanford, CA: Stanford Univ. Press, 1999.

Negri, Antonio. "The Ripe Fruit of Redemption," translated by Arianna Bove. www.generation-online.org (2003).

Norris, Andrew. "The Exemplary Exception: Philosophical and Political Decisions in Giorgio Agamben's Homo Sacer." *Radical Philosophy* 119 (May/June 2003): 6–16.

Norris, Andrew, ed. *Politics, Metaphysics, and Death: Essays on Giorgio Agamben's Homo Sacer.* Durham, NC: Duke Univ. Press, 2005.

Wall, Thomas Carl. *Radical Passivity: Levinas, Blanchot, and Agamben.* Albany: State University of New York, 1999.

LOUIS ALTHUSSER

Key Concepts

- base and superstructure
- practices
- ideology
- Repressive State Apparatuses
- Ideological State Apparatuses
- interpellation

Louis Althusser (1918–1990) was a French Marxist political philosopher. He was born in Algeria and educated in Algiers and France. He was admitted to the École normale supérieure in 1939, but World War II disrupted his studies when he was called to military duty. During the German occupation of France, Althusser was captured and placed in a German prison camp where he remained until the end of the war. Once he was freed, he resumed his studies. In 1948, Althusser completed a master's thesis on the German philosopher Hegel and later passed the *agrégation* in philosophy and was given a teaching appointment.

Althusser was a practicing Catholic for the first thirty years of his life, and during that period he displayed a strong interest in Catholic monastic life and traditions. In the late 1940s, he joined the Communist Party and was a member for the remainder of his life. During the May 1968 Paris strikes, he was in a sanitarium recuperating from a bout of depression, an illness he struggled with throughout his life. Unlike intellectuals such as Alain **BADIOU**, Althusser supported the Communist Party in denying the

revolutionary nature of the student movement, though he later reversed this view.

Althusser murdered his wife in 1980. Declared incompetent to stand trial, he was institutionalized, but then released in 1983. He subsequently lived in near isolation in Paris and died in 1990 of a heart attack. During the last years of his life he wrote two different versions of his autobiography, both of which were published posthumously in 1992, and are included in the 1995 edition of *The Future Lasts Forever*.

Althusser is especially important for the ways in which he reinterpreted Marx's ideas and made them resonate with the intellectual currents prevalent in Europe during the 1960s, most importantly structuralism. His work is sometimes referred to as "structuralist Marxism" or "postmodern Marxism." In addition to structuralism, Althusser's work is marked by a positive reconsideration of psychoanalysis, a body of thought facilely rejected by the Communist Party. Thus, Althusser's rereading of **MARX** is informed by the work of Jacques **LACAN**. In important ways, Althusser's "return to Marx" runs parallel to Lacan's famous "return to Freud" (see Jay, 1993, note 147, p. 373). Althusser's return to the founding texts of Marxist discourse was aimed at liberating Marxist ideas from their Soviet interpretation, as well as from humanistic ones. This rereading was meant to revitalize Marxist ideas and to put them back to use for revolutionary purposes.

Of Althusser's many writings, three have been particularly influential: *For Marx* (1965), *Reading Capital* (1968), and the oft-cited long essay "Ideology and Ideological State Apparatuses" (1969; included in *Lenin and Philosophy and Other Essays*). Althusser's influence has been widespread, helping to shape such diverse fields as cultural studies, film studies, literary theory, and art history.

The reassessment of Marxism Althusser undertakes includes a rejection of some key Marxist assumptions about society. For example, he argues against the version of determinism found in the orthodox Marxist formation of **base** and **superstructure**. Base refers to the particular economic mode of production operating in a given society. Different societies are organized around different economic systems (modes of production)—for instance, agricultural or capitalist. The concept of superstructure refers to political, social, religious, and other noneconomic aspects of a society. Superstructure, then, includes the political and cultural

aspects of a society, such as civic, religious, and other institutional structures. The traditional Marxist view is that the base determines the superstructure. In other words, political, social, and religious spheres are not autonomous, but are dependent on and conditioned by the economic mode or base. Althusser prefers to talk about the idea of social formation (society) as a decentered structure comprised of three conflicting, indeterminate practices: the economic, the political, and the ideological. In Althusser's rethinking, the base and the superstructure are in a relationship that affords the superstructure considerable autonomy. Although in the end, he concedes that the economic is determinant even if it is not dominant in a particular historical moment.

The term **practices**, for Althusser, has a specific meaning: it indicates processes of transformation. "By practice in general," he writes, "I shall mean any process of transformation of determinate given raw material into a determinate product, a transformation effected by a determinate human labour, using determinate means (of 'production')" (1965, p. 166). Economic practices use human labor and other modes of production in order to transform raw materials (nature) into finished (social) products. Political practices deal with the uses of revolution to transform social relations. Ideological practices concern the uses of ideology to transform lived social relations; that is, the way a subject relates to the lived conditions of existence. (It is from this position that any discussion of art history must begin.) Theory is often treated as the opposite of practice, but for Althusser theory is a type of practice. Thus, Marxism is a practice of class struggle.

The term **ideology** is central to Althusser's work. In "Ideology and Ideological State Apparatuses," Althusser melds ideas taken from both Marxist and psychoanalytic thought in order to develop his theory of ideology and its relation to subjectivity. His primary concern in this essay is with the question of how a capitalist society reproduces existing modes of production and their relationship to people: why do people support these processes when, according to Marxist thought, they are in effect acceding to their own domination by the ruling classes? Althusser formulates his answer through the concepts of ideology, ideological state apparatuses, and interpellation.

The construction and maintenance of capitalist society occurs at two levels, the repressive and the ideological. On the one hand,

social control can be coerced by the exertion of repressive force through such institutions as police, armies, courts, and prisons— what Althusser calls **Repressive State Apparatuses** (RSAs). These institutions suppress dissent and maintain the social order as envisioned by the ruling power. But the use of repressive force is not the only way to guarantee assent to capitalism. In addition to the RSAs, Althusser argues that ideology must also be employed to maintain the dominant social formation. He refers to these ideological modes of control as **Ideological State Apparatuses** (ISAs)— including education, family, religion, sports, the arts, television, and other media—which reproduce capitalist values, standards, and assumptions. Ideological discourse produced by ISAs acts on individual subjects in such a way that they see themselves and others as standing within the dominant ideology, subject to it, and willingly supportive—consciously or unconsciously—of the replication of this ruling power. In short, ideology imposes itself on us, but at the same time we act, in effect, as willing agents of the ideological agenda, which we repress. In Althusser's thought, the ISAs represent the means by which capitalist ideology operates as a seductive system in which individuals are instantiated as subjects without being conscious of this subjugation as such. What Althusser adds to Marxist doxa is a knowledge of Lacan's discussion of subject formation within language and the visual (imaginary) realm.

Departing from the earlier Marxist notion that ideology is false consciousness, Althusser understands ideology as an inevitable aspect of all societies—even socialist societies where capitalist exploitation has presumably been eradicated—that serves, in part, to provide human subjects with identities. For Althusser, ideology is a requisite, fundamental structure of subject formation. For this reason, he argues, that "ideology represents the imaginary relationship of individuals to their real conditions of existence" (1969, p. 162). Distinguishing between the imaginary and the real (see Lacan's theory of the mirror stage) allows Althusser to counter the traditional Marxist notion that ideologies are false because they mask an otherwise accessible and transparent world. In contrast to this notion of ideology as misrepresentation, Althusser views ideology as a narrative or story we tell ourselves (i.e., one that we author) in order to understand our relationship to the modes of production. A real, objective world is not accessible to us, only representations of it. A consequence of this line of thought is that our very sense

of ourselves and our lived-experience is a by-product of ideology. There is no exit from ideology in Althusser's political philosophy.

Ideology, then, is a discourse that has marked effects on each individual subject. Althusser understands this effect through the concept of **interpellation**. This concept describes the way ideology hails and positions ("interpellates") individual subjects within particular discourses. As Althusser puts it, "ideology 'acts' or 'functions' in such a way that it ...'transforms' the individuals into subjects" (1969, p. 174). We assume our interpellated position, identify with received social meanings, locate ourselves within these meanings, and act as if we had the freedom of choice in the first place. Althusser's structuralist notion of ideology is antihumanist because it questions the centrality of the autonomous, freely choosing individual in the process. On the contrary, the subject is subjected to the ruling ideology, misrecognizing ideological interpellation for the actions of a freely choosing individual.

Althusser provides an example of interpellation in action. Suppose, he says, an individual is hailed (interpellated) in the street by a policeman who says, "Hey, you there!" This individual turns around to face the policeman. Althusser states: "By this mere one-hundred-and-eighty-degree physical conversion, he becomes a subject. Why? Because he has recognized that the hail was 'really' addressed to him, and that 'it was really him who was hailed' (and not someone else)" (1969, p. 174). The hailing or interpellation of the individual creates a subject who is, without necessarily knowing it, acceding to the ideology of state authority, its laws, and the systems that support and generate it. Ideology transforms us into subjects that think and behave in socially proscribed ways.

Although ideology is understood to subject individuals to the needs and interest of the ruling classes, it is not, according to Althusser, fixed and unchangeable. Rather, ideology always contains contradictions and logical inconsistencies, which are discoverable. This means that the interpellated subject has at least some room to destabilize the ideological process. Change or revolution is possible.

Works of art have a curious and often contradictory position in Althusser's thought because he attempts to construct a threshold between art and ideology—one that would enable what he designates as "real art" to distinguish itself from mere ideology. "The problem of the relations between art and ideology," he writes,

"is a very complicated and difficult one. However, I can tell you in what directions our investigations tend. I do not rank real art among the ideologies, although art does have a quite particular and specific relationship with ideology" ("A Letter on Art," 1966, p. 221). The difficulty arises with Althusser's inability to fully articulate the complexities of this "quite particular and specific relationship" between art and ideology, as well as never having articulated the criteria by which one would discern "real art" from the mediocre. This remains something that has been left to those working after Althusser. Nevertheless, Althusser did sketch out some of his thoughts on art and ideology.

In an essay entitled "Cremonini, Painter of the Abstract" (August 1966, four months after his "A Letter on Art in Reply to André Daspre"), Althusser discusses the work of this Italian abstract painter in terms that reflect the larger scope of his structuralist Marxism. In an assertion that may perhaps be used to extract the criteria by which to judge "real art," he argues that Cremonini "'paints' the relations which bind the objects, places, and times. Cremonini is a painter of abstraction. Not an abstract painter, 'painting' an absent, pure possibility in a new form and matter, but a painter of the real abstract … real relations … between 'men' and their 'things', or rather, to give the term its stronger sense, between 'things' and their 'men'" (p. 230). In unmistakable Marxist language, Althusser calls for the production of artworks that make evident structural relations between people and others, people and mere things.

This is the relation of alienation Marx elaborates in his work on commodity fetishism. For this reason, Althusser also argues that the aesthetics of consumption and the aesthetics of creation are identical. This is because they both "depend on … the category of the subject, whether creator or consumer ('producer' of a 'work', producer of an aesthetic judgment), endowed with the attributes of subjectivity (freedom, projects acts of creation and judgment; aesthetic need, etc.)" and second, "the category of the object (the 'objects' represented, depicted in the work, the work as a produced or consumed object)" (pp. 230–231). However, Althusser wagers that "real art"—a legitimate abstract art which makes the "real relations" that constitute a society evident—although still an ideological effect, can present us with a "radical anti-humanism" wherein "it is because we cannot recognize ourselves in [the artworks] that we can know ourselves in them, in

the specific form provided by art" (p. 240). In other words, art is an ideological effect that is able to refract the relations that constitute capitalist society. This refraction of ideology makes visible that which previously was unseen, unacknowledged, unknown, namely, the forces of production and the forces of interpellation. The distance from ideology that "real art" affords us is a direct result of its undeniable intimacy with the ideology that produces it. Althusser posits that

> the specific function of the work of art is to make visible (*donner à voir*), by establishing a distance from it, the reality of the existing ideology (of any one of its forms), the work of art cannot fail to exercise a directly ideological effect, that it therefore maintains far closer relations with ideology than any other object, and that it is impossible to think of the work of art, in its specifically aesthetic existence, without taking into account the privileged relation between it and ideology, i.e. its direct and inevitable ideological effect. (pp. 241–242)

Exactly how and why art can construct a critical distance even as it remains immanent to ideology is one of the most challenging aspects of Althusser's work. The question of why art takes precedence over other ideological effects is one that he never fully developed. And yet, Marxist art historians continue to grapple with whether or not art is merely a reflection or a refraction of ideology. Does it make visible the very structure of society, the interpellation of humanist subjectivity as an attendant and requisite illusion (a Lacanian *méconnaissance*) of capitalism? Or is the privileging of art above other cultural productions (including mass-produced kitsch, for example) merely symptomatic of that very ideological-aesthetic interpellation? These are two of many possible standing questions that Althusser's work provides contemporary art historical practice.

Further Reading

By Althusser

1965. *For Marx*, translated by Ben Brewster. New York: Pantheon, 1969.

1965. Althusser and Étienne Balibar. *Reading "Capital,"* translated by Ben Brewster. London: New Left Books, 1970.

1966. "Cremonini, Painter of the Abstract." In *Lenin and Philosophy and Other Essays*, translated by Ben Brewster. New York: Monthly Review Press, 1971.

1966. "A Letter on Art in Reply to André Daspre." In *Lenin and Philosophy and Other Essays*, translated by Ben Brewster. New York: Monthly Review Press, 1971.

1969. "Ideology and Ideological State Apparatuses." In *Lenin and Philosophy and Other Essays*, translated by Ben Brewster. New York: Monthly Review Press, 1971.

1992. *The Future Lasts Forever: A Memoir*, translated by Olivier Corpet, Yann Moulier, Boutang, and Richard Veasey. New York: New Press, 1995.

About Althusser

Elliott, Gregory. *Althusser: The Detour of Theory*. London and New York: Verso, 1987.

Elliott, Gregory, ed. *Althusser: A Critical Reader*. Oxford: Blackwell, 1994.

Jay, Martin. "Lacan, Althusser, and the Specular Subject of Ideology." In *Downcast Eyes: The Denigration of Vision in Twentieth-Century French Thought*. Berkeley: Univ. of California Press, 1993.

Kaplan, Ann, and Michael Sprinkler, eds. *The Althusserian Legacy*. London: Verso, 1993.

Payne, Michael. *Reading Knowledge: An Introduction to Barthes, Foucault, and Althusser*. Oxford: Blackwell, 1997.

Smith, Steven B. *Reading Althusser: An Essay on Structural Marxism*. Ithaca, NY: Cornell Univ. Press, 1984.

ALAIN BADIOU

Key Concepts

- event
- generic procedures
- universality of art
- truth
- inaesthetics

Alain Badiou (b. 1937) was born in Rabat, Morocco. He studied at the École normale supérieure in the 1950s where he trained as a mathematician. From 1969 to 1999, he taught at the University of Paris VIII, Vincennes–Saint Denis. In 1999, he was named chair of philosophy at the École normale supérieure. Badiou also teaches at the Collège international de philosophie in Paris. His work makes major contributions not only to philosophy and political theory, but also to mathematics, psychoanalysis, and aesthetics. Badiou is one of the most radical and influential philosophers of our time, a peer of Michel **Foucault** and Jacques **Derrida**. Badiou rejects the contemporary reduction of philosophy to nothing but a matter of language, thereby setting himself against both analytic and continental modes of philosophy. Reiterating the traditional Platonic concerns of philosophy through the lens of Cantor's set theory and the work of Jacques **Lacan**, Badiou has articulated a powerful systematic and interventionist philosophy with profound ethical and political consequences.

Badiou's thought stems directly from his active involvement in leftist politics following the events of May 1968 in Paris. Partly owing to his coming of age as a thinker in this time period, as well as being a student of the French Marxist Louis ALTHUSSER, his work demands an affirmative answer to the question of whether or not something unprecedented can arise—whether a framework, a logic, or an ethics. A major focus of his work is the theorization of the **event**: an unpredictable interruption in one's life that produces a change of discourse, a new relation to desire, a very new *ethos* or "way of being." Badiou's philosophy requires a fidelity to these incalculable events, which may be produced by four types of what he terms **generic procedures**: science, politics, love, and art. It is here that his work becomes very interesting for art history. Art is one of the procedures that may produce a truth-event, an immanent break from within the status quo that produces a multiple being, a "some-one" rendered contingent and induced to reconstruct the very foundations of his or her identity.

In his polemical essay "Fifteen Theses on Contemporary Art" (2004), Badiou forwards a politicized interpretation of his theory of art. In asserting the **universality of art**, he argues that art must be "an impersonal production of a truth that is addressed to everyone" (p. 105). Badiou posits,

> Truth is the only philosophical name for a new universality against the forced universality of globalization … and in that sort of proposition, the question of art is a very important question because art is always a proposition about a new universality.… And, the new universality of art is the creation of a new form of happening of the Idea in the sensible as such. (p. 106)

A work of art is a singularity that may interrupt the viewer and induce a new relation to desire. With this position, Badiou moves the intimacy between art, politics, and love into the foreground. Moreover, art guides Badiou's complicated definition of **truth**:

> A truth contains the following paradox: it is at once something new, hence something rare and exceptional, yet, touching the very being of that of which it is a truth, it is also the most stable, the closest, ontologically speaking, to the initial state of things. This paradox must be developed at length, but

what is clear is that the origin of a truth is the order of the event. (1989, p. 36)

Badiou's work raises the question of truth in a manner that differs greatly from hermeneutic, analytic, and poststructuralist philosophy. His conception of truth is admittedly informed by Lacanian psychoanalysis, which itself subverts the traditional conceptions of truth. Badiou rethinks the relation between knowledge and truth in order to open up new possibilities for political thought. This line of thinking is culled from a tradition of what Badiou terms "anti-philosophers" (NIETZSCHE and Lacan) who stress the discontinuity between truth and knowledge. What this opens up for Badiou is a philosophy tuned to the singularity of what happens, that is, one that addresses the present and not the future. The singularity of the unprecedented, unjustified event that founds Badiou's philosophy demands another temporality and a specific subjectivity that he sees beginning to be addressed in the work of these "anti-philosophers."

In his *Handbook of Inaesthetics* (1998), Badiou provides an extended mediation on art and philosophy. As Peter Hallward argues, Badiou's **inaesthetics** is

> one of the conditions of philosophy, and, like all such conditions, articulates the singular directly with the universal.... Against any notion of art as cultural therapy, as particularist, as identitarian or communitarian, as "imperial" or re-presenta-tive, Badiou affirms the production of contemporary works of art, universally addressed, as so many exceptional attempts "to form the formless" or "to purify the impure." The sole task of an exclusively affirmative art is the effort to render visible all that which, from the perspective of the establishment, is invisi-ble or nonexistent. (2003, pp. 194, 195)

However, in his published work to date, Badiou's most compelling examples of truth-events have been St. Paul and literary figures like Stéphane Mallarmé or Samuel Beckett. He has yet to offer an extended meditation on the visual arts, but his work is being taken up by some art historians to see precisely how visual art constructs a situation in which the irreducible singularity of the event induces a new doctrine of the subject. (In this work, ties to Gilles DELEUZE's work on Francis Bacon and Georges BATAILLE's *informe* are central points of departure.) Art is essential, Badiou insists, to this new

conception of the subject; the "evental subject" that depends on an event rather than a structural process. In this manner, we can see that art is a primary aspect of his materialistic doctrine of the subject. For Badiou, artistic truth begins with an event, but it must be sustained by a subject who enacts a fidelity to the event.

Further Reading
By Badiou

1989. *Manifesto for Philosophy*, translated by Norman Madarasz. Albany: State Univ. of New York Press, 1999.

1997. *Deleuze: The Clamour of Being*, translated by L. Burchill. Minneapolis: Univ. of Minnesota Press, 2000.

1997. *Saint Paul: The Foundation of Universalism*, translated by Ray Brassier. Stanford, CA: Stanford Univ. Press, 2003.

1998. *Ethics: An Essay on the Understanding of Evil*, translated by Peter Hallward. London and New York: Verso, 2002.

1998. *Infinite Thought: Truth and the Return to Philosophy*, translated by Justin Clemens and Oliver Feltham. London and New York: Continuum, 2003.

2004. "Fifteen Theses on Contemporary Art." *lacanian ink* 23 (Spring 2004): 103–119.

2004. *Theoretical Writings*, translated by Ray Brassier and Alberto Toscano. London and New York: Continuum, 2004.

1998. *Handbook of Inaesthetics*, translated by Alberto Toscano. Stanford, CA: Stanford Univ. Press, 2005.

About Badiou

Barker, Jason. *Alain Badiou: A Critical Introduction*. London: Pluto Press, 2002.

Eagleton, Terry. "Alain Badiou." In *Figures of Dissent: Critical Essays on Fish, Spivak, Žižek, and Others*. London and New York: Verso, 2003.

Fink, Bruce. "Alain Badiou." *Umbr(a)* 1 (1996): 11–12.

Hallward, Peter. "Generic Sovereignty: The Philosophy of Alain Badiou." *Angelaki* 3:3 (1998): 113–133.

Hallward, Peter. *Badiou: A Subject to Truth*. Minneapolis: Univ. of Minnesota Press, 2003.

Hallward, Peter, ed. *Think Again: Alain Badiou and the Future of Philosophy*. London and New York: Continuum, 2004.

Žižek, Slavoj. "The Politics of Truth, or, Alain Badiou as a Reader of St. Paul." In *The Ticklish Subject: The Absent Centre of Political Ontology*. London and New York: Verso, 1999.

ROLAND BARTHES

Key Concepts

- myths
- intertextuality
- the death of the author
- author-work versus reader-text
- studium
- punctum

Roland Barthes (1915–1980) was a French semiologist, literary critic, and cultural theorist. Born in 1915 in Cherbourg, France, he was raised in a Protestant bourgeois family. His early life was marked by long bouts with tuberculosis, which resulted in his being placed in a sanitarium for several months during his late adolescence. This experience of isolation turned Barthes inward and during the long hours spent alone he read a prodigious amount, which included completing all of Michelet's volumes on French history. He went on to study French and classics at the Sorbonne in Paris. There he was active in protests against fascism and wrote for leftist journals and magazines. During World War II he taught in Paris, having been exempted from military service because of his tuberculosis. After the war he taught in Romania, before continuing his studies at the University of Alexandria, where he studied structural linguistics with A.J. Greimas. Barthes returned to Paris in the 1950s and worked at the Centre national de la recherche scientifique as a lexicographer and later as a sociologist.

In addition to teaching at the École practique des hautes études from 1960 until his death, he was elected to a chair in literary semiology at the Collège de France in 1976. The traumatic death of his mother triggered the writing of one of Barthes's most famous texts, *Camera Lucida: Reflections on Photography* (1980), which was published shortly before his own death resulting from injuries suffered after being accidentally struck by a laundry truck as he was leaving the Collège de France after one of his lectures in 1980.

From 1960 until his death, Barthes was arguably one of the most influential French intellectuals. His innovative, witty, and complex writings serve as a transition from structuralism to poststructuralism. Along with several others, including Jacques **DERRIDA**, he was a member of the 1960s group organized around the literary journal *Tel Quel*, which produced many of the writers of the Nouveau Roman such as Alain Robbe-Grillet. Despite his own disinterest in writing about the cinema, Barthes was also a major influence on French film theory, especially on the work of Christian Metz on cinematic signs.

Barthes's career can be divided into two main parts. The first consists of structuralist interpretations of literature and popular culture. This early work was informed by phenomenology, and particularly, the work of Ferdinand de **SAUSSURE**. As a result of his studies with Greimas, Barthes based his work on the structuralist conception of the linguistic sign as an arbitrary signifier whose meaning is determined only within the differential structure of language (*langue*) as such. The apex of this structuralist work is undoubtedly his publication in 1957 of *Mythologies*, a semiotic study of the myths of popular culture and everyday life. Barthes submits wrestling, detergent advertisements, the iconography of the striptease, and even the discussions about Einstein's brain to a structuralist analysis. He aims to critique the means by which ideology is naturalized in twentieth-century mass cultural myths by analyzing the semiotics of mythic language (see also his *Elements of Semiology* [1964]).

The second part of Barthes's work begins in the late 1960s, when he turned away from a structuralism with scientific conceits and toward a discourse of desire. Following the advent of poststructuralist thought (signaled by the work of Derrida and others) and coupled with his rereading the work of Jacques **LACAN**, Barthes explains how the second-order languages of any interpretative structure (be it

Marxism or psychoanalysis) enframe a cultural text so as to focus on certain aspects and privilege certain meanings. This sharp focus comes at a cost because it cannot help but severely circumscribe the text, thereby turning discourse into meaning. For Barthes, this is symptomatic of bourgeois ideology. In contrast to the logic of metalanguage, poststructuralism denies the claim of a "natural" or structural relation between the signifier and the signified (a claim made in works as varied as Plato's *Cratylus* and Saussure's *Course on General Linguistics*). Moreover, a defining premise of poststructuralism is that a text always exceeds any interpretative frame; there is always a remainder that problematizes any structuralist claim to definitive meaning, that is, any claim of being *dans le vrai*. Barthes's attention to this remainder is evident in his concept of the "pleasure of the text," which undermines the traditional notions of the author and the work.

This disruptive, antiauthoritarian and antihumanist position is argued in two interconnected essays: "The Death of the Author" (1968) and "From Work to Text" (1971). In some aspects, these two texts—along with poststructuralism itself—are products of the Parisian sociopolitical and cultural climate following the events of May 1968. These two texts present ideas that have thoroughly impacted the way we understand the nature of textuality and interpretation in general. Both are sustained critiques of the traditional role of the author and the conception of the work that undermine the Western cultural premise of an unbroken author-work corpus that grounds the meaning of any work in the notion of authorial intent.

"The Death of the Author" challenges traditional notions of the role of the author, the very status of a literary work, and the passivity of the reader as one who consumes a product. The strength of Barthes's critique lies in his explanation of the conceit of realist representation: the ideological claim that language is transparent and neutral. Rather, Barthes argues that there is no external reality that serves as the signified (the referent) of this conception of language. On the contrary, any notion of reality is constructed in and through language; therefore, one could argue as Barthes does, that there are only representations of reality constructed in and through tendentious language. In relation to his denial of the author-work corpus, Barthes posits that texts can only be understood in relation to other texts. This is the concept of

intertextuality, a term originally coined by Barthes's student and colleague Julia KRISTEVA. For Barthes and Kristeva, every text is part of a larger field of texts that provides a dynamic, shifting context of meaning. Every text is in dialogue with other texts. Meaning in a text, therefore, is not derived from authorial intention but from the network of relations. It is on this basis that Barthes announces **the death of the author**, echoing NIETZSCHE's pronouncement on the death of god decades earlier: "The birth of the reader must be at the cost of the death of the Author" (1968, p. 148).

The birth of the reader, as one who produces meaning in a text as opposed to passively consuming the work of an author, lies at the center of "From Work to Text." There are a couple of important ideas that Barthes presents here: his definition of a text as opposed to a work and his suggestion that the reader's production of a text is an act of desire he terms "the pleasure of the text." (see also his *The Pleasure of the Text* [1976]). Barthes defines an important distinction between the **author-work** and the **reader-text**. The text is a structure, but one that alludes to the structure of the Lacanian subject; it is "decentered, without closure," Barthes contends. Unlike what we find in the author-work model, where the author's life is the origin, a text is irreducible; it cannot be domesticated through the arbitrary application of any interpretive frame. Barthes writes:

> The Text is not a coexistence of meanings but a passage, a traversal; thus it answers not to an interpretation, even a liberal one, but to an explosion, a dissemination … since the text is that social space which leaves no language safe, outside, nor any subject of the enunciation in position as judge, master, analyst, confessor, decoder. The theory of the Text can coincide only with a practice of writing. (1971, pp. 171, 174)

In addition to presenting one of the primary theoretical justifications of interdisciplinarity (since there is no foundation, for example, for an art historian to make definitive claims on his or her texts), Barthes statement here calls for a radical redefinition of reading. This call for a productive reading is inseparable from this theorization of a "writerly text."

In his unparalleled study of Honoré de Balzac's *Sarrasine*, entitled *S/Z* (1970), Barthes provides not only an enactment of his theoretical claims, but he presents some very clear statements

on his notion of a productive reading of a text. He explains that "the writerly is our value" because "the goal of literary work (of literature as work) is to make the reader no longer a consumer, but a producer of the text" (p. 4). The act of reading, for Barthes, is "not a parasitical act," rather it "involves risks of objectivity or subjectivity" because "to read, in fact, is a labor of language" (pp. 10, 11). The labor of reading is to discern the construction of identities, societal relations, and "reality" as such in and through language. Reading is not a passive act, but a performative labor that "does not aim at establishing the truth of the text (its profound, strategic structure), but its plurality (however parsimonious)" (p. 14). Barthes is up-front about the inexistence of the "writerly text" he theorizes, yet he suggests that certain works, usually canonical modernist ones like James Joyce's *Ulysses* (1922) but also some exceptional earlier texts like Sterne's *Tristram Shandy* (1759), signal the presence of the absent theoretical "writerly text" to come. These texts are "writerly" because they require a plural reading. "There cannot be," Barthes argues in relation to the "plural text," "a narrative structure, a grammar, a logic" (*S/Z*, p. 6). This absence of a predetermined reading and narrative logic is what allows for "the pleasure of the text." There are two French terms Barthes uses here: pleasure (*plaisir*), which signifies a reader being able to identify allusions in the text, and the other is bliss or enjoyment (*jouissance*). This kind of heightened pleasure (*jouissance*) has sexual connotations as well as a suggestion of the transformative power of "play" (*jeu*) that Barthes desires. This "pleasure of the text is an ecstatic [*ek-stasis*, breaking from the stasis, the status quo] one that unsettles a reader's historical, cultural, and psychological assumptions. In other words, the "pleasure of the text" undermines any claim to being given, to existing outside of the system of language. The productive reading of a text is "writerly" in that it substitutes any claim of authority, with plurality, contingency, and the potentiality to be rethought or "forgotten" as Barthes is fond of stating.

These concepts of pleasure, plurality, and desire imply a radical redefinition of the task of a critic. This new task of interpretation is a "Nietzschean" one (implying an openness to the Dionysian characteristics of cultural production) that Barthes defines in the following: "To interpret a text is not to give it a (more or less justified, more or less free) meaning, but on the contrary to

appreciate what plural constitutes it" (*S/Z*, p. 5). In her remarkable text *Critical Practice* (1980), Catherine Belsey provides a succinct explanation of the implications of Barthes's poststructuralist position for all of us:

> The object of the critic, then, is to seek not the unity of the work, but the multiplicity and diversity of its possible meanings, its incompleteness, the omissions which it displays but cannot describe, and above all its contradictions. In its absences, and in the collisions between its divergent meanings, the text implicitly criticizes its own ideology; it contains within itself the critique of its own values, in the sense that it is available for a new process of production of meaning by the reader, and in this process it can provide a real knowledge of the limits of ideological representation. (p. 109)

The importance of Barthes's work for contemporary critical practice is that he produces texts in which one can see him translating his theory into practice. His work, though thoroughly situated within the "linguistic turn," is insightful for art historical practice because it demands that we ask questions about how we conceive a work of art. Is a work of art reducible to a text or is it something else? In addition, it forces art historians (as well as cultural critics or historians) to address their own position within discourse; that is, how writing about art objects produces the meaning of those works, which does not preexist their reading, as well as constantly redrawing the profile of the discipline as a whole. This self-reflexivity occurs not only because Barthes writes on these aspects of cultural production, but because his conception of myth and his attention to representations of ideology refocus our attention on the role of art in contemporary Western culture. Here we must not ignore some of the problems with Barthes's reading of the foreign cities (for example, Tokyo) and cultures as inscrutable texts. This is where an informed, non-Western art historian can reread the limitations of *Empire of Signs* (1970) and suggest the ways in which the relation between image and text, idea and representation, should be rethought.

Barthes was a prolific writer. Besides short essays on artists such as Cy Twombly and his critique of the infamous *The Family of Man* exhibition that began at the Museum of Modern Art in 1955, his most important art historical text is on the medium of

photography. *Camera Lucida: Reflections on Photography* (1980) finds its justification in one of his earliest works. In *Mythologies*, Barthes explains how photography is perhaps the predominate text of mass culture. In *Camera Lucida*, he notes that the great portrait photographers are all "great mythologists" (p. 34). However, Barthes's reflections on photography are not undertaken in order to decode the semiotics of the photograph, nor even to further his analysis of modern myth. What remains so intriguing and paradoxical about Barthes's last text is his expressed desire to discover the essence of photography, precisely what makes it so compelling to him. This is a phenomenological ("a vague, casual, even cynical phenomenology," he calls it), or even an ontological, reflection. Barthes: "I wanted to explore it not as a question (a theme) but as a wound: I see, I feel, hence I notice, I observe, and I think" (p. 21).

By drawing on work such as Walter BENJAMIN's "Little History of Photography" (1931), Barthes does suggest a history of photography of sorts. He even manages to cover, however briefly, many of the major twentieth-century photographers. But his interest clearly lies elsewhere. Barthes's text is centered on three concepts that define his relation to photography: the *studium*, the *punctum*, and time (what he refers to as the "that-has-been").

The *studium* of a photograph is "the field of cultural interest" (p. 94). This includes its historicity (e.g., period clothes), representational strategy, its presentation of "reality." These are the elements that one can study and explicate; why one enjoys a certain photograph or how one can justify its historical importance. Barthes's text is weighted more toward the second and third concepts he develops.

The *punctum* is related to the "pleasure of the text"; it is the element of *jouissance* in the photograph. In *S/Z* Barthes describes a plural text as "the same and the new" (p. 16). This is precisely the language he uses to discuss the *punctum*: "it is what I add to the photograph and what is nonetheless already there" (1980, p. 55). It is what wounds or cuts the viewer: an undialectical point that interrupts the passive reading of a photograph. Whether it is a boy's crooked teeth or a woman's pearl necklace, the punctum is a marginal element of a photograph that compels the viewer; it seizes the viewer in the act of looking as in an "unexpected flash" that renders the viewer silent (p. 94). It is an ecstatic moment

Barthes terms "the *kairos* of desire, which unravels any chronology (p. 59). This leads to the indispensable aspect of time that marks the photograph for Barthes.

In looking for the distinct "photographic referent"—the essence or *noeme* of the photograph, what distinguishes it from other representational discourse—Barthes demands that it never forfeit its intimate relation to the past. It remains tethered to the "that-has-been" and renders it "a certificate of presence" in a form other than myth (p. 87). The founding order of photography is, therefore, not art nor communication, but reference. The photograph is "an image without a code" because although "nothing can prevent the Photograph from being analogical" its "*noeme* has nothing to do with analogy.... The important thing is that the photograph possess an evidential force, and that its testimony bears not on the object but on time ... the power of authentication exceeds the power of representation" (pp. 88–89). This relation defines what is unique to photography as opposed to cinema or painting. It simply states that the object in a photograph was there, before the camera, at one point in time. Barthes argues that "what I see is not a memory, an imagination, a reconstitution, a piece of Maya, such as art lavishes upon us, but reality in a past state: at once the past and the real" (p. 82).

It is statements such as these that make this text so curious. Barthes's phenomenological-ontological reading of photography— his interrogation of the medium from a position circumscribed by death—leads to a thesis about ascertaining "the impossible science of the unique being" (p. 71). The direct references to Kristeva's psychoanalytic work, coupled with the undeniable way in which the text is colored by Lacan's framework, suggest that Barthes set out to chart the threshold between image and text, between image and its intensively subjective effect of the viewer, as one marred by the logic of the index, the fetish, and hallucination. It is this liminal state—a state of transformation, a state that changes discourse— that not only designates the essence of photography, but calls for its protection against the incursion of the discourse of art, which Barthes argues will "tame the Photograph ... temper the madness" (p. 117).

There are undoubtedly complications and paradoxes here which have been and still need to be addressed by art historians. But what remains is Barthes's assertion that an authentic aesthetic

experience is one that marks or wounds the viewer—the effect is psychological as well as physical. What we are presented with is a reading of photography that produces its meaning. The plurality of the photograph, its excessive and often silent signification, is the remnant of desire—that which exceeds any discursive frame. In calling for an act of interpretation that is up to the ontological challenge of a reading that needs a relation to the past, the "that-has-been," Barthes makes us hesitate. How are we to negotiate the threshold between image and text, between image and text and time, so that while not denying the constructive power of language, we can still allow for an experience of language as such? The *punctum* of art historical practice is what founds its discourse as historical, but, if the *studium* is privileged over the *punctum*, then the transformation of discourse is impossible. This is because it is love and death— the delimiting states of human life—that change discourse. In many ways Barthes's meditation on photography re-asks one of art history's inescapable questions: is the discipline a science or can critical practice address both the production of art and its reception (which is often intensely personal and perhaps even "mad" as Barthes suggests)? Is it able to interpret an artwork as a text? Can it approach the Nietzschean model of interpretation Barthes forwards, one premised upon the absence of any grammar? Barthes insists that "a grammar of photography is impossible" and demands that art history find itself within a Dionysian sphere, where any temporal and subjective points of orientation are absent (1981, p. 356). This would be an art history that is Apollonian and chronological, but one that remains open to the Dionysian and the kairological.

Further Reading

By Barthes

1957. *Mythologies*, translated by Annette Lavers. New York: Hill & Wang, 1973.

1964. *Elements of Semiology*, translated by Annette Lavers and Colin Smith. New York: Hill & Wang, 1968.

1968. "The Death of the Author." In *Image-Music-Text*, translated by Stephen Heath. New York: Hill & Wang, 1977.

1970. *S/Z*, translated by Richard Miller. New York: Hill & Wang, 1974.

1970. *Empire of Signs*, translated by Richard Howard. New York: Hill & Wang, 1983.

1971. "From Work to Text." In *Image-Music-Text*, translated by Stephen Heath. New York: Hill & Wang, 1977.

1973. *The Pleasure of the Text*, translated by Richard Miller. New York: Hill & Wang, 1976.

1980. *Camera Lucida: Reflections on Photography*, translated by Richard Howard. New York: Hill & Wang, 1981.

1981. *The Grain of the Voice: Interviews 1962–1980*, translated by Linda Coverdale. New York: Hill & Wang, 1985.

About Barthes

Belsey, Catherine. *Critical Practice*. London and New York: Routledge, 1980.

Culler, Jonathan. *Roland Barthes*. Oxford: Oxford Univ. Press, 1983.

Jay, Martin. "The Camera as Memento Mori: Barthes, Metz, and the Cahiers du Cinéma." In *Downcast Eyes: The Denigration of Vision in Twentieth-Century French Thought*. Berkeley: Univ. of California Press, 1993.

Knight, Diana, ed. *Critical Essays on Roland Barthes*. New York: G.K. Hall, 2000.

Lavers, Annette. *Roland Barthes: Structuralism and After*. Cambridge, MA: Harvard Univ. Press, 1982.

Moriarty, Michael. *Roland Barthes*. Cambridge, UK: Polity Press, 1991.

Wiseman, Mary Bittner. *The Ecstasies of Roland Barthes*. London and New York: Routledge, 1989.

GEORGES BATAILLE

Key Concepts

- heterology
- accursed share
- base materialism
- informe

Georges Bataille (1897–1962) was born to a depressive, suicidal mother and a strict disciplinarian father in Puy-de-Dôme, France. At the outset of World War I, an adolescent Bataille converted to Catholicism. The zeal with which he embraced his newfound faith is evident in his first published text, which laments the bombing of the Cathedral of Nôtre-Dame at Reims. Bataille joined a Benedictine seminary with the goal of becoming a priest, but was forced to serve in the French army from 1916 to 1917. His discharge from the army due to tuberculosis and difficulties in his personal life during this time caused him to lose his faith. From 1918 to 1922 Bataille studied paleography and library science at the École des Chartes in Paris. The latter area of study led to his obtaining a position at the Bibliothèque Nationale. During the Nazi occupation of France, it was Bataille's position and savvy that ensured the survival of Walter BENJAMIN's notes for his unfinished project on the Parisian arcades. When Benjamin decided to flee to Spain, he entrusted his working materials to Bataille, who hid them in the library.

In a scholarly and artistic career spanning more than four decades, Bataille wrote on an impressive array of subjects, including eroticism, politics, philosophy, sociology, and art. His thought is unclassifiable, a fact, which led Roland BARTHES to call Bataille a producer of "texts" rather than "works."

During the 1920s, Bataille was involved with the Surrealist movement. His presence within the movement, however, has come to exemplify the schisms that existed within such a manifold group. Bataille has become the face of the dissident Surrealists, those who challenged André Breton's autocratic pronouncements. This led to Bataille and others being "excommunicated" from the group by Breton in his *Second Manifesto of Surrealism* (1929). Besides his involvement with Surrealism, Bataille engaged with a number of short-lived, radical antifascist groups throughout his life. From 1931 to 1934, he was a member of the Democratic Communist Circle, which published the journal *La Critique Sociale*. Soon afterward he organized a group called Contre-Attaque (1935–1936). Most important, perhaps, was his founding of a "secret society" that aimed to turn its back on politics and pursue goals that were solely religious—albeit "anti-Christian, essentially Nietzschean" ("Autobiographical Note," p. 115). The public face of this society was the now famous Collège de Sociologie and its journal *Acéphale* ("headless"), which was published from 1936 to 1939.

In all of his work, Bataille acknowledges a debt to the work of Friedrich NIETZSCHE, especially in his discussion of the Dionysian aspects of artistic creation. In many ways, it is through Bataille that the key figures of poststructuralist thought in France—Jacques DERRIDA, Michel FOUCAULT, and Jacques LACAN—were introduced to Nietzsche. Bataille's work evinces a long-standing interest in human experiences that reveal the limits of thought, experiences of a radical alterity beyond linguistic representation: the burst of laughter, erotic love, potlatch, sacrifice, mystical union. He sought to highlight these disorienting and delimiting experiences that exceed the discernible boundaries of the self. Such experiences, he believed, make communication possible because they transcend the Cartesian self (thought of as a discrete body and mind) situating it in an inescapable relation with others. This disintegration of the self is a kind of self-transcendence that opens one up to the possibility of communion with others: it opens up the possibility of the "sacred." Bataille defines the sacred as that

which originates and limits human behavior. Human experience, therefore, is conceived as an experience of limits (with death being the absolute limit) and their transgression. In *On Nietzsche* (1945), Bataille describes the Christian story of the crucifixion of Christ as a radical act of communication: a self-laceration of the divine that opens toward communion with all human beings.

In an early essay entitled "The Use-Value of D.A.F. de Sade (An Open Letter to my Current Comrades)," written between 1929 and 1930, Bataille proposes a new academic program of study that focuses on this "other scene" of subversive excess, rupture, and self-transcendence. He calls this program **heterology**, defined as the study of the other (*hetero* = "other"), that is, "the science of what is completely other" ("Use-Value," note 2). Indeed, heterology is an apt description of Bataille's entire *oeuvre*. It attends to that which is irredeemably other—the **"accursed share"** within the dominant social order that cannot be assimilated into it. It deals with what is useless in a world driven by use-value and that which is wasteful in a world driven by production; the accursed share names what is determined evil in a world that reduces the sacred to moral goodness.

What Bataille takes from Sade is the notion that sadistic eroticism lessens the anxiety caused by the constitutive human experience of limits. Through sexual degradation and humiliation, one can tap into an experience of the sacred, one can regain an intimacy that has been lost through modernization. These types of sexual experiences are described in Bataille's early autobiographical-fictional text *Historie de l'Oeil* (Story of the Eye) (1928). Bataille's interest in sexual enjoyment (*jouissance*) is taken up in the work of Lacan.

Bataille's heterology was the source of his rift with Breton. Surrealism, as championed by Breton, aimed for a Hegelian sublation of the mundane and the fantastic, the conscious and the unconscious, dream and waking. Arrived at through Breton's quirky readings of **FREUD** and his desire to unite **MARX**'s credo "To change the world" with the nineteenth-century French poet Arthur Rimbaud's intent "To change life," this sublation was supposed to unveil surreality. Bataille and others associated with Surrealism in its initial manifestation did not contest Breton's reliance on psychoanalysis, but rather his insistence that Surrealism be explicitly tied to the Communist Party. In contrast to Breton's historical materialism, Bataille posits a **base materialism**, his attempt to undermine Breton's contention that Surrealism is a

sublation of materiality into thought. In short, **base materialism** critiques the underlying Hegelian premise of Breton's notion of Surrealism. For Hegel, thought is materiality, but for Bataille, there is a base materialism—matter, mere things, filth, scatological elements—that exceeds thought. (Bataille's position is undeniably colored by the famous series of lectures Alexandre Kojève gave on Hegel from 1933 to 1939 in Paris.)

For Bataille base materialism, of which the *informe* (formless) is a primary element, that indicates the possibility of transgression, the continued presence of an "accursed share" that one cannot frame or sublate into something socially acceptable. Base materialism is closely associated with Freudian desublimation. It signals a transgression of moral and political norms, a transgression of the boundaries of human values and their institutions.

In his "Critical Dictionary," published in the dissident Surrealist journal *Documents* in 1929 to 1930, Bataille includes an entry on *L'informe*. In discussing this term, he writes:

> Thus formless is not only an adjective with a certain meaning, but a term serving to deprecate, implying the general demand that everything should have a form. That which it designates has no rights to any sense, and is everywhere crushed underfoot like a spider or a worm. For the satisfaction of academics, the universe must take shape…. To affirm on the other hand that the universe does not resemble anything and is nothing but formless amounts to the claim that the universe is something like a spider or a gob of spittle. (p. 475)

The exclusion not only of idealism, but also of any claim to form or structure in the universe defines base materialism. Bataille's position breaks one of the fundamental premises of traditional aesthetic thought; namely, the social contract (initially forwarded by Plato) that supposedly exists between artists and society: that art imitate life and vice versa. In the context of Plato's *Republic*, breaking this contract results in expulsion from the ideal state. In many ways, this is even the premise of twentieth-century avant-garde art, which claims to best represent the current situation of human life. Thus, against Breton's teleological claim that Surrealism is the face of modernity as such—an authentic art for an existence radically redefined by Freud and Marx—Bataille counters with the

informe, a transgression of the basic role of the artist in Western aesthetic thought.

Nearly all of Bataille's texts are littered with references to art history, ranging from prehistoric art, which aids in the discourse of primitivism and modernism, to the work of Édouard Manet (see also Foucault). Of Manet, Bataille writes: "No painter more heavily invested the subject, not with meaning, but with that which goes beyond and is more significant than meaning" (*Manet*, 1955, p. 95). It quickly becomes clear when examining Bataille's philosophy and his interest in art why he is considered a postmodernist; the concept of the *informe* is central to both. His importance in this regard is best exemplified by the 1996 exhibition at the Centre Georges Pompidou curated by Yves-Alain Bois and Rosalind Krauss, titled: *Formless: A User's Guide* (*L'Informe: Mode d'emploi*).

This exhibition was organized around Bataille's concept of the formless. However, the curators were reticent about merely propping up the term as the latest paradigm for postmodern art. In an exhibition so ambitious in its scope that it included works by Jackson Pollock, Alberto Giacometti, Gordon Matta-Clark, Jean Dubuffet, and Ed Ruscha, among others, the curators set out to "put the formless to work, not only to map certain trajectories, or slippages, but in some small way to 'perform' them" (Bois and Krauss, 1997, 18–21). In the introduction to the catalogue of the show Bois argues:

> Bataille's tastes in art are not in question here. Rather, with regard to the *informe*, it is a matter instead of locating certain operations that brush modernism against the grain, and of doing so without countering modernism's formal certainties by means of the more reassuring and naïve certainties of meaning. On the contrary, these operations split off from modernism, insulting the very opposition of form and content—which is itself formal, arising as it does from binary logic—declaring it null and void. (p. 16)

This exhibition and its catalogue remain one of the most incisive discussions of the relation between modernism and postmodernism. For instance, Bois and Krauss sharply distinguish Bataille's *informe* from related postmodern concepts such as abjection, which stems from the work of Julia KRISTEVA (see her *The Powers of Horror*

[1980]), which have been useful to contemporary art historical discourse in discussing performance art and postwar sculpture. Despite Kristeva's reliance upon the *informe* in theorizing abjection, Krauss argues that the two must not be collapsed, asserting that "it is our position that the formless has its own destiny to fulfill, its own destiny—which is partly that of liberating our thinking from the semantic, the servitude to thematics, to which abject art seems so thoroughly indentured" (p. 252). The feral and scatological nature of the *informe*, which exceeds limits, as well as any attempt to conceptualize and capture it as a style or as a paradigm of artistic practice, remains a concept in and through which art production and reception can be continually rethought. Against the reification of artistic styles or historical periods, the *informe* renders indeterminate both the work of art (its claims to resemblance or representation) and our readings of it.

Further Reading
By Bataille

1928. *Story of the Eye*, translated by Joachim Neugroschel. New York: Urizen Books, 1977.

1929–1930. "Critical Dictionary." In *Art in Theory, 1900–1990*, edited by Charles Harrison and Paul Wood. London: Blackwell, 1992.

1945. *On Nietzsche*, translated by Bruce Boone. New York: Paragon, 1992.

1945. *The Absence of Myth: Writings on Surrealism*, translated by Michael Richardson. London: Verso, 1994.

1949. *The Accursed Share*. Vol. 1, *Consumption*, translated by Robert Hurley. New York: Zone Books, 1988.

1949. *The Accursed Share*. Vol. 2, *The History of Eroticism*; Vol. 3, *Sovereignty*, translated by Robert Hurley. New York: Zone Books, 1991.

1954. *Inner Experience*, translated by Leslie Anne Boldt. Albany: State Univ. of New York Press, 1988.

1955. *Manet*, translated by Austryn Wainhouse and James Emmon. London: Macmillan, 1980.

1955. *Prehistoric Painting: Lascaux, or The Birth of Art*, translated Austryn Wainhouse. London: Macmillan, 1980.

1957. *Eroticism: Death and Sensuality*, translated by Mary Dalwood. San Francisco: City Lights, 1986.

1958. "Autobiographical Note"; 1970 "The Use-Value of D.A.F. Sade (An Open Letter to My Current Comrades)." In *The Bataille Reader*, edited by Fred Botting and Scott Wilson. Oxford: Blackwell, 1997.

About Bataille

Bois, Yves-Alain, and Rosalond E. Krauss. *Formless: A User's Guide*. New York: Zone Books, 1997.

Botting, Fred, and Scott Wilson, eds. *Bataille: A Critical Reader*. Oxford: Blackwell, 1998.

Dean, Carolyn. *The Self and Its Pleasures: Bataille, Lacan, and the History of the Decentered Subject*. Ithaca, NY: Cornell Univ. Press, 1992.

Fer, Briony. "Poussière/Peinture: Bataille on Painting." In *On Abstract Art*. New Haven: Yale Univ. Press, 1997.

Gemerchak, Christopher. *The Sunday of the Negative: Reading Bataille, Reading Hegel*. Albany: State Univ. of New York Press, 2003.

Hollier, Dennis. *Against Architecture: The Writings of Georges Bataille*. Cambridge, MA: MIT Press, 1992.

Jay, Martin. "The Disenchantment of the Eye: Bataille and the Surrealists." In *Downcast Eyes: The Denigration of Vision in Twentieth-Century French Thought*. Berkeley: Univ. of California Press, 1993.

Richardson, Michael. *Georges Bataille*. London and New York: Routledge, 1994.

Stoekl, Allan, ed. "On Bataille." *Yale French Studies* 78 (1990).

Surya, Michael. *Georges Bataille: An Intellectual Biography*, translated by Krzysztof Fijalkowski and Michael Richardson. London: Verso, 2002.

JEAN BAUDRILLARD

Key Concepts

- simulation
- simulacrum
- postmodernity
- hyperreality

Jean Baudrillard (b.1929) was born in Reims in northeastern France. His grandparents were peasant farmers and his parents worked in civil service jobs. At the University of Nanterre, Baudrillard studied sociology under the Marxist Henri Lefebvre. From 1966 until his retirement in 1987, Baudrillard taught sociology at Nanterre. His earliest work was written from the Marxist perspective, but in subsequent texts his intellectual mentors often became the objects of his critiques, including figures such as **Marx**, Lefebvre, and Jean-Paul Sartre. Baudrillard's early engagement with Marxist theory was later eclipsed by poststructuralist ideas in the 1970s. His work bears traces of the theories of Roland **Barthes**, especially his work on modern mythologies, and of Marshall McLuhan's claim that the medium is more important than the message. Baudrillard's first book, *The System of Objects* (1968) is a semiotic analysis of culture influenced by the poststructuralist concept of the indeterminate play of language, **Freud**'s notion of drive and desire, Marx's theory of commodity fetishism, and the French sociologist Marcel Mauss's work on symbolic exchange economies. Baudrillard is a controversial cultural theorist, particularly noted

for his critiques of contemporary consumer society. He is one of the key theorists of postmodernity.

Baudrillard's work on postmodern culture—often simultaneously radical and hyperbolic in its claims—utilizes ideas drawn from various disciplines, including linguistics, philosophy, sociology, and political science. He addresses a wide range of issues, including mass media, mass consumption, travel, war, and terrorism. The best known of Baudrillard's reappraisals of modernity is *Simulacra and Simulation* (1981), in which he analyzes the nature of postmodern culture, asserting that contemporary culture can no longer distinguish image from reality. Baudrillard's basic contention is that the "conventional universe of subject and object, of ends and mean, of good and bad, does not correspond any more to that state of our world" (*Impossible Exchange*, p. 28). There is a shift in Baudrillard's work from Marx to McLuhan, industrial production to consumption, wherein consumerism is the common denominator of contemporary Western society. What defines our society is the endless exchange and consumption of object-signs.

Within the context of his explorations of postmodern Western culture, Baudrillard is especially interested in representation. Drawing on the work of the French Situationist thinker Guy Debord's *The Society of Spectacle* (1967), Baudrillard examines the ways in which technology and media impact how we represent our experiences and what we can know about the world. He argues that contemporary culture is so saturated with images from television, film, advertising, and other forms of mass media that the differences between the real and the imagined, or truth and falsity, have become indistinguishable. Images no longer represent reality, they have become reality as such. Our lives are thus simulations of reality in the sense that **simulation** has no intrinsic or causal connection to what was previously considered reality. Images produced by mass media neither refer to reality nor harbor any independent meaning.

One of the central questions of Baudrillard's work is: what are the implications of living in an image-saturated, postmodern society? In effect, our experiences of the world are mediated through the many images that confront us every day and that frame how and what we see of the world. Notions of the perfect body, for instance, come about not because of some unmediated experience we have

in the world, but largely through all the body images projected by consumer society and advertising technologies.

Central to Baudrillard's understanding of the relationship between reality and representations of it are the concepts of simulacrum and hyperreality. A **simulacrum** is an image or representation of something. Baudrillard uses this term to refer to an image that has replaced the thing it supposedly represents. In *Simulacra and Simulation*, he distinguishes three phases or "orders" of the simulacrum in the history of the sign. With each order, the simulacrum is increasingly alienated from that which it purports to represent. First order simulacra, which alter or mask reality, emerge prominently in the baroque period, with its privileging of artifice over realism. The emergence of second order simulacra arrive with the modern age of mass production. Here the importance of Walter BENJAMIN's essay "The Work of Art in the Age of Its Technological Reproducibility" (1935–1936) is especially felt: the idea that the "aura" of the original, the referent of the reproduction, withers. Third order simulacra are the simulacra of the current postmodern age. In **postmodernity**, the simulacrum is severed from any relation to reality; it is a production of reality as such, not its imitation or representation. With postmodernity, the simulacrum supersedes the real so that we live in a world of simulacra, representations of representations.

Although images may appear to refer to or represent real objects in the so-called real world, "reflecting a preexisting reality," Baudrillard argues that in postmodernity images are the real. Thus, the simulated is the real. One characteristic of such a postmodern world is the proliferation of media for producing images that simulate reality, including film, television, and the World Wide Web. Baudrillard claims that "[t]o simulate is to feign what one doesn't have" (1981, p. 3). In short, simulation does not resemble or refer to reality, it constructs it.

Baudrillard provides us with an example of how an image becomes reality itself. He cites a story by Jorge Luis Borges (a writer whose work also plays a key role in Michel FOUCAULT's *The Order of Things* in which "the cartographers of the Empire draw up a map so detailed that it ends up covering the territory exactly" (1981, p. 1). The map, which is a representation of real space, becomes the reality, or to use Baudrillard's term, a **hyperreality**: "Simulation is no longer that of a territory, a referential being, or a substance.

It is the generation by models of a real without origin or reality: a hyperreal" (p. 1). From this perspective, "[t]he territory no longer precedes the map, nor does it survive it. It is nevertheless the map that precedes the territory—procession of simulacra—that engenders the territory, and if one must return to the fable, today it is the territory whose shreds slowly rot across the extent of the map" (p. 1). For Baudrillard, the map has become reality, not a representation of it. A hyperreal world, then, is one in which the real and the imaginary have imploded and the boundaries separating them no longer stand, nor do boundaries separating previously autonomous spheres. For instance, CNN and other cable news networks blur distinctions between fact, opinion, sports, politics, and entertainment. The news does not describe or represent reality, it is reality. Baudrillard goes so far as to argue that media and other imaginary constructs like Disneyland function to create America itself as nothing more than a hyperreal simulation of the real.

Simulation commonly refers to something fake or counterfeit, unreal, or inauthentic. But Baudrillard does not simply contrast simulation with the real; rather, he sees these as having suffered a radical disconnection. For him, we can no longer meaningfully inquire about the relative truth or falsity of images and representations. At the conclusion of The Ecstasy of Communication (1988), Baudrillard writes:

> And what if reality dissolved before our very eyes? Not into nothingness, but into the more real than real (the triumph of simulacra)? What if the modern universe of communication, of hyper-communication, had plunged us, not into the senseless, but into a tremendous saturation of meaning entirely consumed by its success—without the game, the secret, or distance?… If it were no longer a question of setting truth against illusion, but of perceiving the prevalent illusion as truer than truth. (pp. 103–114)

This absolute reliance upon representations, a seamless realm of images, gives art history a certain importance because it is the discipline that educates people how to read images, how to understand the impasse of truth and appearance.

Baudrillard has written on cinema and its implications for our experience—or inexperience—of modern technological warfare

in *The Evil Demon of Images* (1987). In addition, his work on the simulacrum has been used by the art historian Rosalind Krauss and others to interpret the work of the postmodern artist Cindy Sherman, whose photographic and performative practice is a presentation of simulacra that foregrounds the critical implications of identity construction. Baudrillard himself has weighed in about the postmodern predicament in which we find ourselves and about the significance of abstraction in painting in the essay "Hot Painting: The Inevitable Fate of the Image" (1990). The importance of this text for contemporary art history is due in part to its inclusion in the volume *Reconstructing Modernism*, edited by Serge Guilbaut. The dialogues contained in this work serve as a flashpoint for the often contentious discussions regarding the distinctions between modernism and postmodernism.

For his part, Baudrillard grounds his argument in the distinction between hot and cold societies forwarded by the anthropologist Claude Lévi-Strauss. Baudrillard argues that the onset of the Cold War, coming as it did after the traumatic events of modernity like Auschwitz and Hiroshima, indicates the moment in which Western society "exiled ourselves from history ... we returned to being societies without history, cold societies" (1990, p. 17). Beginning in the 1950s and 1960s, "[w]ar, and history with it, is somehow suspended, satellized, hyperrealized" (p. 17). In his reading of this condition of postmodernity, Baudrillard turns his attention to the meaning of abstraction in art as an interesting form of escape from the referential sphere of the sign. In postwar abstract painting, he argues "a table is still a table, objects are always what they are, but there is no longer any sense, any significance, in representing them as such" (p. 18). Therefore, during the period following World War II both the traditional modernist sense of an image and its attendant conception of history disappear. This includes the related concepts of reason, human memory, and historiography as the successive recitation of events. The work of Jackson Pollock, Mark Rothko, Barnett Newman, and others is not symptomatic of the "intellectual and critical" abstraction of the abstractions of Wassily Kandinsky or Paul Klee; rather, their work is "desperate, nervous, pathetic, and explosive abstraction" (p. 23). Not content to position Abstract Expressionism as merely reactive to its historical context, Baudrillard argues that

expressionist painting is protesting this involution of war into Cold War, this involution of the world into a frozen world, this involution of the imagination itself into the chilly images of television and the other cold media (to which painting itself has now largely acclimatized itself, in its pop, hyperrealist, conceptual guises). It is the last moment of illuminated painting in the context of historical darkness. (p. 26)

The dire tone Baudrillard often takes aside, his comments on Abstract Expressionism as the last gasp of modernist art against the advances of postmodernism, have set the agenda of contemporary art history for quite some time. The problem remains, however, especially now that central aspects of Baudrillard's theory have materialized in our global simulacral village, of how to conceptualize the historical event that interrupts the transmission of simulacra. Rather than asking if it is possible to make a work of art which is not an artwork, perhaps the parallel question we now face is whether or not it is possible for an artwork to not be a simulacrum.

Further Reading

By Baudrillard

1968. *The System of Objects*, translated by Chris Turner. London: Verso, 1996.

1981. *Simulacra and Simulation*, translated by Sheila Faria Glaser. Ann Arbor: Univ. of Michigan, 1994.

1986. *America*, translated by Chris Turner. London: Verso, 1988.

1986. "Hot Painting: The Inevitable Fate of the Image." In *Reconstructing Modernism: Art in New York, Paris, and Montreal 1945–1964*, edited by Serge Guilbaut. Cambridge, MA: MIT Press, 1990.

1987. *The Ecstasy of Communication*, translated by Bernard Schutze and Caroline Schutze. New York: Semiotext(e), 1988.

The Evil Demon of Images, translated by Paul Patton and Paul Foss. Sydney, Australia: Power Institute of Fine Arts, 1987.

1990. *The Transparency of Evil: Essays on Extreme Phenomena*, translated by James Benedict. London: Verso, 1993.

1999. *Impossible Exchange*, translated by Chris Turner. London: Verso, 2001.

1999. *Jean Baudrillard: Selected Writings*. 2nd ed., edited by Mark Poster. Stanford, CA: Stanford Univ. Press, 2001.

1999. *Jean Baudrillard: Art and Artefact*. London and Thousand Oaks: SAGE, 1997.

About Baudrillard

Bennett-Carpenter, Benjamin. "The Divine Simulacrum of Andy Warhol: Baudrillard's Light on the Pope of Pops." *Journal for Cultural and Religious Theory* 1, no. 3 (2001): <www.jcrt.org/archives/01.3/carpenter.shtml>.

Durham, Scott. *Phantom Communities: The Simulacrum and the Limits of Postmodernism.* Stanford, CA: Stanford Univ. Press, 1998.

Gane, Mike. *Baudrillard's Bestiary: Baudrillard and Culture.* London and New York: Routledge, 1991.

Gane, Mike, ed. *Baudrillard Live: Selected Interviews.* London and New York: Routledge, 1993.

Huyssen, Andreas. "In the Shadow of McLuhan: Baudrillard's Theory of Simulation." In *Twilight Memories: Marking Time in a Culture of Amnesia.* London and New York: Routledge, 1995.

Kellner, Douglas. *Jean Baudrillard: From Marxism to Postmodernism and Beyond.* Cambridge, UK: Polity Press, 1989.

Krauss, Rosalind. *Cindy Sherman 1975–1993.* New York: Rizzoli, 1993.

WALTER BENJAMIN

Key Concepts:

- allegory
- profane illumination
- aura
- technological reproducibility

Walter Benjamin (1892–1940) was born in Berlin to an assimilated German-Jewish family. He was educated at the universities of Berlin, Freiburg, Munich, and Bern. As a student he became involved in radical Jewish student movements and, along with his close friend Gershom Scholem, grew increasingly interested in Jewish mysticism. (Scholem went on to become a great scholar of Jewish mysticism.) In 1925, Benjamin submitted *The Origin of German Tragic Drama* as his *Habilitationsschrift* (a document required for promotion to a university position) at the University of Frankfurt. It was rejected because of its unconventional, lyrical style. As a result, Benjamin never held a formal academic post, and instead worked as an independent scholar, freelance critic, and translator.

In 1933, with the rise of National Socialism in Germany, Benjamin moved to Paris where he met Hannah Arendt and Georges **Bataille** along with many other intellectuals. In 1939 he was deprived of his German nationality and spent time in an internment camp for foreign nationals in France. In 1940, at the invitation of Theodor **Adorno** and Max Horkheimer of the Institute for Social Research who had both recently moved from

Frankfurt to New York to escape the Nazis, Benjamin attempted to flee the French Vichy regime for the United States. When he arrived in Port Bou on the French-Spanish border, he was refused entry into Spain. To return to France would have meant certain death. The next morning he was found dead, apparently a suicide from a morphine overdose.

Benjamin wrote on a wide range of topics—from literary tragedy to travel to messianism—and in a range of styles: from essay to commentary to aphorism. Artists, historians, literary critics, and philosophers have all been drawn to his texts for their insight and provocation. For art historical practice, an understanding of his theory of allegory developed in *The Origin of German Tragic Drama* (1928), as well as his essays "The Rigorous Study of Art" (1933), "Surrealism: The Last Snapshot of the European Intelligentsia" (1929), and "The Work of Art in the Age of Its Technological Reproducibility" (1935–1936), is essential.

In *The Origin of German Tragic Drama*, Benjamin takes German Baroque tragic drama as the pretext for a series of reflections on aesthetics, language, allegory, and redemption (a theme, which occupies him throughout his work). Benjamin attempts to rescue the "mourning-play" (*Trauerspiel*) from its debased position as a bankrupt form of classical tragedy. In doing so, he presents an utterly inimitable work of literary criticism that is simultaneously brilliant and esoteric. This study is unique precisely because while appearing to be a commentary on the historicity of the *Trauerspielen*, it is, in fact, an extended critique of cultural history, aesthetics, and politics embedded in a theological ground. The concept that connects this unique meditation on the intersection between concrete historical experiences and ontotheological issues is allegory.

Allegory is the *fils conducteur* of Benjamin's work—from his earliest essays on German Romanticism to his study of the French Symbolist poet Charles Baudelaire. For Benjamin, allegory signifies an ongoing dialectic between theological and artistic creation. In this way, it marks the affinity he reads between artworks in modernity and the seventeeth-century German Baroque mourning play, with its ambiguity, multiplicity of meanings, and fragmentary representations. On this crisis of meaning, Benjamin writes:

> Any person, any object, any relationship can mean absolutely anything else. With this possibility a destructive, but just

verdict is passed on the profane world ... [which] is both elevated and devalued.... Allegories are, in the realm of thoughts, what ruins are in the realm of things. This explains the baroque cult of the ruin ... that which lies here in ruins, the highly significant fragment, the remnant, is, in fact, the finest material in baroque creation. For it is common practice in the literature of the baroque to pile up fragments ceaselessly, without any strict idea of a goal, and, in the unremitting expectation of a miracle. (1928, pp. 175, 178)

This concept of the "highly significant fragment" is a central component of modern and contemporary art. In the theory of allegory, Benjamin presents one of the most modern artistic means of dealing with a preceding tradition—that of citation, tearing a precedent out of context—as, in fact, a gesture that arose with German Baroque drama.

These issues are developed in relation to contemporary artistic practice and poststructuralist thought in Craig Owens's "The Allegorical Impulse: Toward a Theory of Postmodernism" (1980). Owens argues that allegory, while present in modernism, remains *in potentia* until it can be actualized in the excessive activity of reading that characterizes postmodernism. Postmodern art, he argues, transforms our experience of art from a visual to a textual encounter because it attempts to problematize historical reference and foreground the instability of meaning. Owens's essay firmly places Benjamin's thoughts on aesthetics at the forefront of postmodern art history.

Beyond the primary place Benjamin's thought occupies in contemporary art history, his work is also insightful for anyone studying the origins of the discipline of art history or modernist criticism in general. His essay "The Rigorous Study of Art" is a review of the first volume of *Kunstwissenschaftliche Forschungen* (*Research Essays in the Study of Art*), which was edited in 1931 by Otto Pächt, a leading figure in the Viennese school of art history. The importance of Benjamin's review stems not so much from his critique of Heinrich Wölfflin, the author of *Renaissance and Baroque* (1888), *Classic Art* (1899), and *Principles of Art History* (1915) or from his championing of the Viennese art historian Alois Riegl, as from the manner in which it provides a summary of the approach to cultural history deployed in *The Arcades Project*—an approach

which, as this essay makes clear, comes directly from Benjamin's long-standing contemplation of art and art history.

In his estimation of Riegl's work, especially *The Late Roman Art Industry* (1901), Benjamin praises his "focus on materiality" and his "masterly command of the transition from individual object to its cultural and intellectual function" ("Rigorous Study,"1933, p. 668). It is this combination that allows Benjamin to proclaim Riegl—and not the formalist Wölfflin—the "precursor of this new type of art scholar," which is embodied for Benjamin in Hans Sedlmayr, among others included in Pächt's edition. The primary characteristic of this "new type of art scholar" is an "esteem for the insignificant" or "a willingness to push research forward to the point where even the 'insignificant'—no, precisely the insignificant— becomes significant" (p. 668). This focus on the insignificant recalls his statements on allegory and his unfinished *The Arcades Project*. In the work of his peers, these "new researchers" who are "at home in marginal domains" and thereby "the hope of their field," Benjamin sees reflected his own impetus to examine the Parisian arcades as an *ur*-form of capitalist modernity (p. 670).

The importance Benjamin gives the Parisian arcades, which by the 1930s were nearly all destroyed, derives in large part from his fascination with the Surrealists. Benjamin writes that it was this avant-garde group who "first opened our eyes" to "the ruins of the bourgeoisie" which "became for Surrealism, the object of a research no less impassioned than that which the humanists of the Renaissance conducted on the remnants of classical antiquity" (1982, p. 898). More precisely, Benjamin's preoccupation with the arcades can be traced directly to Louis Aragon's observation on the arcades in *Paris Peasant* (1926): "it is only today, when the pickaxe menaces them, that they have at last become the true sanctuaries of a cult of the ephemeral, the ghostly landscape of damnable pleasures and professions." Led by the mercurial André Breton, the Surrealists founded their work on the notion of the "encounter," a situation in which a latent "surreality" is made manifest. This notion of "surreality" is a sublation of dream and reality, the fantastic and the mundane, the unconscious and the conscious. The similarities between the Surrealists' and Benjamin's desires to investigate the cultural and psychological origins of modernity are undeniable. They share an interest in liminal psychic states

(the Surrealists were preoccupied with self-induced trances and the derangement of the senses as put forth by Arthur Rimbaud, one of their artistic precursors), politics, the fleeting experience of everyday life, fantasy, repression, and the outmoded commodity. Because of this constellation of common interests Benjamin sees a direct line between his line of inquiry and that of the Surrealists. This line of inquiry can be characterized as an attempt to identify and actualize the hidden possibilities of the past that remain latent in the present. Seizing these latent potentialities is the act Benjamin terms "profane illumination" in his essay on Surrealism. **Profane illumination** transforms the impoverished experiences of modernity into a revolutionary hope. The intimacy between the materiality of things (the detritus of nineteenth-century capitalism) and redemption (a messianic interruption for Benjamin and the advent of "surreality" for Breton et al.) is premised on a radical, delimited notion of memory. This is a concept familiar to readers of Benjamin's *The Origin of German Tragic Drama*.

The importance of Surrealism to Benjamin's thought is explored by Margaret Cohen in *Profane Illumination: Walter Benjamin and the Paris of Surrealist Revolution* (1993). By providing an in-depth examination of this pairing, Cohen is able to develop the connections between Benjamin's work and that of a larger intellectual tradition (including FREUD and MARX), but she also presents the many ways in which Benjamin's work is situated at the center of the primary debates of twentieth-century art history. Her explication of the categories of the encounter and the Freudian uncanny in terms of Benjamin's work suggests the ways in which art history can approach abstract painting, installation, and even performance art as components of the same discourse that drives the thoughts on art and history put forth by Benjamin and the Surrealists.

Of course, no discussion of Benjamin and art history is complete without his now classic essay, "The Work of Art in the Age of Its Technological Reproducibility" (1935–1936). This essay serves as a direct counterpoint to Martin HEIDEGGER's essay "The Origin of the Work of Art" written at the same time. Although Benjamin makes no reference to Heidegger's essay in his own, there is considerable evidence from Benjamin's correspondence and the notes for *The Arcades Project* that he considered his work as a direct

response to Heidegger's work. Samuel Weber has dealt with this complicated threshold between Benjamin and Heidegger in his remarkable essay "Mass Mediauras; or, Art, Aura, and Media in the Work of Walter Benjamin" (1996).

Benjamin explores the origins of the work of art in relation to what he believes to be a radically new era in art history brought on by new methods of mass reproduction. Important here is the concept of "authenticity," by which Benjamin refers to the original work of art's unique existence in time and space, "the here and now of the original" that "founded the idea of a tradition which has passed the object down as the same, identical thing to the present day"; in other words its "historical testimony" (p. 103). This is the essence or **aura** of the work of art that cannot be reproduced. Aura is what gives the original work its distance, its historical otherness in relation to us. The **technological reproducibility** of art drives "the desire of the present-day masses to 'get-closer' to things, and their equally passionate concern for overcoming each thing's uniqueness by assimilating it as a reproduction" (p. 105). With every reproduction, Benjamin insists, the aura of the original is diminished because "the technology of reproduction detaches the reproduced object from the sphere of tradition. By replicating the work many times over, it substitutes a mass existence for a unique existence" (p. 104). Reproducibility depends on the original work's aura (otherwise there would be no interest in reproducing it) even while it uproots it from the historical time and space that gives it its aura.

Benjamin further argues that the work of art's aura, its being rooted in tradition, has its basis in ritual. This, he insists, was the work of art's first and original use-value. Before "art for art's sake," the work of art was made for use in religious ritual. As artists increasingly did their work with the explicit aim of public exhibition rather than ritual function, the work of art began to break free from its religious roots. Nonetheless, Benjamin argues, until this new age of technological reproducibility, those roots were not severed.

With the advent of photography and film, Benjamin posits that "for the first time in world history, technological reproducibility emancipates the artwork from its parasitic subservience to ritual" (p. 106). In this new age, artists increasingly make their works

with the conscious intention of reproducing them. The original is created for the purpose of its own reproduction. The work of art's reproducibility has become paramount, leading to a qualitative transformation of the nature of art: breaking free from its original roots in ritual practice, it has the potential to serve an entirely new practice, namely, politics: "But as soon as the criterion of authenticity ceases to be applied to artistic production, the whole social function of art is revolutionized. Instead of being founded on ritual, it is based on a different practice: politics" (p. 106).

In Benjamin's view, film is the most important example of this new form of reproducible art. Film, he argues, has the power to "confront the masses directly," whether the goal is nationalism or revolution, acceptance or resistance (p. 116). It does so by distracting spectators—by entertaining or enthralling them with spectacle—while at the same time reshaping their worldview, intervening in their conception of reality. Remember that Benjamin was writing "The Work of Art in the Age of Its Technological Reproducibility" during the rise of Nazism, a movement particularly adept at using art as political propaganda. Think of the pervasive graphic posters, but also nationalistic films like *Triumph of the Will*, the Nazi documentary about the 1934 rally at Nuremberg by Leni Riefenstahl.

Benjamin's essay provokes new questions at the beginning of the twenty-first century, a time in which new media technologies proliferate with ever-increasing speed. Even if we accept Benjamin's argument, we must ask, for example, whether art made in a digital age is a continuation of the age of technological reproduction to which he refers, or whether it somehow exceeds or overturns any notion of an artistic praxis premised on the dialectic of authenticity and inauthenticity, the real and the copy. This defines one area of Benjamin's legacy in art history because this question of the complete liquidation of the aura and its subsequent simulation is taken up by Jean **BAUDRILLARD**.

A pressing issue for contemporary art history is to return to Benjamin's work of art essay and read it with his other works on analogous topics, including "Little History of Photography" (1931) and "The Author as Producer" (1934), as well as his thoughts on Art Nouveau and film in *The Arcades Project*. The importance of Benjamin's work for art history results from his ability to pose the new questions (for example, the effects of reproduction on the work

of art) while reinvesting the long-standing questions of aesthetics: the idea of beauty in relation to materiality, the interstices between language and art, the transmission of memory-images, the function of the exhibition value of the artwork invested by museums, and how to reconcile a study of unique objects with the demands of the overarching discipline of art history.

Further Reading

By Benjamin

1928. *The Origin of German Tragic Drama*, translated by John Osborne. London and New York: Verso, 1998.

1929. "Surrealism: The Last Snapshot of the European Intelligentsia." In *Selected Writings 1927–1934*, vol. 2, edited by Michael W. Jennings, Howard Eiland, and Gary Smith, translated by Edmund Jephcott. Cambridge, MA: The Belknap Press of Harvard Univ. Press, 1999.

1931. "Little History of Photography." In *Selected Writings 1927–1934*, vol. 2, edited Michael W. Jennings, Howard Eiland, and Gary Smith, translated by Edmund Jephcott and Kingsley Shorter. Cambridge, MA: The Belknap Press of Harvard Univ. Press, 1999.

1933. "The Rigorous Study of Art." In *Selected Writings 1927–1934*, vol. 2, edited Michael W. Jennings, Howard Eiland, and Gary Smith, translated by Thomas Y. Levin, Cambridge, MA: The Belknap Press of Harvard Univ. Press, 1999.

1934. "Author as Producer." In *Selected Writings 1927–1934*, vol. 2, edited by Michael W. Jennings, Howard Eiland, and Gary Smith, translated by Edmund Jephcott. Cambridge, MA: The Belknap Press of Harvard Univ. Press, 1999.

1935–1936. "The Work of Art in the Age of Its Technological Reproducibility." In *Selected Writings 1935-1938*, vol. 3, edited by Howard Eiland and Michael W. Jennings, translated by Edmund Jephcott and Harry Zohn. Cambridge, MA: The Belknap Press of Harvard Univ. Press, 2002.

1982. *The Arcades Project*, translated by Howard Eiland and Kevin McLaughlin. Cambridge, MA: The Belknap Press of Harvard Univ. Press, 1999.

About Benjamin

Buck-Morss, Susan. "Aesthetics and Anaesthetics: Walter Benjamin's Artwork Essay Reconsidered." *October* 62 Fall (1992): 3–41.

Caygill, Howard. "Walter Benjamin's Concept of Cultural History." In *The Cambridge Companion to Walter Benjamin*, edited by David S. Ferris. Cambridge, UK: Cambridge Univ. Press, 2004.

Cohen, Margaret. *Profane Illumination: Walter Benjamin and the Paris of Surrealist Revolution*. Berkeley and Los Angeles: Univ. of California Press, 1993.

Coles, Alex, ed. *The Optic of Walter Benjamin*. London: Black Dog, 1999.

Levin, Thomas Y. "Walter Benjamin and the Theory of Art History: An Introduction to 'Rigorous Study of Art.'" *October* 47 Winter (1988): 77–83.

Owens, Craig. "The Allegorical Impulse: Toward a Theory of Postmodernism." In *Art After Modernism: Rethinking Representation*, edited by Brian Wallis. New York: New Museum of Contemporary Art, 1999.

Pensky, Max. *Melancholy Dialectics: Walter Benjamin and the Play of Mourning*. Amherst: Univ. of Massachusetts Press, 1993.

Rochlitz, Rainer. *The Disenchantment of Art: The Philosophy of Walter Benjamin*. New York and London: Guilford Press, 1996.

Weber, Samuel. "Mass Mediauras; or, Art, Aura, and Media in the Work of Walter Benjamin." In *Mass Mediauras: Form, Technics, Media*. Stanford, CA: Stamford Univ. Press, 1996.

PIERRE BOURDIEU

Key Concepts

- habitus
- doxa
- cultural capital
- field of cultural production
- taste

Pierre Bourdieu (1930–2002) was a French sociologist whose work has been widely influential in both the social sciences and the humanities. He was born in rural southwestern France where his father was a postal worker. Bourdieu received a scholarship that enabled him to attend the prestigious lycée Louis le Grand in Paris. He subsequently enrolled at the École normale supérieure where he studied with Louis **ALTHUSSER**. After graduating with a degree in philosophy, Bourdieu first taught at the high school level, but in 1959 he was appointed to a position in philosophy at the Sorbonne. He taught at the University of Paris from 1960 until 1964 when he was named director of studies at the École des hautes études en sciences sociales and founded the Center for the Sociology of Education and Culture. In 1982, Bourdieu was named chair of sociology at the Collège de France. He received the *Medaille d'Or* from the French National Scientific Research Center in 1993.

During his military service, Bourdieu spent time teaching in Algeria. As a result of this experience he became acutely aware of

the racial and class chauvinism of French colonialism. He later conducted ethnographic fieldwork in Algeria, which served as the foundation for many of his later concepts and theories. Bourdieu also conducted fieldwork in France where he studied the structures of social and class differences in French society. He was interested in how systems of social inequality are embedded in cultural practices. He paid particular attention to the study of the French education system and demonstrated how it reproduced class difference despite its claims to the contrary.

Like Jacques **DERRIDA**, Bourdieu was a public intellectual. In 2001, he became a celebrity with the appearance of a popular documentary film about him, entitled *Sociology Is a Combat Sport*. Several of his books, despite his academic prose style, were best sellers in France. Bourdieu matched his status as a public intellectual with political activism. He fought social injustice, publicly criticized the inequalities in the French social class structure, and supported better conditions for the working classes and the homeless. He was also closely associated with antiglobalization movements.

Bourdieu produced a large body of work—he authored more than twenty-five volumes—including books and papers on the sociology of culture and taste, education, language, literature, and photography. Among his best-known texts are *An Outline of a Theory of Practice* (1972), *Distinction: A Social Critique of the Judgment of Taste* (1979), and *The Logic of Practice* (1980). Many of his key concepts (for example, habitus and cultural capital) have had a significant and ongoing influence on the humanities as a whole and art history in particular.

Blending structuralist perspectives on social systems with a concern for human agency, Bourdieu seeks to understand patterns of human behavior and how they are generated by and within society. His concept of practice, developed in *An Outline of a Theory of Practice*, strengthens his contention that social patterns of behavior reproduce structures of domination. By practice, Bourdieu refers to the things that people do as opposed to what they say. This is related to his concern with agency: how do individuals contribute to the reproduction of social restrictions and what is possible and not possible to do in a particular cultural context? Bourdieu develops this notion of practice through the corollary concept of habitus. He defines **habitus** as a system of

durable, transposable dispositions, structured structures predisposed to function as structuring structures, that is, as principles of the generation and structuring of practices and representations which can be objectively "regulated" and "regular" without in any way being the product of obedience to rules. (1972, p. 72)

In other words, a habitus is a set of dispositions that generate and structure human actions and behaviors. It shapes all practice and yet it is not experienced as repressive or enforcing. As a mode of behavior, its effects on us typically go unnoticed as one's habitus is an unconscious internalization of societal structures.

A specific habitus comes into focus when social and cultural markers such as occupation, income, education, religion, and taste preferences (food, clothing, music, and art) are juxtaposed. For example, a corporate executive with an advanced college degree, disposable income, season tickets to the opera, and a taste for fine wine, contrasts with the dispositions (habitus) of a blue collar worker with a high school diploma, significant debt, who watches sports on television, and prefers Budweiser to Bordeaux. Bourdieu locates habitus where these dispositions correlate to a particular social group or class. A specific set of such dispositions is what he means by the term habitus.

Knowing the habitus of a particular person—what social group or class they fit into by virtue of a set of dispositions—does not provide the social scientist with predictive power to know what practices a person will engage in. To claim this would be to remove individual agency and valorize structure over practice. Bourdieu criticizes any method that would attempt to remove agency and practice from our understanding of social structure. Similarly, habitus is not a fixed or static system. Distinctions between one habitus and another, he asserts, are not rigidly set, but have a shared and processual quality. Moreover, dispositions are multiple—we may, for example, apply one set of dispositions in our home life and another while at work—and changeable over time.

How does one acquire a particular habitus? Bourdieu describes this process as one of informal, unconscious learning rather than formal instruction. One learns to inhabit a habitus through practical means, such as using a particular space for a specific purpose, listening to music, cooking, drinking, wearing clothes, driving cars, and giving gifts. The habitus one occupies shapes

the practices that one participates in. For Bourdieu, the notion of habitus reveals that while a person's behavior may be in part determined by formal social rules and mental ideas—which are to be uncovered and described by the social scientist—a significant determinant of behavior is hidden. This hidden factor is the implicit knowledge learned informally and embodied in specific social practices. Once internalized, habitus dispositions are taken for granted. Bourdieu uses the term **doxa** to refer to the taken-for-granted, unquestioned, unexamined ideas about social life that seem to be common sense and natural to the one possessing these dispositions.

Central to this concept of habitus is how Bourdieu conceives of the relationship between the structure and the agent. He theorizes habitus as an alternative to notions such as consciousness or subjectivity. Interestingly, one of his earliest uses of the term occurs in the Postface to his French translation of Erwin Panofsky's *Gothic Architecture and Scholastic Thought*, which includes Panofsky's famous essay on the Abbey Church of Saint-Denis. Bourdieu published his translation in 1967 and the use of the term habitus in this art and architectural context provides an early indication of the importance of these fields to Bourdieu's work. Two elements are significant here. First, how the Romantic notion of the artist as creative genius is negated by the concept of the habitus. Second, how habitus allows Bourdieu to recuperate an element of individual agency through its implicit critique of Ferdinand de Saussure's structuralism, which sacrifices agency to the structure of language as such. Habitus locates an individual in concrete social situations without foreclosing on his or her agency. Bourdieu discusses habitus as a "system of dispositions—a present past that tends to perpetuate itself into the future by reactivation in similarly structured practices" (1980, p. 54). Although habitus is a result of inculcation, Bourdieu does not deny its potential reinscription by one of its members. Habitus is often referred to by Bourdieu as "practical sense" (*sens pratique*). It is this sense that allows for strategy and the existence of agonistic positions.

Bourdieu's concept of habitus, therefore, is not simply a process of socialization or enculturation into a set of practices; it also takes into account the power relations that exist between social classes; that is, with how social inequality is perpetrated and maintained. Habitus is Bourdieu's unique version of ideology. It contrasts the different sets of dispositions (social expectations, lifestyle choices,

and so forth) that exist between different classes. Class distinctions appear clearly in the complex of practices embedded in a particular habitus. This is socially powerful, according to Bourdieu, because class inequalities and the dominance of one class over another occur covertly. Symbolic power is deployed to maintain class distinctions and the appearance of their naturalness. Social class is defined by Bourdieu as "the unity hidden under the diversity and multiplicity of the set of practices performed" (1979, p. 101). Thus, money may have economic exchange value, but it also has symbolic exchange value in that its possession marks one as wealthy and upper class or poor and lower class. Although the economic system of exchange is controlled by the dominant class, it alone does not define social class because rather than the application of overt force there are a "diversity and multiplicity" of social practices at work that define social class.

In order to explain the relation between habitus and social class more fully, Bourdieu reinscribes the economic term capital as that which not only refers to financial assets but also to other resources that confer status and social class. Of course, financial capital matters for the establishment of class distinctions, but so does cultural capital, which Bourdieu best defines in *Distinction*. **Cultural capital** never forfeits its analogy with economic capital, but it refers to a familiarity with objects and practices in the cultural sphere determined by educational level, linguistic competence, and other forms of capital that mark a social class. Cultural capital is used to distinguish and maintain class distinctions and, by extension, social inequality.

Bourdieu defines the arena in which cultural capital flows and accrues value as the **field of cultural production**. This concept of field (*champ*) is related to habitus in that it is a structural social formation. Each field—whether it is the artistic field or the judicial field—has its own laws and standards. Thus, a field is not entirely independent of the economics, each field is, however, "structurally homologous" to every other, including the field of economic production and exchange value. Bourdieu develops this concept of field because it allows him to discuss an agent's actions, which are grounded in objective social relations—they occur in a field—without reducing them to strict determinism. In other words, the agent's actions do not merely passively reflect the larger underlying and determinate economic base, as in Marxist discourse for

instance. Bourdieu breaks with the ideology of the transformative subject as well as socioeconomic determinism. His theory attempts to keep the strengths of each position through an elaboration of the refractive and prismatic means by which structural limitations and their potential inflections traverse a field. For Bourdieu, the logic of the field is structural and yet not conscious. It is defined by antagonism, challenges, threats, and discord. It is here that change and inflection become possible. The field of cultural production, which is central to any discussion of art history, both produces and reproduces its origins, laws, and values, yet it remains contingent and open to reinscription.

The field of cultural production and the wielding of cultural capital color all of Bourdieu's sociological analyses of art. To interpret social class distinction Bourdieu relies on the notion of "cultural competence" to challenge the traditional notion of aesthetic experience. Rather than accepting that aesthetic experience is unique, for instance, Bourdieu's work sets about mapping the "artistic field" in which our traditional notion of aesthetics was initially conceived. He explains the concept of "aesthetics" in terms of its historical invention and preservation as well as its current conditions and consequences of its use. To this end, Bourdieu forwards the notion of cultural competence, a radical critique of Kantian aesthetics and the artistic field it inaugurated. Bourdieu explains how the perception of a work of art is far from "disinterested." It is determined in large part by the perceiver's habitus. It is Bourdieu's work on cultural competence and taste that reformulates how we conceptualize and discuss both the imagined and embodied viewer of a work of art.

Bourdieu employs the category of **taste** to describe how distinctions between high and low culture are made and justified. In his own research, he found a correlation between French aesthetic preferences for the arts on one hand and "taste" preferences for such things as food and fashion on the other. He concluded that such tastes, like other forms of cultural capital, serve to demarcate class differences. Because taste marks distinctions between different levels of socioeconomic status and of cultural competence, it is also an ideological category. Thus, for Bourdieu, distinctions based on taste are part of the arsenal for differentiating social classes: "Taste classifies, and it classifies the classifier. Social subjects, classified by their classifications, distinguish themselves by the

distinctions they make, between the beautiful and the ugly, the distinguished and the vulgar, in which their position in the objective classification is expressed or betrayed" (1979, p. 6).

The manner in which the artistic field is laced with social class distinction and how it is premised on cultural competence is made evident in Bourdieu's studies of the modern museum. The founding of the modern museums of Europe and North America are clear examples of the "homology" between cultural and economic capital. Moreover, despite its pretense of democratic universalism, the modern museum does not erase but rather produces social class distinctions. While they may provide physical access to artworks (the repeated *raison d'être* of civic museums), there is a limiting factor: cultural competence. In *The Love of Art: European Art Museums and Their Public* (1969) and elsewhere, Bourdieu addresses the consequences of cultural competence as a code, acquired through one's habitus and education, that frames cultural knowledge and one's disposition toward art. He writes that "faced with scholarly [or artistic] culture, the least sophisticated are in a position identical with that of ethnologists who find themselves in a foreign society and present, for instance, at a ritual to which they do not hold the key" (*The Field of Cultural Production*, 1969, p. 217). An extension of this insight concerning the particularity and tendentious experience of the "aesthetic," which makes evident the ramifications of one's social class in any experience of art, is seen in how instrumental Bourdieu's work has been in the discourse of Institutional Critique Art, a political strain of Minimalist and Conceptual Art practices. Begun in the late 1960s, this mode of artistic practice functions as a critical autoethnography that attempts to disclose the economic, gender, and racial biases of the putative neutral space of the "white cube" of the museum or gallery. This is done in order to reveal the "structural homology" between the artists, dealers, critics, and collectors who comprise the artistic field and the economic, political, and juridical ones. It is notable that Hans Haacke, one of the earliest practitioners of Institutional Critique Art, cowrote a book with Bourdieu titled *Free Exchange* (1992). Also, it is important to note that Bourdieu's concept of the artistic field differs from the art historian Arthur Danto's notion of the "artworld," which often serves as the backdrop for discussions of this type of critical art practice.

To conclude, it is clear that Bourdieu's work has indelibly marked art historical discourse, especially his work on photography, the modern museum, and cultural capital. Also, his essay "Manet and the Institutionalization of Anomie," which is to be found in *The Field of Cultural Production*, enters into a dialogue with the work on Manet done by other critical theorists such as Georges BATAILLE and Michel FOUCAULT. But perhaps the most important contribution Bourdieu's work makes to art history is his methodology itself. In the text *In Other Words: Essays Towards a Reflexive Sociology*, he argues:

> The theory of the field [leads] to both a rejection of the direct relating of individual biography to the work of literature (or the relating of the "social class" of origin to the work) and also to a rejection of internal analysis of an individual work or even of intertextual analysis. This is because what we have to do is all these things at the same time. (p. 147)

This exemplifies how Bourdieu raises the interpretative stakes for art history and criticism. Rejecting any form of immanent analysis, whether it is Jean BAUDRILLARD's fetishization of signs or Derrida's deconstructive practice, Bourdieu insists upon an interdisciplinary sociology of the work of art and its particular historical field that challenges both art for art's sake aestheticism and the determinant structuralist readings given by psychoanalysis or Marxism. The simultaneity that defines the existence of an artwork within a field of cultural production, coupled with the understanding of habitus and the cultural competence of the viewer, demands nothing short of a total analysis of the production, circulation, and consumption of artworks as cultural capital.

Further Reading

By Bourdieu

1965. *Photography: A Middle-Brow Art*, translated by Shaun Whiteside. Stanford, CA: Stanford Univ. Press, 1990.

1969. *The Love of Art: European Art Museums and Their Public*, translated by Caroline Beattie and Nick Merriman. Stanford, CA: Stanford Univ. Press, 1990.

1969. *The Field of Cultural Production: Essays on Art and Literature*, edited by Randal Johnson. Cambridge, UK: Polity Press, 1993.

1972. *An Outline of a Theory of Practice*, translated by Richard Nice. Cambridge, UK: Cambridge Univ. Press, 1977.

1979. *Distinction: A Social Critique of the Judgment of Taste*, translated by Richard Nice. Cambridge, MA: Harvard Univ. Press, 1984.

1980. *The Logic of Practice*, translated by Richard Nice. Stanford, CA: Stanford Univ. Press, 1990.

1987. *In Other Words: Essays Towards Reflexive Sociology*, translated by Matthew Adamson. Stanford, CA: Stanford Univ. Press, 1990.

1992. *The Rules of Art: Genesis and Structure of the Literary Field*, translated by Susan Emanuel. Stanford, CA: Stanford Univ. Press, 1996.

1992. Bourdieu and Hans Haacke. *Free Exchange*. Cambridge, UK: Polity Press, 1995.

About Bourdieu

Becker, Howard S. *ArtWorlds*. Berkeley: Univ. of California Press, 1982.

Danto, Arthur. "The Artworld." *Journal of Philosophy* 61.19 (October 1964): 571–584.

Heinich, Nathalie. *The Glory of Van Gogh: An Anthropology of Admiration*, translated by Paul Leduc Browne. Princeton, NJ: Princeton Univ. Press, 1996.

Jenkins, Richard. *Pierre Bourdieu*. Rev. ed. London and New York: Routledge, 2002.

Johnson, Randal. "Editor's Introduction: Pierre Bourdieu on Art, Literature and Culture." In *The Field of Culture Production*. Cambridge, UK: Polity Press, 1993.

Lane, Jeremy F. *Pierre Bourdieu: A Critical Introduction*. London: Pluto Press, 2000.

Robbins, Derek. *The Work of Pierre Bourdieu: Recognizing Society*. Buckingham and Philadelphia: Open Univ. Press, 1991.

Shusterman, Richard, ed. *Bourdieu: A Critical Reader*. Oxford: Blackwell, 1999.

Swartz, David. *Culture and Power: The Sociology of Pierre Bourdieu*. Chicago: Univ. of Chicago Press, 1997.

Webb, Jen. *Understanding Bourdieu*. London: Sage, 2002.

Wilson, Elizabeth. "Picasso and Pâté de Foie Gras: Pierre Bourdieu's Sociology of Culture." *diacritics* (Summer 1988): 47–60.

JUDITH BUTLER

Key Concepts

- gender
- performativity
- gender trouble
- paradox of subjection

Judith Butler (b. 1956) is Maxine Elliot Professor in the Departments of Rhetoric and Comparative Literature at the University of California, Berkeley. She received her Ph.D. in philosophy from Yale University in 1984. Her interest in philosophy stems from her Jewish upbringing and the questions it raised concerning ethics and human life in the aftermath of the Holocaust. Her first major publication was a study of Hegel in contemporary French philosophy titled *Subjects of Desire: Hegelian Reflections in Twentieth-Century France* (1987). After this her work became more focused on ethics and identity, especially gender identity. Butler is one of the most important feminist and political philosophers of her generation.

Her most influential work to date, *Gender Trouble: Feminism and the Subversion of Identity* (1990), makes the powerful argument that neither **gender** nor sex is natural, nor are they categories of human identity. At the time of its publication, this was a major challenge to the then common position among feminists that gender (masculinity and femininity) is culturally constructed, whereas sex (male and female) is natural and pregiven. Butler counters that "gender must ... designate the very apparatus of production whereby the sexes themselves are established. As a

result, gender is not to culture as sex is to nature; gender is also the discursive/cultural means by which 'sexed nature' or a 'natural sex' is produced and established as ... prior to culture, a politically neutral surface on which culture acts" (p. 7). In other words, there is no male and female prior to the cultural engendering of these two categories of identity. "Male" and "female" identities are as culturally determined as "masculinity" and "femininity." That sexual identity is natural, that there are two sexes in nature, is a cultural construct.

Butler argues that these categories of identity take social and symbolic form in a culture through repeated iteration. Sexual identity is **performative**. "There is no gender identity," she writes, "behind the expressions of gender... identity is performatively constituted by the very 'expressions' that are said to be its results" (p. 25). Gender is not a category of ontology, rather a subject enacts its identity through language, actions, dress, and manner. It is not who you are but what you do. Gender is constructed through performative iterations.

Butler is critical of forms of feminism that posit "women" as a group with a distinct identity, set of political interests, form of social agency, and so on. In making such assertions, she contends, feminism risks reinforcing a binary conception of gender, thereby reducing the possibilities of social identity for human beings to only two categories, man and woman, defined in opposition to one another. Here Butler's strained dialogue with Luce IRIGARAY, Julia KRISTEVA, and psychoanalytic discourse is most clearly felt. Writing from a historical context informed by poststructuralist thought, Butler calls for performances of identity that produce **gender trouble** within the social and symbolic order; that is, drawing out the contradictions and excesses within oneself—the parts that do not "come together" into a simple, unified whole— and acting out a multiplicity of gendered and sexual identities. The goal here is to undermine the binary oppositions that produce gender and sexual identity so as to open up new forms of social and ethical agency in the world.

In developing her theory of performativity, Butler draws on Michel FOUCAULT's theory of power. Arguing against a reductive view of power as the dominant force of law, Foucault conceives of power as a "multiple and mobile field of force relations, wherein far-reaching, but never completely stable, effects of domination are produced"

(*The History of Sexuality*, vol. 1: *An Introduction*, 1976, 102). Power takes form within society through ceaseless struggles and negotiations. It does not simply come down from on high but rather it circulates through society. In the process it materializes or takes a "terminal form" within a particular sociopolitical system of power/knowledge. Yet the "terminal forms" power takes are not entirely stable because they can never contain or totalize all the actual and potential forces within it. Although they appear to us as terminal and fixed, they are, in fact, temporary and contingent. There are always points of resistance that cut across the social order and its stratifications of power and privilege, opening possibilities for subversion.

In *Gender Trouble* and *Bodies That Matter: On the Discursive Limits of "Sex"* (1993), Butler develops Foucault's insights into the formation and subversion of terminal forms of power into a psychoanalytically informed interpretation of gender and sexual identity politics. She conceives of every social and symbolic order as a regulatory consolidation of power in the Foucauldian sense. Such an order is established and maintained by prohibitions and repeated performances of identities within that order. Yet, as Butler puts it, to be constituted within such an order is not to be determined by it. There is always the possibility of agency, of acting out within the system in ways that are subversive and transformative of it, because there are always aspects of oneself that are "socially impossible," that cannot be reduced to the order of things, that exceed any particular identity within that order. Hence her serious interest in drag, cross-dressing, and other forms of gender trouble.

Butler's call "to recast the symbolic" is a *de facto* political gesture (p. 22). Her thinking about performativity is inseparable from her political positions. These come across clearly in the dialogues she has with Ernesto Laclau and Slavoj Žižek collected in *Contingency, Hegemony, Universality: Contemporary Dialogues on the Left* (2000). Butler has argued that

> [t]he incompletion of every ideological formulation is central to the radical democratic project's notion of political futurity. The subjection of every ideological formation to a rearticualtion of these linkages constitutes the temporal order of democracy as an incalculable future, leaving open the production of new subject-positions, new political signifiers, and new linkages to become the rallying points for politicization. (1993, p. 193)

The intricacies of this position are best understood through her discussion of subjection. In *The Psychic Life of Power* (1997), Butler engages Foucault, **FREUD**, **LACAN**, **ALTHUSSER**, and others to explore further the issue of agency within the social and symbolic order, which she terms the "**paradox of subjection**." The paradox lies in the fact that subjectivity is founded on subjection. That is, in order to become an acting subject in a society one must be subjected to its order (for example, its language, laws, or values). Irigaray describes the symbolic order as "a certain game" in which a woman finds herself "signed up without having begun to play" (*Speculum of the Other Woman*, 1974, p. 22). So it is, in fact, with all forms of subjectivity. One acts within a certain social and symbolic order, a "game" with certain rules to which and by which one is initially "subjected." Paradoxically, it is this subjection that makes subversion possible. Butler writes: "Subjection signifies the process of becoming subordinated by power as well as the process of becoming a subject…. A power exerted on a subject, subjection is nevertheless a power assumed by the subject, an assumption that constitutes the instrument of that subject's becoming" (1997, pp. 2, 11). Simply put, to be conditioned or formed by a certain terminal form of power is not to be determined by it. A subject's agency, she insists, one's exercise of power, is not "tethered" to the constitutive conditions. The subject is an effect of power and yet power itself can become the effect of the subject.

Butler has applied her theoretical interests in identity politics, subjectivity, and power to the issues of ethics and violence in the aftermath of September 11, 2001. In particular, she focuses on media representations of the "face of the enemy." How is it that America's enemies have been othered in such a way as to render them inhuman and their lives ungrievable, thereby turning us away from the reality of life as fragile and precarious? In exploring these issues, Butler draws on the work of Emmanuel **LEVINAS**, especially his concept of the face-to-face encounter as the ultimate ethical situation, a moment of obligation to the other, whose pleas for clemency reverberate with the commandment "thou shall not kill." Media representations reduce the face of the other to the enemy (both as target and as victim of war) and thereby deny the possibility of a genuine face-to-face encounter. The ethical imperative is foreclosed in this fashion. In a series of questions that also refer to Giorgio **AGAMBEN**'s notion of "bare life," Butler

asks how one conceives of life in the aftermath of a trauma and, more importantly perhaps, how does one live up to the ethical possibility of bearing witness to the dehumanized face of alterity?

The ethical and political implications of Butler's theory of identity politics have brought questions regarding the visual representations of the gendered subject into the foreground. Her importance to queer theory and feminist studies has made her indispensable to art history. The insight that there is no gender-neutral art historical knowledge has added another inflection to the intersection of art history and feminism. Feminist art historians such as Griselda Pollock and Linda Nochlin made the initial inroads into the resolutely gendered matrix of art historical discourse, but the inclusion of Butler's work has influenced another generation of feminist art historians (which include males). For example, Amelia Jones's work on Marcel Duchamp and Performance Art is certainly informed by Butler's work. Therefore, it is both in the discourse surrounding the interpretation of representations of gender as well as in the epistemological reinscription of the discipline of art history—a masculinist and yet curiously homosexual enterprise from its inception with Wincklemann—that the weight of Butler's work is felt.

Further Reading

By Butler

Subjects of Desire: Hegelian Reflections in Twentieth-Century France. New York: Columbia Univ. Press, 1987.

Gender Trouble: Feminism and the Subversion of Identity. London and New York: Routledge, 1990.

Butler and Joan W. Scott, eds. *Feminists Theorize the Political.* London and New York: Routledge, 1992.

Bodies That Matter: On the Discursive Limits of "Sex." London and New York: Routledge, 1992.

Excitable Speech: A Politics of the Performative. London and New York: Routledge, 1997.

The Psychic Life of Power: Theories of Subjection. Stanford, CA: Stanford Univ. Press, 1997.

"Ruled Out: Vocabularies of the Censor." In *Censorship and Silencing: Practices of Cultural Regulation,* edited by Robert C. Post. Los Angeles: Getty Research Institute for the History of Art and the Humanities, 1998.

"Subversive Bodily Acts." In *Spectacular Optical,* edited by Sandra Antelo-Suarez and Michael Mark Madore. New York: Trans/Art, Cultures, Media, 1998.

The Judith Butler Reader, edited by Sara Salih. Oxford: Blackwell, 2004.

Precarious Life: The Powers of Mourning and Violence. New York: Verso, 2004.

About Butler

Benhabib, Seyla. *Situating the Self: Gender, Community and Postmodernism in Contemporary Ethics*. London and New York: Routledge, 1992.

Davis, Whitney. "Gender." In *Critical Terms for Art History*, edited by Robert S. Nelson and Richard Schiff. Chicago: Univ. of Chicago Press, 1996.

Jones, Amelia, ed. *The Feminism and Visual Culture Reader*. London and New York: Routledge, 2003.

GILLES DELEUZE AND FÉLIX GUATTARI

Key Concepts

- rhizome
- schizoanalysis
- deterritorialization
- desiring/machines
- concepts
- percept
- affect

Gilles Deleuze (1925–1995) was born in France and, after a long illness, committed suicide in November 1995. He studied at the Sorbonne under Georges Canguilhem and Jean Hyppolite. He proceeded to teach philosophy at the Sorbonne, the University of Lyon, and at the invitation of Michel **Foucault**, at the experimental University of Paris VIII at Vincennes. He retired in 1987. Deleuze was a prolific writer, penning individual monographs—which he termed a "philosophical geography"—on philosophy, literature, and art. This work includes important studies of the history of philosophy on **Nietzsche**, Bergson, Spinoza, Proust, Leibniz, as well as critiques of Kantian and Platonic thought. His work radically rethinks issues such as representation, linguistic meaning, subjectivity, and difference.

Félix Guattari (1930–1992) was a practicing psychoanalyst and political activist. He embraced both radical psychotherapy

or "antipsychiatry" (working at the Clinique de la Borde from 1950 until his death) and Marxist politics, though he became disillusioned with the French Communist Party after the May 1968 strikes. He received his training with Jacques LACAN at the École freudienne de Paris and underwent analysis with him from 1962 to 1969. His close association with Lacanian psychoanalytic theory was strained when Guattari later critiqued some of the central aspects of psychoanalytic thought. In addition to his work with Deleuze, Guattari individually published works on psychoanalytic theory and collaborated with other Marxist thinkers and psychoanalysts.

Deleuze and Guattari met in 1969 and started working together soon after. Their collaborations include four books that are especially noteworthy for their dual critique of Marxist and Freudian thought: *Capitalism and Schizophrenia*, vol. 1, *Anti-Oedipus* (1972), vol. 2, *A Thousand Plateaus* (1980), *Kafka: Toward a Minor Literature* (1975), and *What Is Philosophy?* (1991). In the two volumes of *Capitalism and Schizophrenia*, Deleuze and Guattari attempt to undermine essentialism and the grand structuralist narratives of MARX and FREUD. A focal part of this attempt to undermine essentialist thought is made evident by their collaboration itself. Guattari's involvement at the Clinique de la Borde centered on experimentation aimed at ending the doctor/patient hierarchy through a collaborative and dynamic methodology. This can be seen as the model for their radical multivocal writing efforts. Collaboration as a method of inquiry defines a key strain of poststructuralist thought. At the beginning of *A Thousand Plateaus* they offer the following explanation of their work together: "Since each of us was several, there was already a crowd.... To reach, not the point where one no longer says I, but the point where it is no longer of any importance whether one says I. We are no longer ourselves. Each will know his own. We have been aided, inspired, multiplied" (p. 3). Echoing the French poet Arthur Rimbaud's famous declaration that "I is an other," Deleuze and Guattari present their work as an open system, as a discussion rather than an authoritative tract. It is the product of a multiplicity without unity because there is no author in the traditional sense whose style or biography grounds the work. This only strengthens their insistent critiques of modernist ideas concerning the primacy of hierarchy, truth, subjectivity, and representation. The collaborative effort is designed to induce encounters and connections, a folding and unfolding of a line of

thought so as to instigate another becoming—a "line of flight." Although the many neologisms they employ are more suggestive than definitive, there is one polyvalent concept that covers a lot of ground: the **rhizome**.

They refer to their collaborations as "rhizome-books." "We call a 'plateau' any multiplicity connected to other multiplicities by superficial underground stems in such a way as to form or extend a rhizome. We are writing this book as a rhizome. It is composed of plateaus," they insist (1980, p. 22). A rhizome is a botanical term referring to a horizontal system (like crabgrass), usually underground, that sends out roots and shoots from multiple nodes. It is not possible to locate a rhizome's source root. Rhizomatic thinking, for Deleuze and Guattari, contrasts with aborescent (treelike) thinking that develops from root to trunk to branch to leaf. Aborescent modes of thought, according to them, are especially characteristic of the grand narratives of modernist, capitalist thought (see **LYOTARD**). Resisting these tendencies, their rhizomatic texts create concepts to describe ways of seeing and understanding of both individual subjects and larger institutional entities. In order to destabilize what they refer to as fascist ways of acting in the world, they arm themselves with concepts like the rhizome, which demand that we think and conceptualize outside established, hegemonic, and naturalized modes of modern common sense.

It is important to note that despite the tendency to associate Deleuze and Guattari with postmodernism, they did not themselves see their intellectual project in this light. Guattari, for instance, repudiated postmodernism as "nothing but the last gasp of modernism; nothing, that is, but a reaction to and, in a certain way, a mirror of the formalist abuses and reductions of modernism from which, in the end, it is no different" (Guattari, 1986, p. 109). From here we can see that, according to Deleuze and Guattari, their primary target is the aborescent mode that has dominated Western thought. This is the mode of thought that defines modernism: a "formalist abuse and reduction" in that it naturalizes hierarchic orders and gives priority to teleologic narratives of origin. Rhizomatic thinking, on the other hand, suggests a nonhierarchy of polyphonic narratives without origin or central root to serve as the source. "A rhizome," they argue, "has no beginning or end; it is always in the middle, between

things, interbeing, *intermezzo* ... the fabric of the rhizome is the conjunction, 'and ... and ... and'. This conjunction carries enough force to shake and uproot the verb 'to be'" (1980, p. 25). The concept of the rhizome is unlocalizable; it is always between things, an "acentered, nonhierarchical, nonsignfying system" that, unlike a structure which is formed by points and positions, is composed of "lines of flight" or "**deterritorializations**," that is, "all manner of 'becomings'" (1980, p. 21). Thus, rhizomatic thinking is a philosophical concept premised on difference and chance, time and not space, becoming rather than being. Without beginning or end, rhizomatic thinking disrupts; it is a play of forces and forms.

To unearth aborescent thought is to question the modern foundations of the human subject. Aborescence constructs the world in terms of freely choosing, autonomous, individual entities. In such a mode of thought, subject/object dichotomies are determinant. Deleuze and Guattari insist upon subverting this order through rhizomatic thinking. The rhizome is a conceptual force that undermines the dominant, transcendent interpretations of human subjectivity and history by cultivating heterogeneous relationships. They oppose these transcendent models (for example, Freudian psychoanalysis) with an immanent mode of interpretation in which becoming is not foreclosed upon, but remains in play.

In *Anti-Oedipus*, Deleuze and Guattari take up the political nature of desire. In many ways this text broke the unquestioned bond that existed in France between psychoanalysis and leftist political parties. They attacked this alliance because it posed a new threat, an authoritative, centralized, fascism of reason—a "state philosophy" that inhibits becoming. Their critique of institutional psychoanalysis as well as their simultaneous creation of a post-Freudian materialism is accomplished with the concept of **schizoanalysis**, a rhizomatic alternative to the aborescent thinking of psychoanalysis. In their schizoanalytic polemic against Freud (and by extension Lacan), they refute his negative notion of desire as lack, which the founder of psychoanalysis explained through the conceptual framework of the Oedipus complex. For Freud, the Oedipus complex is universal and ahistorical; it is a putatively natural human disposition. For Deleuze and Guattari, this framework is repressive because it subjects everyone to the same transcendent structure (mother-father-child). Rather than

viewing the unconscious as characterized by desire as lack, they understand the unconscious as productive of desire and hence it falls victim to the repressive control of the capitalist state. In analysis, the immanent interpretation of individuals is recast into the transcendent interpretation of Freudian desire, the family triangle. The individual is thereby subjected to the repression and restraint of the psychoanalytic framework, and the patient is subjected to the interpretation of the powerful and authoritative analyst.

Libidinal impulses are instead to be understood as desire-producing and therefore potentially disruptive of a capitalist state, which wants to control desire and cast it in negative terms. By extension, culture, language, and other symbolic systems are also repressive because they subject people to their rules and codes. State and cultural institutions think in binary terms, thereby limiting multiplicity, becoming. In an interview conducted with Deleuze and Guattari in 1972, Deleuze explains:

> [*Anti-Oedipus*] is both a criticism of the Oedipus complex and psychoanalysis, and a study of capitalism and the relations between capitalism and schizophrenia. But the first aspect is entirely dependent on the second.... We're proposing schizoanalysis as opposed to psychoanalysis: just look at the two things psychoanalysis can't deal with: it never gets through to anyone's desiring machines, because it is stuck in oedipal figures or structures; it never gets through to the social investments of the libido, because its stuck in its domestic investments. (*Negotiations*, p. 20)

In traditional psychoanalysis, the analysis is always predetermined. The analysand is subjected to the oedipal framework. Schizoanalysis, on the other hand, is rhizomatic because it "treats the unconscious as an acentered system" and "the issue is to *produce the unconscious*, and with it new statements, different desires: the rhizome is precisely this production of the unconscious" (1980, p. 18). The conceptual persona of the schizophrenic is privileged by Deleuze and Guattari because it exemplifies fragmented subjectivity and "a desire lacking nothing, a flux that overcomes barriers and codes, a name that no longer designates any ego" (1972, p. 131). It is the relation the schizophrenic has to desire that serves as the basis of schizoanalysis.

Desire is not conceived of as something to be repressed or contained, rather it is a flow that exists prior to any representation of desire in psychoanalysis, prior to any subject/object relation. In traditional psychoanalysis, desire is "territorialized" through political and ideological structures like family, religion, school, medicine, media, and so forth. What Deleuze and Guattari posit is a "deterritorialized" desire. Deterritorialization is desire as flow; it opens up the possibility of multiple ways and directions at once, regardless of socially sanctioned boundaries that only seek to domesticate the flow of desire. Deterritorialized desire produces without structure because it is rhizomatic.

It is in the midst of this discussion of deterritorialization that Deleuze and Guattari forward their concept of **desiring-machines**. This refers, in part, to the idea that desire stems from a moment prior to structure and representation. Bodies are desiring-machines in which such things as ideas, feelings, and desires flow in and out of the body-machine and into and out of other desiring-machines. The desiring-machine is an impersonal concept that serves to negate the personal, subjective representations of the unconscious given in Freud's domestic/theatrical metaphor of *"ein anderer Schauplatz"* and even Lacan's contention that the unconscious is structured like a language.

Schizoanalysis, therefore, seeks to deterritorialize the structures of desire presented by psychoanalytic thought. It resists any discrete, hierarchical structuration, in favor of a fragmented, porous space in which boundaries are fluid, desire flows in multiple directions, and there is no "subject" (as in a being) other than becoming. Schizoanalysis is an attempt to construct a plane of immanence as a means to exit from the "mucky little kingdom" of "state philosophy" (*Negotiations*, p. 17).

Deleuze and Guattari's philosophy is an open system of concepts that relate to circumstances, situations—events—rather than essences. **Concepts** (for example, the Cartesian *cogito*) are not given, but must be created and invented. In this fundamental act of philosophy—the creation of concepts—philosophers are creative and reflective. In this they are inextricably linked to scientists and artists. These connections are discussed in *What Is Philosophy?* which marks the final collaboration of these two men.

The thinking on art presented in this last collaborative text is adumbrated in *A Thousand Plateaus*, where Deleuze and Guattari

develop concepts such as the smooth and striated, the white canvas and the black hole. Art originates in the middle—it is in medias res—between the black hole (chaos) and the white wall. "Even when painting becomes abstract, all it does is rediscover the black hole and the white wall, the great composition of the white canvas and the black slash. Tearing, but also stretching of the canvas along the axis of escape (*fuite*), at a vanishing point (*point de fuite*), along a diagonal, by a knife slice, slash, or hole," they write (1980, p. 173). This line of thought returns in *What Is Philosophy?* where they discuss artists and writers as varied as Cézanne, Monet, Melville, and Wordsworth all under this concept of black hole and white wall, chaos and the structures of perception. They argue that art, philosophy, and science want to "tear open the firmament and plunge into chaos":

> Painters go through a catastrophe, or through a conflagration, and leave the trace of this passage on the canvas, as of the leap that leads them from chaos to composition.... It is as if the *struggle against chaos* does not take place without an affinity with the enemy, because another struggle develops and takes on more importance—the *struggle against opinion*, which claims to protect us from ourselves. (1991, p. 203)

Here we can see several recurring strands of thought: deterritorialization, distancing, folding and unfolding, forgetting the status of the structure (whether it is visual and linguistic representation). This thesis concerns the "plane of composition" art constructs, and in which becoming remains a potentiality. Challenges to this potentiality arise when art criticism denies the possibility of this becoming by not addressing the "composition of chaos"—how artists can "tear open the firmament itself, to let in a bit of free and windy chaos and to frame in a sudden light a vision that appears through the rent"—and instead merely "patch over the rent with opinions: communications" (1991, pp. 203–204). Art, as a becoming or an emergence, must present sensations, not the familiar; it must be allowed to present a bit of the chaos—to compose chaos itself. Deleuze and Guattari assert that the institutional structures of art historical discourse more often than not fail the composition of art because they interpret it as representation, as another instance for opinion and judgment, rather than as another potentiality for becoming otherwise.

One critique of this position may be that it romanticizes the role of the artist, uncritically accepting the fiction of the artist as agonistic seer. But Deleuze and Guattari match their assertions about the artist and his or her role with a pair of concepts they deploy to aid in explaining everything from Baroque art to the twentieth-century painting of Francis Bacon. (Note: extended discussions of these subjects appear in monographs Deleuze wrote alone: *The Fold: Leibniz and the Baroque* [1988] and *Francis Bacon: The Logic of Sensation* [1981].) This pair of concepts is the percept and the affect.

Deleuze and Guattari develop their understanding of the percept and the affect in *What Is Philosophy?* but Deleuze first addressed them in his two volumes on cinema. The work of art, as we have seen, is a preservation of chaos in a bloc of sensation; the work of art is a plane of composition. In an argument that echoes Martin HEIDEGGER's "The Origin of the Work of Art" (1935–1936), Deleuze and Guattari posit that

> art is the language of sensations. Art does not have opinions. Art undoes the triple organization of perceptions, affections, and opinions in order to substitute a monument composed of percepts, affects, and blocs of sensations that take the place of language … the language of sensation [is] the foreign language within language that summons forth a people to come (1991, p. 176).

A **percept** is not a perception because it is independent of individual experience; it is "the landscape before man, in the absence of man" (p. 169). Whenever discussing percept, Deleuze and Guattari cite Cézanne's statement about his work: "Man absent from but entirely within the landscape." Percept as the landscape in the absence of the human is tied to becoming; percept is vision, a becoming-animal vision: "to make perceptible the imperceptible forces that populate the world, affect us, make us become" (p. 182). **Affect** is the nonhuman becoming of man. "Affects," they argue, "are no longer feelings or affections; they go beyond the strength of those who undergo them … [it] is not the passage from one lived state to another but man's nonhuman becoming" (pp. 164, 173). They insist that percept and affect are not a return to origins, as if beneath the illusion of civilized perception and affection there

exists another, primitive existence. Rather, it is a question of the here and now; it is a question of finding ourselves immanently within a percept that induces us to become otherwise.

Is it possible to become otherwise, to experience that which is nonhuman? Is it possible to grasp the percept within the artwork as a monument of sensation so that it affects us? With these terms, Deleuze and Guattari pose questions about whether or not new possibilities for life are open to us and, if so, then it is in the deterritory of art, the plane of composition that defines it, that we must find ourselves becoming. It is in this deterritorialized space of becoming that art has always existed, one in which "art does not wait for human beings to begin" (1980, p. 320). The line of becoming "constitutes a zone of proximity and indiscernibility, a no-man's land, a nonlocalizable relation sweeping up the two distant or contiguous points, carrying one into the proximity of the other" (1980, p. 293). This is the plane of composition art constructs: a zone of proximity and indiscernibility between man and animal, space and time. For Deleuze and Guattari, to think art is to think it as a rhizome, as a deterritorializing force that forms percepts and affects, inducing us to become otherwise. The catch, of course, is whether or not art historical discourse is up to the challenge of percept and affect rather than judgment and opinion. The sheer range of references, art historical styles and movements that Deleuze and Guattari ensnare in the conceptual net they cast is impossible to ignore. Moreover, the distance between Kantian aesthetics and the position Deleuze and Guattari unfold could not be starker. Perhaps the future of the intersection between art history and critical theory lies here more than anywhere else.

Further Reading

By Deleuze and Guattari

1972. *Anti-Oedipus: Capitalism and Schizophrenia*, translated by Robert Hurley, Mark Seem, and Helen R. Lane. Minneapolis: Univ. of Minnesota Press, 1983.

1975. *Kafka: Toward a Minor Literature*, translated by Dana Polan. Minneapolis: Univ. of Minnesota Press, 1986.

1980. *A Thousand Plateaus: Capitalism and Schizophrenia*, translated by Brian Massumi. Minneapolis: Univ. of Minnesota Press, 1987.

By Deleuze

1981. *Francis Bacon: The Logic of Sensation*, translated by Daniel W. Smith. Cambridge, MA: MIT Press, 2003.

1981. *Negotiations, 1972–1990*, translated by Martin Joughin. New York: Columbia Univ. Press, 1995.

1983. *Cinema I: The Movement-Image*, translated by Hugh Tomlinson and Barbara Habberjam. Minneapolis: Univ. of Minnesota Press, 1986.

1985. *Cinema II: The Time-Image*, translated by Hugh Tomlinson and Robert Galeta. Minneapolis: Univ. of Minnesota Press, 1986.

1988. *The Fold: Leibniz and the Baroque*, translated by Tom Conley. Minneapolis: Univ. of Minnesota Press, 1993.

1991. *What Is Philosophy?* translated by Hugh Tomlinson and Graham Burchell. New York: Columbia Univ. Press, 1994.

By Guattari

1986. "The Postmodern Impasse." In *The Guattari Reader*, edited by Gary Genosko. Oxford: Blackwell, 1996.

About Deleuze and Guattari

Badiou, Alain. *Deleuze: The Clamor of Being*, translated by Louise Burchill. Minneapolis: Univ. of Minnesota Press, 2000.

Bogue, Ronald. *Deleuze and Guattari*. London and New York: Routledge, 1989.

Buchanan, Ian, ed. *A Deleuzian Century?* Durham, NC: Duke Univ. Press, 1999.

Hardt, Michael. *Gilles Deleuze: An Apprenticeship in Philosophy*. Minneapolis: Univ. of Minnesota Press, 1993.

Massumi, Brian. *A User's Guide to Capitalism and Schizophrenia: Deviations from Deleuze and Guattari*. Cambridge, MA: MIT Press, 1992.

Olkowski, Dorothea. *Gilles Deleuze and the Ruin of Representation*. Berkeley, CA: Univ. of California Press, 1999.

JACQUES DERRIDA

Key Concepts

- deconstruction
- trace
- *différance*
- parergon
- blindness
- trait

Jacques Derrida (1930–2004) was born to a middle-class Jewish family in the Algerian suburb of El-Biar. During World War II, when he was ten-years-old, he and other Jews were expelled from the public school system. Later, with the arrival of Allied forces, Derrida enrolled in a Jewish school. He moved to France when he was nineteen and began his studies at the Grandes École preparatory program where he studied phenomenology with Emmanuel LEVINAS. He went on to teach at the École normale supérieure and the École des hautes études in Paris, in addition he held teaching posts at several American universities, including Johns Hopkins, New York University, and the University of California at Irvine. Throughout his career, Derrida demonstrated a strong commitment to public education, especially through his work with the Research Group on the Teaching of Philosophy, which advocates making philosophy a fundamental discipline in secondary school curricula. His social and political activism were matched by his unparalleled reputation and a critical style that has been often imitated but not reproduced. Derrida's passing in

October 2004 from pancreatic cancer marks a decisive loss for all those who knew him and who were compelled by his work.

It would be impossible to summarize Derrida's work and influence to date, even if we were to limit ourselves to his contributions to philosophy, literary theory, cultural studies, and art history. Yet there is a consistent orientation throughout his many texts. This orientation could be described as a kind of close reading, a relentless attention to how the fundamental presuppositions of Western thought are articulated. Derrida's attention to the paradoxes or aporias of Western thought is undertaken to reveal the uncertainties, instabilities, and impasses implicit in our intellectual traditions, moving us to the edge of knowing, to a point at which "what once seemed assured is now revealed in its precariousness" ("An Interview with Derrida," 1985, p. 110). This is not, as his critics allege, done out of some nihilistic contempt for all things Western or as a result of a masturbatory fascination with groundless intellectual free play. It is done to antagonize our habitual assumptions about "how things are" so as to open up spaces for continued reflection and the possibility of innovative and creative thinking. He treats the Western intellectual tradition as a living discourse and works to keep our intellectual disciplines and educational institutions from ossifying.

This is the proper context in which to understand the term **deconstruction**, a concept that has too often been misunderstood by Derrida's readers, who perhaps do not always read him as well as he reads others. He first used the term in *Of Grammatology* (1967). (The English translation and accompanying introduction were the work of Gayatri Chakravorty SPIVAK.) The term was developed and refined while Derrida was a member of the Yale School of Literary Criticism, along with Harold Bloom, Paul de Man, Geoffrey Hartman, and J. Hillis Miller in the late 1960s and early 1970s. Derrida's usage arose from his dealing with Martin HEIDEGGER's term *Destruktion* or *Abbau*. In French translation, Heidegger's term carries the sense of annihilation or demolition as well as destructuration. When Derrida published his text, the term deconstruction was seldom used in France, where its primary sense was mechanical, referring to the process of disassembly in order to understand parts in relation to the whole. For Derrida, deconstruction was conceived not as a negative operation aimed only at tearing down, but rather as a kind of close analysis that seeks "to understand how

an 'ensemble' was constituted and to reconstruct it to this end" ("Letter to a Japanese Friend," 1983, p. 272). It is in the process of reading closely, with an eye for how a discourse is constructed, that one also comes to see the points of potential instability within the structure. Deconstruction is the event that happens within a close reading. In one of many statements in which Derrida asserts that deconstruction is not a method of analysis or a critique, we read: "Deconstruction takes place, it is an event that does not await the deliberation, consciousness, or organization of a subject, or even of modernity. *It deconstructs it-self. It can be deconstructed. [Ça se déconstruit.]*" (1983, p. 274). Deconstruction happens to both the text at hand, the one being closely read, and to the interpretation itself.

Deconstruction, then, is what happens when one works through a certain logic of thinking in such a way as to reach what that logic cannot admit, what it must exclude, the unthinkable upon which that very logic is premised. Terry Eagleton offers this summation:

> Deconstruction is the name given to the critical operation by which oppositions can be partly undermined, or by which they can be shown partly to undermine each other in the process of textual meaning.... The tactic of deconstructive criticism ... is to show how texts come to embarrass their own ruling systems of logic; and deconstruction shows this by fastening on the "symptomatic" points, the aporia or impasses of meaning, where texts gets into trouble, come unstuck, offer to contradict themselves. (1989, pp. 132–134)

What is crucial to remember here is that Derrida does not pose deconstruction as a proper name, nor as a transcendent interpretative gesture. The happening of deconstruction occurs in the situation of the text and its interpretation, both poles presuppose a limit, a border. "The deconstructive reading," as Barbara Johnson, one of Derrida's early English translators puts it, "does not point out the flaws or weaknesses or stupidities of an author, but the *necessity* with which what he *does* see is symmetrically related to what he does *not* see" (*Dissemination*, 1972, p. xv). This notion of implicit "blindness" plays a central role in Derrida's meditations on art and art history, which we will discuss below.

Throughout his life, Derrida was criticized for writing texts that are too difficult for many readers to understand. He defended

himself by insisting that his texts require so much from the reader because they are fundamentally concerned with questioning precisely those things we think we understand. Derrida's texts are not mere expositions of his ideas, but—in an attempt to undermine even this notion of a representation of ideas—they are performances of his arguments. This performance is a writing, but a writing that does not claim to represent ideas. In an interview conducted in 1990, Derrida explains: "What I do with words is make them explode so that nonverbal appears in the verbal. That is to say that I make the words function in such a way that at a certain moment they no longer belong to discourse, to what regulates discourse.… By treating words as proper names, one disrupts the usual order of discourse" (*Deconstruction in the Visual Arts*, p. 20). For him, this poetic manipulation of the body of language—of its very materiality—is inextricably tied to a bodily performance by the writer.

Derrida first articulates this position in 1967, with the simultaneous publication of three books: *Speech and Phenomena*, a treatise on Edmund Husserl's phenomenology; *Of Grammatology*, a critique of how Western theories of language and communication have privileged speech over writing; and *Writing and Difference*, a collection of essays (some written as early as 1959) offering close readings of major contemporary thinkers including Claude Lévi-Strauss and Georges BATAILLE. With the publication of these texts Derrida emerged as a major force in contemporary philosophy and literary studies. Five years later, in 1972, he published three more texts: *Dissemination*, also on writing with attention paid to Plato, Mallarmé, and Sigmund FREUD; *Positions*, a collection of interviews with him; and *Margins of Philosophy*, readings of and in the margins of philosophical texts.

A year before his first set of texts was published, Derrida gave a lecture at Johns Hopkins University titled "Structure, Sign, and Play in the Discourse of the Human Sciences" (later published in *Writing and Difference*). More than any other, it is this essay that led to the widespread association of Derrida with poststructuralism, a term coined not by Derrida but by American literary scholars who appropriated his theories for their own research.

In this lecture, Derrida situates his work in the aftermath of the intellectual revolution of structuralism, which he views as a transformative moment that destabilized the inherited understandings about language and meaning in Western thought.

He describes this complex transformation as the "moment when language invaded the universal problematic, the moment when, in the absence of a center or origin, everything became discourse ... that is to say, a system in which the central signified, the original transcendental signified, is never absolutely present outside a system of differences" (*Writing and Difference*, p. 280). Here, Derrida expresses his appreciation for the discourse inaugurated by Ferdinand de SAUSSURE while simultaneously pressing the implications of structuralism. Rather than limiting Saussure's model to written or even visual texts, Derrida argues for a "generalized text" in which "reality" as such exists as a kind of indeterminate linguistic flux. This absence of a structural center or ordering (first) principle ("God," "Being," or some other transcendental signified) in language, one that would guarantee meaning and coherence within its system of signification, "extends the domain and the play of signification infinitely," he insists (p. 280). Derrida is not simply undermining Saussurean structuralism in the name of an infinite and unstable play of meaning; rather, he is calling attention to the radical implication of structuralism, namely, that *there is nothing outside language* to control, limit, or direct the play of signification. This reading posits that if signs are not inherently stable, then neither is meaning. It is an ultimate "undecidability" that pervades all language. Contrary to the either–or of structuralism, the ever-presence of these undecidable elements poisons any oppositional logic.

Derrida proceeds to consider what our options are in the wake of the crisis in meaning he has just described. He identifies two responses, two "interpretations of interpretation." On the one hand, there is a melancholic, remorseful nostalgia for origins, a longing for "archaic and natural innocence" that "seeks to decipher, dreams of deciphering a truth or an origin which escapes play ... and which lives the necessity of interpretation as exile" (p. 292). Derrida reads Lévi-Strauss's search for the foundational, structural, elements of myth as an example of this mode of interpretation. On the other hand, there is the exuberant affirmation of play in a world without center or ground or security, as exemplified in the work of Friedrich NIETZSCHE. Both are responses to the modern Western experience of being ungrounded and dislocated. While one longs with nostalgia for that which is forever lost, the other gets lost in limitless, deracinated play.

Perhaps one of the clearest examples of the change brought about by this argument is the visual and textual arrangement of Derrida's performative text *Glas* (1974). This text is comprised of two vertical columns, which are interrupted by quoted statements from different authors. The left-hand column is about G.W.F. Hegel; the right-hand column about the French writer Jean Genet. Derrida desires to open the discourse of philosophy to literature by challenging the traditional notions of authorship and even what constitutes a "literary" work. His method of composition—a kind of radical collage—is taken from artistic practice. The title *Glas* functions as an undecidable. In French the word means "knell" (like the ringing of bells in a "death knell"), but when spoken it sounds like glace, meaning ice, mirror, window. All of these meanings remain in play in Derrida's text, which itself constructs a "hinge" (*brisure*) between literature and philosophy so as to suspend any sense of an impervious border between two disciplines founded on "writing."

The argument Derrida performs in *Glas* stems from his discussion of speech and writing in his earlier work (especially *Of Grammatology*) and it plays a role in his later discussions of art and aesthetics (the undecidable terrain between art history and philosophy). Derrida's early work is an extended mediation on how the boundaries of philosophical discourse are created and sustained, as well as how philosophy conceives of language as a means to arrive at concepts such as "truth" and "presence." Beginning with the privileging of speech over writing that Derrida reads in one of the founding texts of Western philosophy (*Phaedrus* by Plato), he proceeds to cast a rather large net that ensnares everything from poetry to architecture. Derrida argues that speech is conceived as closer to thought, and thus writing is considered derivative, supplemental to speech as thought. Western philosophy is characterized by this logocentrism: a history of speech as presence, or a repression of writing. Derrida's displaces the "origin" (*archē*) of both speech and writing in a concept of "arche-writing," a trace. This is meant to undermine metaphysical thinking by challenging its notion of presence. It is speech that has been given this task of carrying full presence, whereas writing is associated with distance, delay, and ambiguity. By writing a letter to a friend, for instance, the writer is absent and yet the trace of his or her presence is conjured. Neither simply present, nor absent,

the **trace** is undecidable: a play of presence and absence at the very "origin" of any system of meaning. Beyond addressing the inherent instability of language, Derrida's reinscription of "writing" as an undecidable play at work in both speech and writing challenges any discursive structure premised on presence and, by extension, traditional notions of "truth" or "being." Writing, for him, must be iterable—repeatable but with difference. This marks the entrance of Derrida's famous concept of *différance*, signifying how meaning in language is always different and deferred. Writing, for Derrida, signifies an event: the *an-archic* deconstruction of Western philosophy.

By turning his attention to iterability and how meaning is construed as *différance*, Derrida proceeds to argue that not even context can insure the reception of intent in language. No context can enclose iterability. This does not eradicate context, but it can no longer entirely govern or insure meaning. Recall how Derrida's texts are not outside of the texts he reads. Rather than being in a transcendent position of authority, his texts are implicit within the host text he explicates. His strategy, therefore, is one of rehearsal (*répétition* in French). Derrida rehearses or reiterates the texts he reads; he enacts them again in order to deconstruct them. Therefore, as Derrida acknowledges, his texts bear the "traits" of the others. The performances Derrida enacts in his "writerly texts" (see **BARTHES**) aim only at the deconstruction of presence; his work is an extended meditation on the presence-absence of the trace. This meditation is extended to his commentaries on artworks and aesthetics. Derrida's famous discussion of the frame (*parergon*, that which is extrinsic to the work, what is by-the-work) is an extension of his thinking the "hinge" between speech and writing, philosophy and literature.

> This hinge [*brisure*] of language as writing, this discontinuity … marks the impossibility that a sign, the unity of a signifier and a signified, be produced within the plenitude of a present and an absolute presence.… Before thinking to reduce it or to restore the meaning of the full speech which claims to be truth, one must ask the question of meaning and of its origin in difference. Such is the place of a problematic of the *trace*.… To recognize writing in speech, that is to say difference and the absence of speech, is to begin to think the lure. There is no ethics without the presence of *the other* but also, and consequently, without absence, dissimulation, detour,

difference, writing. The arche-writing is the origin of morality as of immorality. The nonethical opening of ethics. A violent opening. (*Of Grammatology*, pp. 69–70, 139–140).

In his later writings Derrida examines ethics, hospitality, and forgiveness (texts where the importance of Levinas is especially felt), but before he turns to these concepts his work encounters aesthetics. In this sense, his notion of writing and ethics passes through the creation and reception of art.

Derrida's interest in what he terms the "spatial arts" receives its most extended discussion in *The Truth in Painting* (1978). Here, he engages the Italian artist Valerio Adami's "Drawings After *Glas*." Adami's work participates in a dialogue with Derrida's performative text; Derrida, in turn, provides a reading of Adami's paintings. The *en abyme* element of this relationship—which Derrida coyly calls a "bargain"—is tied to the practice of deconstruction, but also to Derrida's thoughts on the Kantian sublime, which receive considerable attention in the text. Through his reading of the fragmented, phonetic symbols that pervade Adami's drawings—gl, tr, +R—Derrida argues that this decomposed language signifies the very materiality of language. Because there are so many things one can do with language—with its phonetic semes—it is impossible to saturate a context. There is always already something that exceeds the border—or frame—of the context. Questions concerning the inherent instability of meaning return in Derrida's discussion of Adami's work.

The task Derrida sets himself in *The Truth in Painting* is to interrogate the fundamental concepts of aesthetics. He situates his text in "a matrix of inquiry" that asks "what defines the limits of my domain, the limits of a corpus, the legitimacy of questions, and so on" (*Deconstruction in the Visual Arts*, p. 9). Derrida focuses on the ways in which aesthetic discourse is written, equally shifting between its two disciplinary frames—art history and philosophy. In doing so he extends the scope of deconstruction beyond what is traditionally thought of as "textual." He insists that "the most effective deconstruction, and I have often said this, is one that deals with the nondiscursive, or with discursive institutions that don't have the form of written discourse" (p. 14). However, what Derrida proceeds to do, as suggested by his reading of Adami's work, is to reveal how and why aesthetics is a discursive practice

and what the epistemological and ethical consequences of this *ekphrasis*—the verbal description of an artwork—are.

In a gesture that reminds one of *Glas*, Derrida situates *The Truth in Painting* amid three of the most important texts of aesthetics: Immanuel Kant's *Critique of Judgment* (1790), Hegel's *Lectures on Aesthetics* (1842), and Heidegger's essay "The Origin of the Work of Art" (1935–1936). Derrida begins by simply re-asking the basic questions of aesthetics. What is a work of art? How has our experience of the work of art been described? What are the criteria by which it can be judged or evaluated? Moreover, he is interested in how and why aesthetics has come to be an indispensable arena for the enactment of philosophy. He shows how Kant works with binary oppositions such as understanding/reason and agreeable/ beautiful, and ultimately posits aesthetic judgment as a way to bridge them. For Derrida, Kantian aesthetics is constructed on the model of metaphysical thought, which posits an unassailable foundation or first principle. This first principle is the putative intrinsic value of the aesthetic object—its beauty and meaning. Kant argues that it is this intrinsic value of the aesthetic that one must address at the expense of everything extrinsic; that is, circumstances of production, reception, monetary value, and so forth. The gaze of aesthetic judgment must acknowledge firm boundaries between the intrinsic and extrinsic value of the artwork. This demand is present, Derrida argues, throughout aesthetics, from Plato to Heidegger. It is a discourse, in fact, not on the work of art itself (*ergon*), but rather on its frame, the **parergon**, that which encloses and defines an inside while creating an outside. *Parergon* in Greek signifies what is incidental, what is "by-the-work." The frame of a work of art is what separates the work from what is extrinsic to it, and yet the frame maintains a discourse between this interior and its exterior. In Kant's work, the frame, the room in which a work of art is to be found, and any ornament (for example, drapery) whatsoever, constitute the *parerga*. Derrida divulges that there is no way we can be sure about these imposed limits or borders; the frame functions not as a barrier but as a "hinge" that simultaneously breaks with all that is extrinsic to the work and yet remains connected to it. The initial attempt by aesthetics to define its object of study falls into disarray because without a clearly defined object, the "science of aesthetics" cannot guarantee its concepts of aesthetic experience, judgment, or truth. The frame also serves as another opportunity

for Derrida to forward his theory of the "generalized text" because there is no object of study specific to aesthetics; there is no frame that defines and polices the borders between the disciplines of art history and philosophy.

This situation allows Derrida to return to a statement made by Cézanne in a 1905 letter to Émile Bernard: "I owe you the truth in painting and I will tell it to you" (cited in *The Truth in Painting*, 1978, p. 2). Derrida plays with this notion of "rendering" the truth: it is what is owed as much as what is represented (rendered). Derrida does not simply come out and announce the "truth in painting." In his thinking, this would be to fall victim again to the logic of presence that he attempts to deconstruct. Rather, he states: "I write four times here, around painting" (p. 9). The first pass "around painting" follows the frame, the *parergon*, that which is neither inside nor outside the work—the determining limit of the work of art. This is where he deals with Kant, Hegel, and Heidegger. The second iteration is his reading of the "graphic traits" in Adami's work. The third pass allows Derrida to extend his discussion of the signature and to develop the concept of the "counter-signature," which brings into play the entirety of the exhibition-reception system of a work of art. In the final "writing around," Derrida turns his attention to *ekphrasis*, particularly how Heidegger and Meyer Shapiro write about as well as overwrite a painting by Vincent Van Gogh entitled *Old Shoes* (1886–1887). Derrida refers to this final section as a "polylogue," where he challenges the appropriation of the painting by means of language.

In addition to this famous polylogue on the medium of painting, Derrida collaborated with the architects Peter Eisenman and Bernard Tschumi. The exchanges between Derrida and Eisenman regarding their plans for a garden at La Villette in Paris evince the difficulty of collaboration as such and the application of deconstruction to the idiom and practice of architecture. Nonetheless, deconstruction played a central role in the advent of postmodern architecture. Derrida's importance to this field is best exemplified by the 1988 exhibition *Deconstructivist Architecture* at the Museum of Modern Art in New York.

Lastly, while Derrida's work has greatly informed the manner in which art historical discourse engages everything from museum space to Pop Art (see Sarat Maharaj's "Pop Art's Pharmacies" [1992], which develops Derrida's concept of the *pharmakon*), there

is a space between Derrida's *The Truth in Painting* and his *Memoirs of the Blind* that needs to be addressed. In 1990 Derrida curated an exhibition of painting and drawing at the Louvre in Paris. The centerpiece of his exhibition was a work by Joseph-Benoît Suvée titled *Butades, or the Origin of Drawing* (1791). The subject of the painting is the mythical origin of painting as told through the story of the Corinthian woman Butades, who, before her separation from her lover, traces his shadow on the wall. This image fascinates Derrida because it suggests that the origin of art is not perception, as traditional aesthetics has argued, but rather memory. This mythic origin of art allows Derrida to connect writing, which was disparaged by Socrates in the *Phaedrus* as a crutch that will weaken humanity's capacity for memory, and drawing. Writing and drawing are modes of representation motivated not by what avails itself to perception, but by the trace of a presence-absence. Derrida explains: "Space isn't only the visible, and moreover the invisible … for me, is not simply the opposite of vision. This is difficult to explain, but in [*Memoirs of the Blind*] I tried to show that the painter and the drawer is blind, that she or he writes, draws, or paints as a blind person … it is an experience of blindness. Thus the visual arts are also the arts of the blind. For that reason I would speak of the spatial arts. It more conveniently allows me to link it with the notions of text, spacing, and so on" (1990, p. 24). The key here is that meaning in the spatial arts is not intrinsic; it is always already a trace of an absence, of what cannot be seen. Simply put, one cannot simultaneously see and write about a work of art, therefore any *ekphrasis* is **blindness**. This is the situation of aesthetics. One way that Derrida deals with this situation is to reject the authorial, magisterial voice of the art historian who translates the visual into text. He suggests that any writing on or around a work of art is a refracted self-portrait, a ruin of presence (see the work of Walter **Benjamin**).

Connections between *The Truth in Painting* and *Memoirs of the Blind* traverse a single line of thought. Derrida argues that the "common feature [trait] of his writing four times "around painting"—four times around the *truth* in painting—is the **trait**.

> Insofar as it is never common, nor even one, with and without itself. Its divisibility founds text, traces, and remains…. A trait never appears, never itself, because it marks the difference between the forms or the contents of the appearing. A trait

never appears, never itself, never for the first time. It begins by retrac(t)ing [*se retirer*]. I follow here the logical succession of what I long ago called, before getting around to the turn of painting, the *broaching* [*entame*] of the origin: that which opens, with a trace, without initiating anything. (1978, p. 11)

Derrida has taken us full circle. The trace, the an-archic "origin" of philosophy is tethered to the trait that problematizes the discipline of art history. Because any autotelic "origin" is a wager of full presence, Derrida counters with an ethics of the absent, which remains ever-present in abeyance, suspended and interloping as *différance*.

The importance of Derrida's work lies not in the answers he gives to the fundamental questions of art history, but in its uncanny ability to present those same questions in a new light. How does art history constitute its object of study? Where does the discipline locate meaning? How and why does it draw its borders? Why does the discipline resist theory and the notion of the "generalized text"? These questions will continue to haunt art history as long as the traits that Derrida draws through epistemology, aesthetics, and politics are taken as discrete structures rather than as an ensemble that must be rehearsed. Whenever these questions are posed, in the margins of that text, Derrida will have been a present-absence.

Further Reading

By Derrida

1967. *Writing and Difference*, translated by Alan Bass. Chicago: Univ. of Chicago Press, 1978.

1967. *Of Grammatology*, translated by Gayatri Chakravorty Spivak. Rev. ed. Baltimore: The Johns Hopkins Univ. Press, 1998.

1972. *Dissemination*, translated by Barbara Johnson. Chicago: Univ. of Chicago Press, 1981.

1978. *The Truth in Painting*, translated by Geoff Bennington and Ian McLeod. Chicago: Univ. of Chicago Press, 1987.

1983. "Letter to a Japanese Friend." In *A Derrida Reader: Between the Blinds*, edited by Peggy Kamuf. New York: Columbia Univ. Press, 1991.

"An Interview with Derrida," translated by David Allison. In *Derrida and Difference*, edited by David Wood and Robert Bernasconi. Warwick, UK: Parousia Press, 1985.

1990. *Memoirs of the Blind*. Chicago: Univ. of Chicago Press, 1993.

About Derrida

Arac, Jonathan, et al., eds. *The Yale Critics: Deconstruction in America*. Minneapolis: Univ. of Minnesota Press, 1983.

Beardsworth, Richard. *Derrida and the Political*. London and New York: Routledge, 1996.

Brunette, Peter, and David Wills, eds. *Deconstruction in the Visual Arts*. Cambridge, UK: Cambridge Univ. Press, 1993.

Culler, Jonathan. *On Deconstruction: Thought and Criticism After Structuralism*. London and New York: Routledge, 1983.

Duro, Paul, ed. *The Rhetoric of the Frame: Essays on the Boundaries of the Artwork*. Cambridge, UK: Cambridge Univ. Press, 1996.

Eagleton, Terry. *Literary Theory: An Introduction*. Minneapolis: Univ. of Minnesota Press, 1989.

Hamacher, Werner. "(The End of Art with the Mask)." In *Hegel After Derrida*, edited by Stuart Barnett. London and New York: Routledge, 1998.

Maharaj, Sarat. "Pop Art's Pharmacies." *Art History* 15 (1992): 134.

Melville, Stephen. "Aesthetic Detachment: Review of Jacques Derrida, *The Truth in Painting*." In *Seams: Art as a Philosophical Context*, edited by Jeremy Gilbert-Rolfe. Amsterdam: G+B Arts, 1996.

Menke-Eggers, Christoph. *The Sovereignty of Art: Aesthetic Negativity in Adorno and Derrida*. Cambridge, MA: MIT Press, 1998.

Spivak, Gayatri Chakravorty. "Translator's Preface." In *Of Grammatology*, translated by Gayatri Chakravorty Spivak. Rev. ed. Baltimore: Johns Hopkins Univ. Press, 1998.

Spivak, Gayatri Chakravorty. "Appendix on Deconstruction." In *A Critique of Postcolonial Reason: Toward a History of the Vanishing Present*. Cambridge, MA: Harvard Univ. Press, 1999.

Wigley, Mark. *The Architecture of Deconstruction: Derrida's Haunt*. Cambridge, MA: MIT Press, 1993.

Wood, David, ed. *Derrida: A Critical Reader*. Oxford: Blackwell, 1992.

MICHEL FOUCAULT

Key Concepts

- biopolitics
- archaeology of knowledge
- discourse
- genealogy
- resemblance/similitude

Michel Foucault (1926–1984) was a French philosopher, social and intellectual historian, and renowned cultural critic. He was born in Poitiers, the son of upper middle-class parents. He went to Paris after World War II and was admitted to the esteemed École normale supérieure in 1946, where he received his agrégation in philosophy in 1952 under the guidance of Georges Canguilhem. Like many other French intellectuals in the 1940s and 1950s, Foucault, at the suggestion of Louis ALTHUSSER, became a member of the French Communist Party in 1950, but he left the party in 1953.

During the 1950s and early 1960s, Foucault held teaching positions at various European universities while conducting research, and writing his first widely influential books, including *Madness and Civilization* (1961), *The Birth of the Clinic* (1963), and *The Order of Things* (1966), which became a best seller in France and made Foucault a celebrity.

In response to the May 1968 strikes and student demonstrations, the French government opened the University of Paris VIII at

Vincennes. Foucault, who had been working at the University of Tunis since 1966, was immediately named chair of its philosophy department. In 1970, Foucault was elected to the Collège de France, the country's most prestigious academic institution. This permanent appointment as professor of the history of systems of thought provided him with a position in which he could devote nearly all his time to research and writing. His only teaching-related responsibility was to give an annual sequence of a dozen or so public lectures on his work, one of which was the famous "What Is an Author," delivered in 1969.

During this period Foucault also became increasingly involved in social and political activism. His advocacy for prisoner rights, for example, influenced his history of the prison system, *Discipline and Punish* (1975). Around this same time he turned his attention to sexuality, publishing the first of three volumes on *The History of Sexuality* in 1976. He completed the other two volumes shortly before his death from AIDS-related complications in 1984.

Regardless of how one evaluates Foucault's scholarship, there is little doubt that the questions and issues he raises have permanently reshaped the humanities and social sciences. Foucault's scholarly output is impressive both for its quantity and for its breadth of interests and insight. His work relentlessly challenges what counts as commonsense knowledge about human nature, history, and politics. Moreover, he questions the assumptions of thinkers such as Sigmund **Freud** and Karl **Marx** whose ideas underlie Western intellectual thought.

Foucault's work explores the parameters of what he calls the "human sciences," that academic field in which humanistic and social science discourses construct knowledge and subjectivity. He analyzes how various institutions (psychiatric clinics, prisons, schools, and so forth) produce bodies of knowledge in and through which people are disciplined into becoming modern subjects. In this process Foucault has brilliantly shown how knowledge and power are inextricably bound and wielded as **biopolitics**. He explains how power in modernity is biopolitical; it is not merely about a simple top-down subjugation, rather biopolitics exceeds the traditional juridical–political order by pervading the bodies and lives of its subjects.

Conceptual terms such as biopolitics, discourse, subjectivity, and knowledge-power are essential to an understanding of Foucault's

theories. These concepts can be positioned within three areas that were central to Foucault's cultural analysis: (1) the archaeology of knowledge, (2) genealogy of power, and (3) ethics. Underlying all three areas is a concern with the notion of the subject and subjection, that is, the process by which a human subject is constructed (see also Judith **BUTLER** on the paradoxes of subjection, which she develops in relation to Foucault).

The **archaeology of knowledge** is the name Foucault gives (in a book of the same title published in 1969) to his method of historical and epistemological inquiry. For him, archaeology refers to a historical analysis that seeks to uncover the discourses operating within systems of meaning. His concern is not with historical "truth," but rather with understanding how discursive formations—for example, medical discourse on sexuality—come to be seen as natural and self-evident, accurately representing a body of knowledge. His attempt to uncover the structures and rules through which knowledge is constructed and implemented is informed by, but not limited to, structuralist thought. In the preface to *The Order of Things* Foucault explains his method: "what I am attempting to bring to light is the epistemological field, the *episteme* in which knowledge, envisaged apart from all criteria having reference to its rational value or to its objective forms, grounds its positivity and thereby manifests a history which is not that of its growing perfection, but rather that of its conditions of possibility" (p. xxii). It is discursive knowledge that determines the "conditions of possibility" that Foucault desires to reveal. Discursive knowledge regulates what can be said and done, what constitutes right and wrong, and what counts for knowledge in the first place. In other words, **discourse** establishes and controls knowledge. Foucault's archaeological method regards discourse as both fluid and systematic, mutable and stable. For instance, the medical discourse of the Renaissance bears no necessary similarity to contemporary medical discourse, yet each has a distinctive historical archive. The goal of Foucault's work is not to uncover the "quasi-continuity" between these periods, which, in his mind, is the misguided work of traditional historiography. On the contrary, he insists that the goal of his work "has not been to analyze the phenomena of power, nor to elaborate the foundations of such an analysis. My objective, instead, has been to create a history of the

different modes by which, in our culture, human beings are made subjects" ("The Subject and Power," 1982, p. 208).

During the 1970s, Foucault devoted his attention to what he described as the genealogy of power, a history of the meanings and effects of power and how discourse and other "technologies of power" are employed to discipline human behavior. The term **genealogy** is used by Foucault to refer to a mode of historical analysis that he develops in texts such as *Discipline and Punish* and the first volume of *The History of Sexuality: An Introduction.* The concept of genealogy is borrowed from Friedrich **NIETZSCHE**, who published *On the Genealogy of Morals* in 1887. Foucault addresses his debt to Nietzsche in his 1971 essay "Nietzsche, Genealogy, History."

In this essay, Foucault advances an alternative to the traditional narration of history. He critiques the teleology of traditional historiography, wherein historical events are narrated as a simple relation of causes and effects that produce human events. In this scheme events can be traced, in a linear and logical fashion, backward to origins. To counter this epistemic structure, Foucault posits that historical narrative is fragmented, nonlinear, discontinuous; it exists without being grounded in the certitude of cause and effect. His concept of genealogy, which is a conceptual refinement of his notion of archaeology, does not rest on any point of origin, whether it be an active human subject or the authoritative voice of the historian. "Genealogy," he writes, "is gray, meticulous and patiently documentary. It operates on a field of tangled and confused parchments, on documents that have been scratched over and recopied many times" (1971, p. 139). For Foucault, then, history is an ambiguous and often conflicting textual narrative. History bears the marks of repeated emendations—additions, deletions, embellishments, and other textual manipulations—that makes it impossible to follow a cause-and-effect lineage back to an origin. A historical origin is thus something at once obscured and unrecoverable. Historical truth suffers a similar fate in this critique. Following Nietzsche, Foucault interprets any claim to historical truth, any claim by a historian or cultural critics of being *dans le vrai*, as an error and as yet another instance of knowledge-power.

Genealogy as a method underscores the interpretive nature of any narration of the past. Moreover, it presents the past as always and inevitably read through contemporary interests and concerns.

Objectivity is abandoned in favor of acknowledging the historian's political and ideological investment in the narrative being told. Even if historical truth exists, Foucault argues, historians have no particular or privileged access to it. He is most interested in understanding historical documents as discourses of knowledge that highlight some perspectives while suppressing others. He wants to reread the past and narrate the story from perspectives that disrupt the fiction of the historical past as such. In this desire to narrate a counter-practice, Foucault concentrates on minor elements, "accidents," and other elements of discourse that exceed their ideological emplacement in the order of things. This genealogical approach interrupts any idea of history as relating the "truth" of past events—of telling what "actually" happened. Rather than chasing after some ephemeral grand narrative that silences any discontinuities, Foucault seeks to interpret the past in ways that will not deny the ambiguity, contingency, and struggle that must accompany any genealogical analysis. (There is a clear tie to Walter **BENJAMIN**'s philosophy of history here.) Because the historian must admit the place from which she or he enunciates any narrative of history, the myth of history as a unified story divides into a multiplicity of narratives about the past. Thus, we begin to understand history not in terms of a static and fixed past—as an object placed before us—but as a continually changing narrative discourse contingent upon the present.

Foucault applies his genealogical analysis to the history of power, exploring how power operates to produce particular kinds of subjects. For him, power is not a monolithic, nonchanging force, instead it has a genealogy. For instance, a Marxist view of power as the force wielded by governments, corporations, and others who control the economic means of production is very different from a feminist view of patriarchal power. Resisting these totalizing systems of thought, Foucault's genealogy of power is multivalent. In "The Subject and Power" (1982), he insists that the concept of power must always include the possibility of resistance to power. Power, therefore, is always a relationship that creates subjects, but it can always be resisted. In other words, we can oppose the subject positions that discourses and material practices consign us.

It has been said that Foucault's work forecloses upon the very possibility of change because he rejects the liberal humanist ideology of agency, but the challenge his work presents lies in

being able to discern the underlying thesis of all his work: the possibility of biopolitical discursive change. As he stated in a lecture at Dartmouth College given in 1980:

> I have tried to get out from the philosophy of the subject through a genealogy of this subject, by studying the constitution of the subject across history which has led us up to the modern concept of the self. This has not always been an easy task, since most historians prefer a history of social processes, and most philosophers prefer a subject without history. ("About the Beginnings of the Hermeneutics Self," p. 160)

A genealogical view of subjectivity is Foucault's attempt to abandon the essentializing conceptions of the human subject as a singular, transcendent entity.

In his later work, Foucault devotes himself to the issue of the "ethics of self." Ethics here, however, does not simply mean an individual's morals. Foucault is interested in identifying the "technologies" of the self, the regulated forms of behavior that constitute a particular human subject. Such technologies, which include sexual, political, legal, educational, and religious patterns of behavior, may be taken for granted or even go completely unnoticed by the subject who is constituted by them. Nonetheless, they function to discipline the body and mind within a larger order of power-knowledge. Technologies of the self are subjectivizing practices that create and shape one's sense of self. These practices are not universal, but variable over time and place. Foucault demonstrates that these technologies of the self are practices

> which permit individuals to effect by their own means, or with the help of others a certain number of operations on their own bodies and souls, thoughts, conduct, and way of being, so as to transform themselves in order to attain a certain state of happiness, purity, wisdom, perfection, or immortality. ("Technologies of the Self," p. 146)

Significant here is the ethical idea that individuals can resist power and transform their own subjectivity. Foucault's discussion of ethics here contrasts the Greek notion of ethics as a matter of personal choice, which emphasizes the rational control of deviant desires, with his call for an "ethics of the self," which challenges the presupposed benefits of the discourse of mastery, control, and

repression. However, what he suggests in its place is a more general notion of the Greek notion of ethics as "an aesthetics of existence." "What strikes me," Foucault explained in an interview from 1983, "is the fact that in our society, art has become something which is related only to objects and not to individuals, or to life. That art is something which is specialized or which is done by experts who are artists. But couldn't everyone's life become a work of art? Why should the lamp or the house be an art object, but not our life" ("On the Genealogy of Ethics: An Overview of Work in Progress," p. 350). What Foucault calls for here is not a blind utopic project, but rather an "aesthetics of existence" that does not transcend discourse as much as it tests the limits and the possibility of difference within the same.

As suggested by his interest in "technologies of the self," Foucault's work is invested in understanding how various systems of representation subject individuals. This ethical question of an "aesthetic of existence" intersects with the discipline of art history as a discursive practice that proscribes our modern relation to art objects by authoring a historical narrative of art and life. This art historical power-knowledge has been submitted to a Foucauldian genealogical analysis by Donald Preziosi, whose *Rethinking Art History: A Meditation on a Coy Science* (1989) remains the most astute explication of not only the historical premises of the discipline of art history, but also the sociopolitical and ethical consequences of its discourse and the subjects it helps to produce.

Throughout his work Foucault exhibits an interest in visual representation, particularly the history of painting in the West. The first chapter of *The Order of Things* is an extended meditation upon Diego Rodriguez de Silva y Velázquez's *Las Meninas* (1656). Here Foucault enacts an archaeological reading of the work that aims to define the classical age (up to the seventeenth century) as one of the "two great discontinuities in the episteme of Western culture," the other being the modern age (1966, p. xxii). It is the idea of representation freed from resemblance, of representation as such, without an ostensible subject that Foucault reads in the painting. The system of representation represents itself rather than merely the subject of the painting. The defining characteristic of the classical episteme is this system of representation freed from resemblance. Foucault's analysis of *Las Meninas* has endured several art historical critiques, but its importance lies more in his choice

to begin *The Order of Things* not with a text but with a painting, a visual text. Beyond making evident the system of representation, the painting leads Foucault to raise a series of questions about the presupposed viewer of a work of art. What kind of subject is the viewer of a work of art? Foucault writes that "we do not know who we are, or what we are doing. Seen or seeing?" (p. 5). The system of representation works without a subject/viewer and without an artist/author. What it makes evident is the importance of the tabula of representation, "the entire cycle of representation," that once freed from resemblance will color the epistemic break that Foucault signifies as the modern age. Foucault locates his readings of artworks in "the threshold that separates us from classical thought and constitutes our modernity" (p. xxiv).

He produces two additional studies of artists and their work: one on Édouard Manet and another on René Magritte. In 1971, while at the University of Tunis, Foucault proposed a conference on Édouard Manet. Foucault planned a monograph on Manet, but unfortunately the project was never brought to fruition. However, a transcription of the lecture Foucault gave is available in French. His argument for Manet's importance is quite ambitious. He contends that Manet "makes possible" (*a rendu possible*) not only Impressionism, but all painting after Impressionism as well, including nearly all twentieth-century modern and contemporary work. The lecture is divided into three sections, in each of which he gives a reading of various Manet paintings. The first concerns "the space of the canvas" (*l'espace de la toile*) and how Manet makes use of the material properties of the canvas. The second— *L'éclairage*—addresses his use of real exterior light to construct the tableau-object. Manet's positioning of the viewer in relation to the "tableau-object" is Foucault's focus in the third section which he entitled "The Place of the Spectator" (*La place du spectateur*). Foucault asserts that after the Middle Ages, Western painting tried to make the viewer forget that the painted work exists only in a certain fragment of rectangular space (whether on a wall, a piece of wood, a canvas, or a sheet of paper). This disavowal of the structural limits of the surface-space of Western painting (a two-dimensional, rectilinear picture plane) results in an "illusion-elision." The attempt to construct an ideal space (the illusion of three dimensions and depth) from which and in which a viewer is presented with a spectacle, marks the trajectory of Western painting

from the Renaissance up to Manet in Foucault's reading. Manet is granted such a privileged position because, somewhat predictably, Foucault posits that he draws our attention to the properties and limitations of the material of painting: the canvas, the space-surface, the pigment. It is Manet's invention of the "tableau-object," the tableau as materiality, that Foucault believes is the fundamental event of modern Western painting.

Foucault engages the work of the Belgian Surrealist Magritte in *This Is Not a Pipe* (1973). This work is the result of Foucault's long-standing interest in the Surrealists, including some of its dissident figures like Georges **Bataille**. Foucault explores the meanings of Magritte's famous *Ceci n'est pas une pipe* (1926) in which a visual representation of a pipe is seemingly negated by a handwritten script. The inclusion of text within the painting challenges the discursive code that prohibits the inclusion of the linguistic within the visual. In the short text Foucault posits two principles that dominate painting from the fifteenth to the twentieth century: "the separation between plastic representation (which implies resemblance) and linguistic reference (which excludes it)" and "an equivalence between the fact of resemblance and the affirmation of a representative bond" (pp. 32, 34). Foucault acknowledges the absence of a common ground, a common place, between the visual and the linguistic, but it is precisely within this threshold that Magritte creates his works. The argument hinges on Foucault's distinction between resemblance and similitude. "To me," he writes, "it appears that Magritte dissociated similitude from resemblance, and brought the former into play against the latter" (p. 44). **Resemblance**, for Foucault, has a "model," a referent or an "origin" that "orders and hierarchizes the increasingly less faithful copies that can be struck from it ... [it] serves representation, which rules over it" (p. 44). On the other hand, **similitude**

> develops in series that have neither beginning nor end, that can be followed in one direction as easily as in another, that obey no hierarchy, but propagate themselves from small differences among small differences ... similitude serves repetition, which ranges across it. Resemblance predicates itself upon a model it must return to and reveal; similitude circulates as an infinite and reversible relation of the similar to the similar. (p. 44)

What Foucault argues here is that similitude is not a mimetic representation, but it is a series, an open-ended exchange. In Magritte's work there is a rejection of resemblance ("This is not a pipe"), and in its place there is sketched only "an open network of similitudes" (p. 47). Magritte severs the system of representation from the thing-itself. Furthermore, Foucault argues that modern and contemporary art are systems of similitude—simulacra in much the same way Jean **Baudrillard** discusses the term—wherein text and image ceaselessly circulate around "the ghost of the thing-itself" (p. 49). More so than other attempts at dealing with the intersection of the textual and the visual by Wassily Kandinsky and Paul Klee, the play of affirming and negating, of representing nothing other than similitude, that Magritte's painting inaugurates allows Foucault to conclude that "the 'This is a pipe' silently hidden in mimetic representation has become the 'This is not a pipe' of circulating similitudes" (p. 54).

Foucault ends his meditation on Magritte and contemporary aesthetics with a reference to Andy Warhol. He writes: "A day will come when, by means of similitude relayed indefinitely along the length of a series, the image itself, along with the name it bears, will lose its identity. Campbell, Campbell, Campbell, Campbell" (p. 54). This connects Foucault's work on Magritte with his essay "Theatrum Philosophicum" (1970) where he again mentions Warhol. This time it is in the context of reviewing Gilles **Deleuze**'s *Repetition and Difference* (1969) and *The Logic of Sense* (1969). In a few poetic lines, Foucault asserts:

> This is the greatness of Warhol with his canned foods, senseless accidents, and his series of advertising smiles: the oral and nutritional equivalence of half-opened lips, teeth, tomato sauce, that hygiene based on detergents; the equivalence of death in the cavity of an eviscerated car, at the top of a telephone pole and at the end of a wire, and between the glistening steel blue arms of the electric chair … in concentrating on this boundless monotony, we find the sudden illumination of multiplicity itself—with nothing at its center, at its highest point, or beyond it—a flickering of light … suddenly, arising from the background of the old inertia of equivalences, the striped form of the event tears through the darkness, and the eternal phantasm informs that soup can, that singular and depthless face. (1970, p. 189).

The equivalences of the similar, the repetition of the same, and yet Foucault sees in Warhol's work the outlines of an event, of that "possibility of change" he sought throughout his work: a change that refuses to name itself transcendence; a change Foucault here terms difference. From out of the repetition of the same, it is possible that difference can present itself. This is what Foucault's work provides art history: the opportunity to rethink and delimit the system of representation in order to make change possible. It is an "aesthetics of existence" that is always already an ethics of the self.

Further Reading

By Foucault

1961. *Madness and Civilization: A History of Insanity in the Age of Reason*, translated by Richard Howard. New York: Vintage, 1973.

1963. *The Birth of the Clinic: An Archaeology of Medical Perception*, translated by A. M. Sheridan-Smith. New York: Pantheon, 1973.

1966. *The Order of Things: An Archaeology of the Human Sciences*, translated by Alan Sheridan. New York: Vintage, 1970.

1969. *The Archaeology of Knowledge*, translated by A. M. Sheridan-Smith. London: Tavistock, 1974.

1969. "What is an Author?" In *Language, Counter-Memory, Practice: Selected Essays and Interviews*, edited by Donald F. Bouchard. Ithaca, NY: Cornell Univ. Press, 1977.

1970. "Theatrum Philosophicum." In *Language, Counter-Memory, Practice: Selected Essays and Interviews*, edited by Donald F. Bouchard. Ithaca, NY: Cornell Univ. Press, 1977.

1971. "Nietzsche, Genealogy, History." In *Language, Counter-Memory, Practice: Selected Essays and Interviews*, edited by Donald F. Bouchard. Ithaca, NY: Cornell Univ. Press, 1977.

1973. *This Is Not a Pipe*. translated by James Harkness. Berkeley: Univ. of California Press, 1983.

1976. *The History of Sexuality*, vol. 1, *An Introduction*, translated by Robert Hurley. New York: Vintage, 1978.

1980. "About the Beginning of the Hermeneutics of the Self." In *Religion and Culture*, edited by Jeremy R. Carrette. London and New York: Routledge, 1999.

1980. "Technologies of the Self." In *The Essential Foucault*, edited by Paul Rabinow and Nikolas Rose. New York: New Press, 2003.

1982. "The Subject and Power." *Afterword to Michel Foucault: Beyond Structuralism and Hermeneutics*, edited by Hubert L. Dreyfus and Paul Rabinow. Chicago: Univ. of Chicago Press, 1983.

1983. *Foucault Live: Interviews, 1961–84*, edited by Sylvere Lotringer. New York: Semiotext(e), 1996.

1983. "On the Genealogy of Ethics: An Overview of Work in Progress." In *The Foucault Reader*, edited by Paul Rabinow. New York: Pantheon, 1984.

Le Peinture de Manet. Paris: Éditions du Seuil, 2004.

About Foucault

Bennett, Tony. *The Birth of the Museum: History, Theory, Politics*. London and New York: Routledge, 1995.

Carroll, David. *Paraesthetics: Foucault, Lyotard, Derrida*. New York: Methuen, 1987.

Deleuze, Gilles. *Foucault*, translated by Seán Hand. Minneapolis: Univ. of Minnesota Press, 1988.

Gutting, Gary, ed. *The Cambridge Companion to Foucault*. Cambridge, UK: Cambridge Univ. Press, 1994.

McNay, Louis. *Foucault: A Critical Introduction*. New York: Continuum, 1994.

Mills, Sara. *Michel Foucault*. London and New York: Routledge, 2003.

O'Leary, Timothy. *Foucault: The Art of Ethics*. New York: Continuum, 2002.

Preziosi, Donald. *Rethinking Art History: Meditations on a Coy Science*. New Haven: Yale Univ. Press, 1989.

Shapiro, Gary. "Art and Its Doubles: Danto, Foucault, and Their Simulacra." In *Danto and His Critics*, edited by Mark Rollins. Oxford: Blackwell, 1993.

Shapiro, Gary. *Archaeologies of Vision: Foucault and Nietzsche on Seeing and Saying*. Chicago: Univ. of Chicago Press, 2003.

MARTIN HEIDEGGER

Key Concepts:

- Being
- Dasein
- aletheia
- clearing
- the work of the work of art
- world and earth

Martin Heidegger (1889–1976) is one of the most influential and controversial thinkers of the twentieth century. Born in 1889 to a Catholic family from Messkirch in Baden, Germany, Heidegger's early life was marked by an intense interest in religion. From a young age he wanted to become a priest. This culminated in two years of theological study at Freiburg University, but Heidegger ultimately changed paths. In 1911, he began studying natural science and mathematics, which led to a doctorate in philosophy with a dissertation titled *The Doctrine of Judgment in Psychologism* (1913). Heidegger's goal was to be appointed as Freiburg's professor in Catholic philosophy. His qualifying dissertation (*Habilitationsschrift*) on Duns Scotus and medieval philosophy did not get him the post and so in 1915 Heidegger began his teaching career as a lecturer at Freiburg. It is at this time that Heidegger developed a personal relationship with Edmund Husserl, the founder of phenomenology. Heidegger's work on Duns Scotus had been influenced by Husserl's thought, but it was not until his time

at Freiburg before and after World War I that Heidegger shifted from Catholic philosophy to phenomenology.

In 1919, Heidegger turned his attention to the work of Aristotle, Sören Kierkegaard, and Friedrich **NIETZSCHE**, but the major influence continued to be Husserl, with whom Heidegger worked closely. Heidegger's own growth as a thinker owes much to his close reading of his mentor's *Logical Investigations* (1900–1901). Eventually, Heidegger broke away from Husserlian phenomenology and its attendant notion of the transcendental consciousness in order to develop his own system of thought, resulting in the publication of *Sein und Zeit* (*Being and Time*) in 1927. During the interwar period, Heidegger married Elfride Petri, a Lutheran, and they had two sons, both of whom served in Hitler's Wehrmacht. In 1925, Heidegger began a year-long affair with Hannah Arendt, the German-Jewish philosopher. Arendt was one of Heidegger's most promising students, but their affair was unable to withstand the strain caused by Heidegger's support for Nazism. Arendt and Heidegger did, however, maintain a friendship through correspondence and occasional visits that lasted until Arendt's death in 1975.

Heidegger's engagement with Nazism during the 1930s has been the source of warranted unease regarding his thought. When the Nazis rose to power, Heidegger deluded himself into eliding his philosophy with the ultimate aims of Hitler—most problematically, that of the fulfillment of the destiny of the German people. Heidegger's biography and especially the work completed during this period of Nazi affiliation (including his essay "The Origin of the Work of Art") are marred by many unanswered questions regarding his avowed conservative and nationalistic support for Hitler's policies, which resulted in his joining the Nazi Party and being elected director of Freiburg University in 1933. Heidegger was forced to resign from his post in 1934 when the Nazis determined his lectures and his desire to integrate the goals of National Socialism into the life of the university were of no direct use to the party. After the war, Heidegger was not allowed to teach in Germany due to his support of the Nazis. In 1950, he resumed lecturing at Freiburg and elsewhere. He died in 1976 at his home in Zähringen.

Heidegger's work exerts an enormous influence on postwar critical theory, especially in France. The work of Jean-Paul Sartre, Jacques **DERRIDA**, Michel **FOUCAULT**, Jacques **LACAN**, Gilles **DELEUZE**,

and Giorgio AGAMBEN is undeniably colored by various aspects of Heidegger's work. Despite the fact that many of these thinkers are Jewish, politically leftist, and, most significantly, committed to thinking an alternative (a heteronomic becoming) to the notion of an essentialist being, Heidegger remains a decisive factor for all of them. His work is central to any discussion of poststructuralism, post-Marxism, and identity politics. Perhaps this paradox is best demonstrated by the Romanian poet Paul Celan's 1967 visit with Heidegger in Todtnauberg. Celan survived a Nazi labor camp, but his parents were less fortunate. His poetry is driven by an attempt to interrogate the threshold between language and experience. The question arises: why did Celan accept Heidegger's invitation and why did he describe the three-day visit as "most happy and productive"? What remains especially problematic, as Celan himself discovered, is Heidegger's silence: his refusal to discuss, explain, or even attempt to justify (if that is at all possible) his support of Nazism. In spite of this silence, Heidegger's work has received a critical reading that does not foreclose upon the potentiality of his thought. It is crucial that the issue of Heidegger and Nazism be addressed in the most stark terms, but the conclusion of this address must not be a complete rejection. As Jürgen Habermas has stated, the goal is "to think Heidegger against Heidegger." This is a question of ethics and politics, a question of critical reading—one of the primary lessons of critical theory as such. It is for this reason that Derrida argues: "Why isn't the case closed? Why is Heidegger's trial never over and done with?... we have to, we've already had to, respect the possibility and impossibility of this rule: that it remains to come" (Derrida, *Points*, 1995, pp. 193–194).

Heidegger's *Being and Time* is one of the more difficult texts in the history of philosophy. This is in no small part because of his ambition to enact a radical "destructuring" (*Destruktion*) of the entire metaphysical tradition. Toward this end, Heidegger redefines the normative terms of philosophical discourse: subject, object, being, thought. This is the first step because he sets out to "destruct" the structures and semantics that have accrued around and over the sole subject of his work: **Being** (*Sein*). By Being, Heidegger does not mean the traditional concern of metaphysics, the being of beings, the essence of an entity (*Seiend*), whether a dog or a hammer. Rather, Heidegger is after an unpresupposed Being, an intransitive Being, the meaning of Being as such. This is

what he terms "fundamental ontology." In many ways, his primary question is "what is 'is'?" To be rather than to be something, this is Heidegger's starting point, one he claims has been neglected and forgotten throughout the history of Western metaphysics. In order to begin addressing these issues Heidegger first has to "destruct" metaphysics: the meaning of existence, the duality of thought and matter since Descartes, and even Husserl's phenomenology. For Heidegger, the history of metaphysics is the history of the concealment of Being. In contrast, he posits "thinking" as that which can take into view Being as Being, Being as such. Many of the central elements of this "thinking" are found in *Being and Time*.

Heidegger posits that human being (*Dasein*) is defined by a process of becoming; Dasein is disclosive because it always already has an understanding of Being. Dasein is not subjectivity or rationality, but describes the specificity of human being as an entity. This process of becoming-being is a movement of disclosing and understanding Being, whether it is that of Dasein or other entities. Therefore, Dasein is defined by its very openness to itself (as the becoming disclosedness of Being) and its openness to other entities. Heidegger terms this openness "the there" (*das Da*) because Dasein makes possible the disclosure of its own existence as openness. In addition, this self-disclosure (Being related to itself) allows for the disclosure of other beings: the being-the-there (*Da-sein*) of other beings.

He also argues that the meaning of Dasein is "being-in-the-world." Contrary to the *ego cogito* of Descartes and even the concept of the ego forwarded by Sigmund **FREUD**, both of which construct their respective worlds, Heidegger argues that Dasein is thrown into a preexisting world of historically constituted situations, moods, and a determinate use of language. Dasein, he insists, is defined by its "thrownness" (*Geworfenheit*)—its always already being-in-the world. In other words, there is never a moment when Dasein is not absorbed in the world, that is, absorbed in social discourse. At the same time, however, Dasein is temporal. While Dasein is beleaguered with being thrown into the world and the demands made upon it by *das Man* ("the They"), the anonymous field of the other, it is also a projection into the future. Thus Dasein is a "thrown projection" (*geworfener Entwurf*). This becoming-absent of Dasein—its being-unto-death, its mortality—opens up the field of significance for Being as such because the temporality of Dasein is

the horizon for any disclosure of Being. The temporality of Dasein is central to the realm of disclosure Heidegger terms "the Open," the very "topology of Being" that his work sets out to think (1954, p. 12).

To describe the temporal situation of Dasein in relation to Being, the becoming present of what one already is—*the being-there that defines Dasein*—Heidegger recuperates a Greek term, *alētheia*. The term means disclosure or unconcealment. Heidegger's interest in this term stems from its prefix *a-* (un- or dis-), which indicates a privation or an absence at the heart of this concept of unconcealment. This prefix shelters the root of the term and, by extension, the root of truth—the presence of Being: *lēthē*, concealment. *Alētheia* was the ancient Greek word for truth, but Heidegger reclaims and redefines the term neither as the truth of metaphysics nor as the designation of a correct proposition, but as the truth of thinking. His conception of **aletheia** defines the very process of the becoming present of Being. This becoming present is determined by disclosure, the anticipation of absence. Aletheia is a central term in Heidegger's thought because it indicates the play of absence and presence that organizes any thinking about Being. In aletheia, what was concealed comes to presence, but never completely. This coming to presence is partial and discursive because every presence of Being is predicated on the absence of Being. It is this structure of disclosure that delimits the field of significance. In other words, the topology of Being is aletheia because all entities are defined in their being as becoming "the there" of Dasein. In his early work, Heidegger is insistent that disclosure never happens except in Dasein as Da-sein.

Heidegger's point is that disclosure-as-such occurs in certain place. In *Being and Time*, the place was Dasein, which is defined as a being that held itself open to beings as Da-sein. However, Heidegger's thought undergoes a change in the 1930s. It is important to recall that *Being and Time* represents only one-third of Heidegger's initial project. His inability to shift from the analytic of Dasein to the interrogation of Being as such caused him to rethink the place of disclosure. Heidegger ultimately proposes the concept of the "**clearing**" (*Lichtung*) as the place of disclosure. The "clearing" is a threshold beyond Dasein. In fact, Dasein exists (ex-ists as Heidegger writes it to denote its constitutive lack of immanence), along with all other entities, in the "clearing." What is made

present in the "clearing" is the disclosure of Being. In the "clearing" a being (for example, a hammer) appears in a certain way, as a tool or as something dangerous. Appearing in one aspect of its being conceals another. Every unconcealing is predicated on a concealing and what is concealed are other possibilities. "Each being we encounter," Heidegger writes, "and which encounters us keeps to this curious opposition of presence in that it always withholds itself at the same time in a concealedness" ("The Origin of the Work of Art," 1950, p. 52). In abandoning his thesis that one must account for one particular entity (Dasein) before one can talk about being as such, Heidegger turns to other paradigms that allow him to discuss Being. The primary and related ones are poetry, art, and technology. Although the means of discussing the disclosure of Being changes, Dasein remains a central character, less in its ontology than in its use of language and in its productions.

The crucial text for us is "The Origin of the Work of Art" (1935–1936), which includes an "Addendum" written by Heidegger in 1956. The draft of this essay was written as early as 1931, and in November of 1935 he lectured publicly on the subject. The long essay is divided into three sections: "Thing and Work," "The Work and Truth," and "Truth and Art." Each of these sections is organized around a single example: Vincent Van Gogh's *Old Shoes* (1886-1887), a fifth-century B.C.E. Doric temple of Hera II in Paestum (Lucania), Italy, and the poetry of Friedrich Hölderlin.

Heidegger's interest lies in understanding "**the work of the work of art**." What "work" does the work of art accomplish? In attempting to answer this pressing question he distinguishes between the work of art as a specific entity (a particular painting or poem) and art itself. Art itself here means the essence or the origin of all art. Art is important to Heidegger because, for him, it is a unique kind of disclosure: the work of art is able to disclose not merely an entity but the disclosure-as-such of that entity's being. The work of the work of art, Heidegger argues, is the "installation"—the setting-into-work (*Sich-ins-Werk-setzen*)—of aletheia, the "fixing into place" and "letting happen" of truth.

The work of art reveals the happening of **world** and **earth**. The world, as discussed above, is the realm of human activity and relations into which Dasein is thrown. But in this essay Heidegger expands his understanding of this concept of world. "There is only 'world' where there is language, that is, understanding of being,"

he insists (1977, p. 32). Earth refers not only to nature and natural entities, a mass of matter, or an astronomical idea of a planet; instead, it is that "on which and in which man bases his dwelling … that which comes forth and shelters … effortless and untiring" (1950, pp. 41, 45). The world as "the self-disclosing openness of the broad paths of the simple and essential decision in the destiny of a historical people" and the earth as the realm of concealment, sheltering and preserving, are inextricable from one another (1950, p. 47). These two concepts, Heidegger explains, are bound in "strife" (*Streit*). This "strife" is not disorder, rather it is conceived by Heidegger in a way that is very similar to Hegel's original understanding of the term sublation (*Aufhebung*). Heidegger writes that in "strife" "the opponents raise each other into the self-assertion of their natures" not to indicate their contingency, but so that each "surrender[s] to the concealed originality of the source of [its] own being. In the 'strife', each opponent carries the other beyond itself" (translation slightly modified; pp. 47–48).

The work of art belongs to both realms—world and earth—at once. It is the work of the work of art to allow the "strife" between the world and the earth to remain undecided; it is not to reconcile them. The work of the work of art situates the Open of the world by setting it into the earth. Thus, this place of strife, of pain, is what Heidegger calls the "clearing" or the Open.

His two art historical examples, Van Gogh's shoes and the Greek temple, are chosen precisely to foreground the "strife" between the world and the earth. By extension, they reveal the relation between the work of art and disclosure-as-such. Art is a way of unveiling or discovering a means to put aletheia into a work. The truth erupts in the work of art in the form of the "strife" between world and earth. Here we can see that the "strife" is what illuminates (German, *Lichtung* for "clearing" has this connotation as well) the contours of the "clearing."

Heidegger explains: "In the midst of beings as a whole an open place occurs. There is a clearing, a lighting…. Only this clearing grants and guarantees to us humans a passage to those beings that we ourselves are not and access to the being that we ourselves are" (p. 51). In this manner, the representation of a peasant's shoes by Van Gogh indicates being-in-the-world: more than a mere thing and yet in and of themselves unable to presence their being. In their contact with the earth, the shoes present the happening of

truth in the work of art—the aletheia of Being—disclosed in the primal conflict between world and earth within the "clearing." This is the "nature of truth" for Heidegger. He explains that it happens in Van Gogh's painting, but that its fullest expression—its destiny so to speak—is more pressing in the Greek temple and in Hölderlin's poetry because in these instances the work of the work of art is tethered to a "native ground" and the historical destiny of a people.

Heidegger concludes his meditation on the work of art by turning to poetry. His argument has two key steps. He claims that "art breaks open an open place, in whose openness everything is other than usual" (p. 70). This is how he describes the happening of truth, that is, the setting-itself-into-work of truth. The second step follows from the first: "Art, as the setting-into-work of truth, is poetry" (p. 72). Art is never gathered from ordinary things at hand, nor is poetry merely everyday language; instead, Heidegger conceives both as exemplary.

This displacement of art (both plastic and architectonic) under the aegis of poetry evinces Heidegger's position that it is language which first brings Being into appearance as word. It is poetic language that first conceals Being, not visual or spatial representation. He privileges the originary power of "saying" and "naming," which is why Heidegger ends his essay on the work of art with a discussion of Hölderlin's poem "The Journey." However this does not diminish the importance of art or art history. On the contrary, art history, the history of art, is historical because it "preserves" the happening of truth in the work. This is given added significance because art, for Heidegger, "is history in the essential sense that it grounds history" (p. 75). He foregrounds the work of the work of art—the setting-into-work of truth—because it is authentically historical (*geschichtlich*), that is, it presences the history of Being, the oblivion of metaphysics. In short, it counteracts the forgetting of Being he sees in the history of metaphysics.

Heidegger's thinking on the work of art (and, in fact, the entirety of his philosophy) has been subjected to many critical readings. The responses it elicits have run the gamut from dismissive to celebratory. Perhaps the most extraordinary response to "The Origin of the Work of Art" essay is to be found in the exchange between Derrida and Meyer Shapiro, the famous art historian. Derrida's deconstructive reading of Heidegger's text, which develops its aporias and extends them in order to problematize any historical reading of the work of

art, appears in the section titled "Restitutions" from his *The Truth in Painting* (1978). The other response is Shapiro's "The Still Life as a Personal Object—A Note on Heidegger and van Gogh," which was published in a 1968 anthology. (All three of these texts and an explanation of their theoretical and historical importance are to be found in Donald Preziosi's *The Art of Art History: A Critical Anthology* [1998].)

Heidegger's conceptual pairs of metaphysics/aesthetics and thinking/overcoming of aesthetics are central to the intersection of art history and critical theory. One immediate aspect of this distinction is whether or not the method enacted in "The Origin of the Work of Art" essay can initiate "an overcoming of aesthetics." Questions like these are addressed in the responses offered by Derrida and Shapiro, but one of the most intriguing meditations is found in Agamben's *The Man Without Content* (1994). The answers to several of the fundamental questions for art history in an epoch of the putative death of aesthetics and now critical theory itself lie in a return to Heidegger's thinking, especially his assertion that in its "origin" the work of art founds a people, a community. The makeup or face of that community is an inescapable task left for us to shelter.

Also, a reconsideration of Heidegger's call for "preservers" of the work of art rather than interpreters or appreciators is long overdue. His understanding of the work of the work of art moves us away from the notion of an artwork as a self-sovereign object, as a performance of artistic genius, or as a mere stimulant of experience. The authentic "riddle of art" is to "preserve" the work of art:

> Preserving the work means: standing within the openness of beings that happens in the work.... Preserving the work does not reduce people to their private experiences, but brings then into affiliation with the truth happening in the work.... Most of all, knowledge in the manner of preserving is far removed from that merely aestheticizing connoisseurship of the work's formal aspects, its qualities, and charms.... As soon as the thrust into the extraordinary is parried and captured by the sphere of familiarity and connoisseurship, the art business has begun. (1950, p. 66)

This is the (im-)possible task Heidegger sets "preservers" of the work of art. He does not name them art historians, philosophers,

or cultural historians; they are only named "preservers" and they are asked "to think." Their charge is the very disclosure of Being that the artwork appropriates as its work. This opposes technology's mode of production, which Heidegger believes has replaced metaphysics.

Technology, for him, signifies the complete eclipse of the "clearing." In Heidegger's thought the work of art is a "fixing in place" of truth as aletheia that is always already a "letting happen" of this very presencing. This "letting happen" is, in many ways, "the highest task" of preserving the work of art; it is "nothing passive" but rather a "working" and a "willing" (1956, p. 83). Any new paradigms developed by art historians, whether in terms of reconceptualizing the concept of the "viewer" or even the productive activity of the artist vis-à-vis technology, gain from addressing Heidegger's contention that the truth of the work of art is this "letting happen" in the "clearing"—precisely the threshold that constructs and unites in "dif-ference" the *aisthesis* (sensory involvement of the spectator) of the viewer and the *technē* of the artist. The work of art does not belong to the artist who produced it nor does it belong to a particular viewer. Its poetic address is impersonal; it is addressed to the threshold, to the thesis of Being that Heidegger offers to us as "preservers": "to let forth in its radiance and presence" (p. 83). This is diametrically opposed to the *Ge-stell*, the enframing, of technology, which emplaces and stores beings as a mere "standing reserve." Thus, the work of art stands in stark contrast to technology's model of use and consumption. Heidegger's thesis about the work of art is that the past and the future of art is to be decided in the Open between the viewer and the artist, precisely where the work of art is to be "preserved."

Yet his basic contention is that different historical periods are defined by their different understanding of Being. These understandings account for different preoccupations when it comes to works of art. Our postmodern epoch is marked by technology. As a result it has not produced an overcoming of aesthetics, but rather it has only negated it as an anti-aesthetics. But with the logic of aletheia, the overcoming of aesthetics remains present in its absence. There is an aesthetics to come, one grounded not in the viewer or the artist, but in the work of the work of art that constructs and preserves both sides of this Janus-face of aesthetics in the Open. "But the question remains," Heidegger asks, fearing

the answer may very well be technology rather than art, "is art still an essential and necessary way in which that truth happens which is decisive for our historical existence, or is art no longer of this character? If, it is such no longer, then there remains the question why this is so" (1950, p. 78). Perhaps this is the pressing question of Heidegger's work that remains to come.

Further Reading

By Heidegger

1927. *Being and Time*, translated by Joan Stambaugh. Albany: State Univ. of New York Press, 1996.

1950. "The Origin of the Work of Art." In *Poetry, Language, Thought*, translated by Albert Hofstader. New York: Perennial Classics, 2001.

1954. "The Thinker As Poet." In *Poetry, Language, Thought*, translated by Albert Hofstader. New York: Perennial Classics, 2001.

1953. *Introduction to Metaphysics*, translated by Gregory Fried and Richard Polt. New Haven: Yale Univ. Press, 2000.

1956. "Addendum." In *Poetry, Language, Thought*, translated by Albert Hofstader. New York: Perennial Classics, 2001.

1957. *On the Way to Language*, translated by Peter D. Hertz. New York: Harper & Row, 1972.

1977. *Four Seminars*, translated by Andrew Mitchell and François Raffoul. Bloomington: Indiana Univ. Press, 2003.

The Question Concerning Technology and Other Essays, translated by William Lovitt. New York: Harper & Row, 1977.

About Heidegger

Biemel, Walter. "Elucidations of Heidegger's Lecture 'The Origin of the Work of Art' and the Destination of Thinking." In *Reading Heidegger: Commemorations*, edited by John Sallis. Bloomington, Indiana: Univ. Press, 1993.

Clark, Timothy. *Martin Heidegger*. London and New York: Routledge, 2002.

Derrida, Jacques. *Points…: Interviews 1974–1994*, translated by Peggy Kamuf, et al., edited by Elisabeth Weber. Stanford, CA: Stanford Univ. Press, 1995.

Farias, Victor. *Heidegger and Nazism*, translated by Paul Burrell and Gabriel Ricci. Philadelphia: Temple Univ. Press, 1989.

Fóti, Véronique. "Heidegger and 'The Way of Art': The Empty Origin and Contemporary Abstraction." *Continental Philosophy Review* 31 (1998): 337–351.

Gadamer, Hans-Georg. "The Truth of the Work of Art." In *Heidegger's Ways*, translated by John W. Stanley. Albany: State Univ. of New York Press, 1994.

Guignon, Charles, ed. *The Cambridge Companion to Heidegger*. Cambridge, UK: Cambridge Univ. Press, 1993.

Harries, Karsten, and Christoph Jamme, eds. *Martin Heidegger: Politics, Art, and Technology*. London and New York: Holmes & Meier, 1994.

Lacoue-Labarthe, Phillipe. *Heidegger, Art and Politics*, translated by Chris Turner. Oxford: Blackwell, 1990.

Preziosi, Donald. *The Art of Art History: A Critical Anthology*. Oxford: Oxford Univ. Press, 1998.

Vattimo, Gianni. *The End of Modernity*, translated by Jon R. Snyder. Baltimore: The Johns Hopkins Univ. Press, 1991.

Wolin, Richard, ed. *The Heidegger Controversy: A Critical Reader*. Cambridge, MA: MIT Press, 1993.

LUCE IRIGARAY

Key Concepts

- sexual difference
- specul(ariz)ation
- phallocentric
- écriture féminine

Luce Irigaray was born in Belgium in 1930. She earned her master's degree from the University of Louvain in 1955 and taught high school in Brussels until 1959. She then moved to Paris to continue her studies, receiving a psychology diploma in 1962 from the University of Paris. She attended Jacques **LACAN**'s seminars, became a member of his École freudienne, and trained to become an analyst. In 1968, she earned her doctorate in linguistics with a work entitled "Le langage de déments." This led to a teaching post at the University of Paris VIII at Vincennes (1970–1974). Upon publishing *Speculum of the Other Woman* (1974), which argued that psychoanalysis was a phallocentric discourse, she was expelled from the École freudienne by Lacan and lost her faculty position as a result of his actions. Throughout her career, Irigarary has been an active leftist political thinker as well being involved in many women's groups and struggles. Her work has established her as one of the most prominent feminist philosophers in the postwar period.

Unlike some other French feminists with whom she is frequently identified (especially Julia **KRISTEVA**), Irigaray has consistently held that there is in fact such a thing as **sexual difference** and that

female sexual identity is autonomous and unique, grounded in women's specific embodied experiences.

In *Speculum of the Other Woman* and other early works such as *This Sex Which Is Not One* (collected essays published in 1977), she argues that the Western intellectual tradition has essentially elided the feminine, positing it not on its own terms but rather in relation to, or over against, the masculine as the normative human identity. "Woman" in Western discourse has largely been defined as man's other. To demonstrate this, Irigaray enacts a critical mimicry of the discourses of **FREUD**, Plato, and other male intellectuals "about women"—what are they? where do they come from? what are they for?—that demonstrates how "woman" functions primarily as a vague idea that only serves to clarify the concept of "man." She describes this in terms of a process of **specul(ariz)ation**, that is, a process of male speculation about woman as man's other that associates her with a series of othered terms and concepts within a larger set of oppositions that organize the Western patriarchal symbolic order (see Lacan's definitions of the symbolic and imaginary orders in this volume). Within this set of structural oppositions or "interpretative modalities" that shape our understanding of the world, "woman" and the "feminine" are associated in each pairing with the negative term, the term of lack or absence: light-dark, in-out, heavens-earth, and especially phallus-lack, original-derivative, and active-passive. In a chapter entitled "The Blind Spot of an Old Dream of Symmetry" Irigaray writes:

> All these are interpretative modalities of the female function rigorously postulated by the pursuit of a certain game for which she will always find herself signed up without having begun to play. Set between—at least—two, or two half, men. A hinge bending according to their exchanges. A reserve supply of *negativity* sustaining the articulation of their moves, or refusals to move, in a partial fictional progress toward the mastery of power. Of knowledge. In which she will have no part. Off-stage, off-side, beyond representation, beyond selfhood. A power in reserve for the dialectical operations to come. We shall come back to this. (1974, p. 22)

Here one can see both Irigaray's poetic, polysemic writing style and the primary direction her work takes: to posit a female imaginary,

a different sexual economy that would allow for the articulation of women's desire—that would allow a woman to speak as a woman without having to perform as "woman" within the phallocentric symbolic order.

Irigaray situates her critique of the primary structures of Western cultural and political discourse as **phallocentric** in a psychoanalytic register. This allows her to construct a female imaginary that undermines its authority to speak for women and abuse difference in general. Psychoanalytic discourse is critiqued in the process. In psychoanalytic discourse, the "phallus" occupies a primary place since the boy–mother relationship is privileged by Freud and Lacan. In theorizing the castration complex, for instance, female genitalia are inscribed as a lack or absence. Furthermore, Lacan will translate this constitutive lack into language itself. Here the constitution of the male subject in and through language remains a question of the phallus and dispossession. The "phallus" here becomes the signifier of a pre-Oedipal relation with the mother and symbolizes the primary repression that constructs an individual's unconscious. Thus, the discourse and the scopic regime of psychoanalysis are phallocentric; the role played by the phallus as visual index and master signifier within language is that on which the discourse is founded.

Irigaray's desire to posit a female imaginary, which exists prior to the acquisition of a subject position within the phallocentric symbolic order (language), is undertaken in order to end the state of affairs in which the "'feminine' is always described in terms of deficiency or atrophy, as the other side of the sex that alone holds monopoly on value: the male sex" (1977, p. 69). Working against this symbolic reduction of woman to the "other side" of man, Irigaray asserts the nonoppositional difference of a real embodied other woman. Here woman is not reducible to an object of exchange within the male sexual economy. This is an otherness with agency that is unpredictable and irreducible to the male economy. As such, her voice, actions, and ways of seeing (not simply talked about, acted upon, and seen) have a subversive power within that economy. The aim being a "destruc(tura)tion" of the privileged male/masculine subject of Western discourse and society: "A fantastic, phantasmatic fragmentation. A destruc(tura)tion in which the 'subject' is shattered, scuttled, while still claiming surreptitiously

that he is the reason for it all" (1974, p. 135). The woman's subjectivity, therefore, can bring about a collapse of the binary logic of the phallocentric symbolic order, thereby opening up new possibilities for social relations.

Irigaray's philosophy has been charged with biological essentialism, but her primary goal is not the definition of a feminine essence, but a radical ethics of sexual difference. She articulates this female imaginary not through a proscriptive polemic style, but rather through an immanent deconstruction of the primary texts of the phallocentric order (see Jacques **DERRIDA**). Examples of this praxis can be found in her innovative close reading of Maurice **MERLEAU-PONTY** in "The Invisible of the Flesh: A Reading of Merleau-Ponty, 'The Intertwining—The Chiasm'" (1982), where she claims that Merleau-Ponty's phenomenology, with its distinction between sight and touch as well as its insistence on embodied experience, actually performs a feminist epistemology. This line of argument is continued in discussions of **écriture féminine**. This feminist experimental–deconstructive praxis of writing arises in the 1970s with Hélène Cixous's text "The Laugh of Medusa" (1975). *Écriture féminine* is a kind of hysterical–mystical writing with the body that privileges the tactile over the visual; it denotes a radical subject position that resists a simple engendering by the symbolic order, thereby remaining in an indeterminate threshold between "male" and "female." Irigaray is often included in discussions of *écriture féminine* because of the open structure of her texts, which strive to undermine the patriarchal, authoritative voice of the symbolic order.

Irigaray spends little time in her work discussing artistic production or reception. Rather her interest in aesthetics comes across in smaller pieces that are always subsumed into her larger philosophy. The reason she is less concerned with aesthetics as such— only to the degree that it enters her discussion of gender—is her deep commitment to an ethics of difference and her fear that aesthetics overshadows this ethics in contemporary society. Her focus on the body and flesh is understandable in this light. She argues:

> When art shows an awareness of the flesh, this does not mean that the ethics of the couple has been resolved. It gives the nod to the importance of the issue and to its valuable aesthetic potential. There is a danger that ethics should become a

part of aesthetics and seen as secondary to the life of the people, pleasant but not essential to spiritual development. (*Sexes and Genealogies*, 1982, p. 145)

Her point is that the representation of difference does not substitute for the work required to ethically reinscribe the symbolic order, which includes the cultural, political, and religious registers.

The importance of Irigaray's work to our understanding of the ways in which the phallocentric cultural and libidinal economy perpetuates the unequal exchange of women in a patriarchal society is undeniable. Even at their most difficult and, at times frustrating, moments, her texts evince a commitment to an ethics of sexual difference that has influenced not only contemporary feminist art (beginning in the 1970s), but the very discursive practice of art history itself. The manner in which women artists are written about and the ways in which the construction of gender occurs in and through visual representation are indelibly marked by Irigaray's texts. In addition, future work on Irigaray needs to take into account the entirety of her philosophy, rather than myopically focusing on the two early texts *Speculum of the Other Woman* and *This Sex Which Is Not One*. It is in later texts like "A Natal Lacuna" (1994), wherein Irigaray performs a psychoanalytic reading of the work of Unica Zürn, and "How Can We Create Our Beauty" (a chapter in her publication *Je, Tu, Nous: Toward a Culture of Difference*) that Irigaray begins to address art as a way of revisiting the central points of her philosophy. For example, in this latter text, she posits "beauty" as a concept of the "becoming woman" of women—it is a potentiality that challenges the cultural discourse of the same. Here she writes:

> Very often, when looking at women's works of art, I have been saddened by the sense of anguish they express, an anguish so strong it approaches horror.... The experience of art, which I expected to offer a moment of happiness and repose, of compensation for the fragmentary nature of daily life, of unity and communication, or communion, would become yet another source of pain, a burden. (1990, p. 107)

Reminiscent in some ways of Jean-François LYOTARD's concept of the sublime, Irigaray's tenor, however, expresses her difference. The aesthetic experience that is foreclosed—the one of "communication,

or communion"—suggests that her sense of "anguish" is not simply caused by the impossibility of representing a feminine essence, but results from the twilight in which the work of art exists, its exile from the social sphere—our very *sensus communis*. Irigaray's ethics of difference is bound to the construction of a political sphere, and the difficulty works of art have in addressing a community of viewers or even in suggesting the composition of one is the cause of her resistance to prematurely folding ethics into aesthetics. The aesthetic experience of "beauty" remains a potentiality in Irigaray's thought as it undermines the symbolic order, its phallocentric discursivity, with an experience of alterity that it cannot fully take into account. However, how to negotiate the scopic regime so that the aesthetic experience is not circumscribed into just another utterance of the status quo remains an open question. Is it possible for the aesthetic experience, perhaps even the Kantian one in which an ethical demand is placed upon whoever participates in aesthetic judgment, to found an ethical, social space? This is a primary concern of poststructuralist philosophy. With this question, Irigaray's thoughts on aesthetics traverse ethics only to end up face-to-face with **Marx** and Judith **Butler**.

Further Reading
By Irigaray

1974. *Speculum of the Other Woman*, translated by Gillian C. Gill. Ithaca, NY: Cornell Univ. Press, 1985.

1977. *This Sex Which Is Not One*, translated by Catherine Porter. Ithaca, NY: Cornell Univ. Press, 1985.

1982. "The Invisible of the Flesh: A Reading of Merleau-Ponty, 'The Intertwining—The Chiasm.'" In *An Ethics of Sexual Difference*, translated by Carolyn Burke and Gillian C. Gill. Ithaca, NY: Cornell Univ. Press, 1993.

1982. "A Natal Lacuna," translated by Margaret Whitford. *Women's Art Magazine* 58 (May/June 1994): 11–13.

1982. *Sexes and Genealogies*, translated by Gillian C. Gill. New York: Columbia Univ. Press, 1993.

1990. *The Irigaray Reader*, edited by Margaret Whitford. Oxford: Blackwell, 1991.

1990. *Je, Tu, Nous: Toward a Culture of Difference*, translated by Allison Martin. London and New York: Routledge, 1993.

About Irigaray

Battersby, Christine. "Situating the Aesthetic: A Feminist Defence." In *Thinking Art: Beyond Traditional Aesthetics*, edited by Andrew Benjamin and Peter Osbourne. London: Institute of Contemporary Arts, 1991.

Berg, Maggie. "Luce Irigaray's 'Contradictions': Poststructuralism and Feminism." *Signs: Journal of Women in Culture and Society* 17.1 (Autumn 1991): 80-91.

Butler, Judith. *Bodies That Matter: On the Discursive Limits of "Sex."* London and New York: Routledge, 1993.

Cheah, Pheng, and Elizabeth Brosz, eds. "Irigaray and the Political Future of Sexual Difference." *Diacritics* 28.1 (Spring 1998).

Jay, Martin. "'Phallogocularcentrism': Derrida and Irigaray." In *Downcast Eyes: The Denigration of Vision in Twentieth-Century French Thought*. Berkeley: Univ. of California Press, 1993.

Robinson, Hilary. "Louise Bourgeois' 'Cells': Gesturing Towards the Mother." In *Museum of Modern Art Papers*, vol. I, *Louise Bourgeois*, edited by Ian Cole. Oxford: Museum of Modern Art, 1991.

Schor, Naomi. "Previous Engagements: The Receptions of Irigaray." In *Engaging with Irigaray: Feminist Philosophy and Modern Europe*, edited by Carolyn Burke, Naomi Schor, and Margaret Whitford. New York: Columbia Univ. Press, 1994.

Whitford, Margaret. *Luce Irigaray: Philosophy in the Feminine*. London and New York: Routledge, 1991.

JULIA KRISTEVA

Key Concepts

- semiotic
- symbolic
- signifying process
- abjection
- color

Julia Kristeva (b. 1941) is a psychoanalyst and feminist theorist of language and literature. Born in Bulgaria, she moved to Paris in 1965 on a doctoral research fellowship. There she quickly became involved in the leftist intellectual movement that congregated around the literary journal *Tel Quel*, in which Jacques DERRIDA was also a participant. Her most influential teacher during that time was Roland BARTHES. Her doctoral thesis, *Revolution in Poetic Language*, published in 1974, led to her appointment as chair in linguistics at the University of Paris VII, where she has remained throughout her academic career. Since 1979, she has also maintained a psychoanalytic practice.

Kristeva situates her work at the intersection of linguistics, psychoanalysis, and feminist theory. She has written on an impressive array of topics, but overall her interest lies less in the formal structures of language and meaning than in what escapes and disrupts them—the unrepresentable, inexpressible other within language, within the self, and within society. In this presence within language she reads the possibility for revolutionary social transformation.

In *Revolution in Poetic Language*, Kristeva refers to the revolutionary alterity or otherness within language as the **semiotic**, which exists in relation to the **symbolic**. The semiotic is decipherable within language (especially in poetic language), yet it is in tension with the dominant symbolic order that governs language (see Jacques LACAN). Kristeva's semiotic, however, differs from the standard meaning of semiotics as the science of signs. What Kristeva forwards here is a "semanalysis," a combination of semiotics and psychoanalysis that aims at revealing how the laws of the symbolic are resisted. In psychoanalytic terms, the semiotic is associated with the prelinguistic phase and the mother's body. Indeed, Kristeva associates this semiotic element in poetic language with the mother, the child, prelinguistic babbling, and so on. It exists within language as a potentially subversive, eruptive force. The semiotic, then, can never be entirely constrained by the symbolic; it perpetually infiltrates the symbolic construction of meaning, reintroducing fluidity and heterogeneity within the speaking/writing subject. It reopens the process of creation. Kristeva describes it as the "very precondition" of the symbolic order (1974, p. 50). Insofar as the symbolic order of language is identified with consciousness, we can think of the semiotic as language's unconscious. The infiltration of the semiotic within language indexes the continual presence of archaic drives, the loss of relation with one's mother.

Throughout her works, Kristeva focuses on the **signifying process** more than its product. She reads a text in order to discover not only the processes by which it comes to have meaning (signify), but also what it is within the text that resists and undermines that process (see her "The System and the Speaking Subject"). In this respect, we can think of her methodology as a kind of psychoanalysis of texts that does not take their final fixed state for granted. Rather, they are read in order to explore how they came into being, how they came to say what they say, as well as to indicate what was repressed in the process (i.e., what within them keeps them fundamentally unstable). In this manner, we can refer not only to the signifying process, but also to the *signifying economy*, a term Kristeva borrows from FREUD's metapsychology. Her analysis seeks those places in language that open the possibility of individual and social transformation, "the production of a different kind of subject, one capable of bringing about new social relations, and

thus joining in the process of capitalism's subversion" (1974, p. 105). In this way, psychoanalysis takes on a more sociopolitical aspect in her work. In *Strangers to Ourselves* (1998), for example, she calls for open national borders and an ethics of the neighbor whereby immigrants and foreigners are treated with respect. Her argument is premised on the proposition that ethics necessarily begins with the psychoanalytic realization that we are all "strangers to ourselves."

To date Kristeva's theory of **abjection**—a result of the primal loss or sacrifice of the pre-Oedipal bond between mother and child—has been most used in feminist readings of art, especially in relation to performance art. In her own writings on art historical subjects, however, Kristeva focuses on much more traditional topics, primarily Renaissance painting. For her, painting is irreducible to the symbolic order because the form and content of a painting are not merely symptomatic of the historical context in which it was created. Nor is painting an exit from the symbolic; one cannot return to the semiotic order as such. This desire to return to the semiotic—a fantasy of undifferentiated unity—is a source of conflict between her and some other radical feminists. Art and literature, she argues, offer us a means of resistance to the reign of the symbolic; they can interrupt the symbolic order and refashion it.

Kristeva's essay on the Venetian Renaissance painter Giovanni Bellini addresses the figure of the mother in his works, but it also extends beyond the particularities of Bellini's autobiography and his work to discuss his use of light and color in general. In "Motherhood According to Bellini" (1975), she posits:

> The language of art, too, follows (but differently and more closely) the other aspect of maternal jouissance, the sublimation taking place at the very moment of primal repression within the mother's body, arising perhaps unwittingly out of her marginal position. At the intersection of sign and rhythm, of representation and light, of the symbolic and the semiotic, the artist speaks from a place where she is not, where he knows not. He delineates what, in her, is a body rejoicing [*jouissant*]." (1977, p. 242)

The continued presence of this absent experience of unity with the mother is the place from which the artist speaks in visual language.

As such it has the ability to frustrate the symbolic order's proscription of representation and enjoyment (*jouissance*).

Kristeva's assertion about Bellini should be read in light of Freud's work on Leonardo da Vinci, but the distance she travels from Freud's position is most evident in her 1972 essay on Giotto, the Florentine fresco painter who broke with the representational strategies and canon of Byzantine art to initiate the achievements of Renaissance painting in the West. For Kristeva, the symbolic in painting is the iconography and the narrative themes—in short, the accepted artistic canon. But the semiotic, as that which exceeds the principle and limits of the symbolic without transgressing them entirely, are indicated by color and the representation of space in a painting. In works of art, the semiotic element (which indexes the presence of repressed drives, desire, and impulses) escapes from the canonical norms and is able to induce the viewer to take up a new relation to desire. It is this relation to desire that constitutes the "self" in post-Freudian psychoanalysis. It is for this reason that she titles this essay "Giotto's Joy": signifying *jouissance*, the ecstasy of delimiting the "self."

Beyond acknowledging Giotto's work as the harbinger of the episteme of the Renaissance, Kristeva reads the signifying economy in his work vis-à-vis the social context of late medieval northern Italy. His importance, for Kristeva, lies in his use of color and his construction of pictorial space, two elements that break from a visual signifying practice modeled on verbal communication. Color in Giotto's work indicates the abandonment of the traditional signified (Catholic theology), namely, narrative and canonical representation. Kristeva develops this notion of color in her reading of Giotto's frescoes for the Arena Chapel in Padua.

It is Giotto's use of **color**—"a process of liberation *through and against the norm*"—that best represents how Western painting claimed to serve Catholic theology while simultaneously betraying it, abandoning its themes and iconography" (1977, p. 215). In other words, color is the surplus *jouissance* of the semiotic, the complex remainder that escapes the "cathexis of chromatic elements and the ideological values that a particular age places on them" (p. 233).

However, she undertakes this reading of Giotto not only to add to the scholarship on this particular artist, but also as a means of shedding light on modernist painting. Her aim in this essay is "to encourage the return to the ('formal' and ideological) history of

painting's subject within its contemporary production; to present the avant-garde with a genetic-dialectical reflection on what produced it and/or that from which it sets itself apart" (p. 233). In an ambitious reading of the entire history of Western painting from Giotto to Piet Mondrian, Kristeva forwards a theory of color that aids in explicating the transition from figurative realism to abstraction in art. She writes:

> By overflowing, softening, and dialectizing lines, color emerges inevitably as the "device" by which painting gets away from the identification of objects and therefore from realism.... Color is the shattering of unity. Thus, it is through color—colors—that the subject escapes its alienation with a code (representational, ideological, symbolic, and so forth) that it, as conscious subject, accepts. Similarly, it is through color that Western painting began to escape the constraints of narrative and perspective norm (as with Giotto) as well as representation itself (as with Cézanne, Matisse, Rothko, Mondrian). (p. 221)

Kristeva's point here is that the translation of the plastic arts into linguistic categories (the triad of signifier, signified, referent) fails to account for certain aspects of the visual arts such as color. Her examination of color is an interpretative strategy that reveals the limitations of the traditional semiological analysis of art. To correct this myopic focus, she supplements the structure of the sign with the psychic economy Freud develops between perception and thought processes, where thought denotes conscious activity and "thing-presentations" are aligned with perception (the unconscious). Thus, to the semiological definition she adds the "triple register of exterior drives, interior drives, and signifier"— the Freudian economy that problematizes both representation and language (p. 218).

This "semanalysis" is Kristeva's contribution to art historical analysis: her combination of semiotics and psychoanalysis, the triad of the sign with that of the psychic economy. It is through thinking about the work of art and raising questions concerning its interpretation that she challenges the one-way street of traditional semiology: "How can we find our way through what separates words from what is both with a name and more than a name: a painting?... We must develop, then, a second-stage

naming in order to name an excess of names, a more-than-name become space and color—a painting" (p. 210). The answers to this question about both the practice of painting (an artist's biography and sociohistorical context) and the interpretative method only arise only when enjoyment or *jouissance* is adequately taken into account. In "Giotto's Joy," Kristeva attempts to construct a theory of painting that, while informed by linguistics, can grasp the ecstasies of creating and presenting signs, precisely that which exceeds traditional semiological analysis. (See Barthes's *Camera Lucida* for a different version of this discussion.) Giotto's joy, his *jouissance*, is

> the sublimated jouissance of a subject liberating himself for the transcendental dominion of One Meaning (white) through the advent of its instinctual drives, again articulated within a complex and regulated distribution….This chromatic joy is the indication of a deep ideological and subjective transformation; it discreetly enters the theological signified, distorting and doing violence to it without relinquishing it. (p. 224)

Nothing less than the ecstatic transformation of the individual as well as the collective is what Kristeva desires from art: the irruption of the semiotic into the tyranny of the symbolic.

Further Reading

By Kristeva

1973. "The System and the Speaking Subject." In *The Kristeva Reader*, edited by Toril Moi. New York: Columbia Univ. Press, 1986.

1974. *Revolution in Poetic Language*, abridged and translated by Margaret Waller. New York: Columbia Univ. Press, 1984.

1977. *Desire in Language: A Semiotic Approach to Literature and Art*, edited by Leon S. Roudiez. New York: Columbia Univ. Press, 1980.

1980. *Julia Kristeva: Interviews*, edited by Ross Mitchell Guberman. New York: Columbia Univ. Press, 1996.

1980. *Powers of Horror: An Essay on Abjection*, translated by Leon S. Roudiez. New York: Columbia Univ. Press, 1982.

1988. *Strangers to Ourselves*, translated by Leon S. Roudiez. New York: Columbia Univ. Press, 1998.

About Kristeva

Beardsworth, Sara. *Julia Kristeva: Psychoanalysis and Modernity*. Albany: State Univ. of New York Press, 2004.

Oliver, Kelly, ed. *Ethics, Politics, and Difference in Julia Kristeva's Writings*. London and New York: Routledge, 1993.

Oliver, Kelly. *Reading Kristeva: Unraveling the Double-Bind*. Bloomington: Indiana Univ. Press, 1993.

Smith, Anne-Marie. *Julia Kristeva: Speaking the Unspeakable*. London: Pluto Press, 1998.

JACQUES LACAN

Key Concepts

- orders: Symbolic, Imaginary, and Real
- unconscious
- *objet a*
- subject
- mirror stage
- desire
- gaze

Jacques Lacan (1901–1981) was born in Paris to a Roman Catholic family. He earned a medical degree at the Sorbonne and then trained as a psychoanalyst. His relationship with mainstream psychoanalysis in Europe was tense, and he resigned from the Société psychoanalytique de Paris in 1953—the same year he gave his famous lecture "The Function and the Field of Speech and Language" at the International Psychoanalytic Association in Rome (also referred to as "The Rome Discourse"). In that same year he inaugurated his weekly seminar, which continued almost until his death. Lacan's seminar was the primary venue for sharing his work. Most of his published essays were originally given as papers in his seminars, which were attended by many influential intellectuals, including Julia KRISTEVA and Luce IRIGARAY. In 1963, he founded the École freudienne de Paris.

Focused on the formation of the subject and the role of the unconscious, Lacan's work constitutes a radical reinterpretation of

Freud in the light of structuralism (especially the structural linguistics of **Saussure** and the structural anthropology of Lévi-Strauss). Lacan's famous assertation is that the "unconscious is structured like a language." Dissenting from the common conception, widespread among his contemporaries, of the ego or conscious self as autonomous, sovereign, and biologically determined, Lacan theorized that it was interpolated within a system of meaning that it had no part in creating. Far from being autonomous and sovereign, it becomes a self or an ego—an "I"—when it is subjected to a preexisting **Symbolic** order. The **unconscious**, is not a biologically determined realm of libidinal drives; rather, it is formed in tandem with the formation of the ego. It is the remainder (what Lacan calls the *objet (petit)* **a**) of the ego's subjection to the Symbolic (at times also referred to as *Autre*); that is, it is created as the excess of unadulterated pleasure that does not fit with the conception of the self as formed by primary repression or the acquisition of language. Thus, the unconscious reveals the presence of the **subject** within the construct of the self. For this reason Lacan will state that the subject is on the side of the unconscious; that is where it will be found. Far from being an autonomous, sovereign agent in the world, the ego is an illusion, a symbolically constructed identity whose excesses and aporias are revealed by the eruptions of the unconscious into conscious life.

Besides the Symbolic, which we will return to in a moment, Lacan's theory of the subject relies upon two other orders: the **Imaginary** and the **Real** (these three orders are inseparable and produce one another in his thought). The Imaginary is developed in tandem with Lacan's well-known formulation of the **mirror stage** (for a clear discussion of both, see "The Mirror Stage as Formative of the Function of the I as Revealed in Psychoanalytic Experience," first presented in 1949). It is important to note that Lacan, while addressing the mirror stage in his early work, continues to revisit this concept throughout his career, revising and refining it. He identifies the mirror stage as an important means by which the child is inaugurated into the Imaginary. He understands the Imaginary as preceding the child's entry into the Symbolic and continuing to operate along with it throughout life. The Imaginary is the order in which the child becomes aware of itself as a specular image. It is in this order that the ego is created through an illusory representation, which Lacan terms a

"misrecognition" (*méconnaissance*). In general, the Imaginary is the general matrix of *self as other* as well as *self and other* structured by this logic of "misrecognition."

Lacan argues that the mirror stage occurs between the ages of six and eighteen months, when the child first recognizes itself in a mirror as a seemingly coherent whole entity. In this moment, before the child can speak or even walk, the child recognizes itself as other, as an objectification of itself in an image whose point of view and position are external. In other words, the mirror stage "describes the function of the ego via the process of identification; the ego is the result of identifying with its own specular image....The baby sees its own image as a whole, and the synthesis of this image produces a sense of contrast with the uncoordination of the body, which is experienced as a fragmented body" (Evans, 1996, p. 115). In this respect, the mirror stage, which inaugurates the Imaginary, may be seen as "one of those crises of alienation around which the Lacanian subject is organized, since to know oneself through an external image is to be defined through self-alienation" (Silverman, 1983, p. 158). The construction of the ego or the self is accomplished through an act at once narcissistic and aggressive. The aggressivity is between both the subject and its body-image and between the subject and others (for example, the parent who holds the child before the mirror).

According to Lacan's often criticized narrative of child development, the child's entry into language coincides with its separation from the mother. The mother, therefore, is the child's first experience of lack-absence, which creates the condition of desire. The father intervenes in the mother–child relationship at a moment coinciding with the child's entry into the Symbolic and loss of union with the mother. In this schema, the father is identified with this order which constitutes and governs subjectivity. For this reason, Lacan sometimes calls the Symbolic *le Nom-du-Père* ("the Name of the Father"), which in French is pronounced the same as *le Non-du-Père* ("the No of the Father"), thus signifying Godlike authority and prohibition.

Lacan develops this understanding of ego formation and the unconscious vis-à-vis the structural linguistics of Saussure. For Lacan, the birth of subjectivity is one's entry into language, understood as a synchronic system of signs and social codes that generate meaning. It is the Symbolic that locates and "subjects"

you, thereby enabling the becoming of a self, an "I." Before Lacan, most psychoanalysts believed that the development of the ego as the seat of consciousness was a biological development. Lacan's radical inflection of this premise is to insist that birth into language is birth into subjectivity. As he famously pronounced in "The Rome Discourse," "Man thus speaks, but it is because the symbol has made him man" ("The Function and Field of Speech and Language in Psychoanalysis," 1956, p. 65). And later in the same essay: "Symbols in fact envelop the life of man with a network so total that they join together those who are going to engender him 'by bone and flesh' before he comes into the world" (p. 67).

The Real is the order in Lacan's system that underwrites, so to speak, the actions described in the Imaginary and the Symbolic. He posits that the subject emerges from its nonindividuated, prelinguistic state of being not into unmediated reality but into a culturally constructed world of symbols. The *objet a* is precisely a remnant of this prior state that remains embedded within the Symbolic and, in fact, it determines the entirety of the subject's position within the field of signification. Moreover, the *objet a* is not the specular image of the Imaginary; rather, it is the object-cause of desire that makes us seek pleasure or enjoyment (*jouissance*) in the other. The *objet a* is, therefore, an irreducible alterity within the self, residing between the Real and Imaginary.

Lacan terms this prior, undifferentiated state as the Real because it is "absolutely without fissure" (1978, p. 97). The Real is that which resists symbolization. For this reason Lacan will argue that the Symbolic introduces "a cut in the real." The constitutive inability to signify the Real is why Lacan discusses it in relation to anxiety and trauma. Nonetheless, throughout the life of a subject there are moments in which the remnant of the Real is approached. In these encounters there is a potentiality for the self to embody that portion of itself—the *objet a*—that it repudiates.

In *Seminar XI: The Four Fundamental Concepts of Psychoanalysis* Lacan states: "Where do we meet this real? For what we have in the discovery of psychoanalysis is an encounter, an essential encounter—an appointment to which we are always called with a real that eludes us" (p. 53). To denote this cause of anxiety, this chance encounter with the Real, Lacan uses the Aristotelian terms *tuché* and *automaton*. The term *automaton* refers to the behavior of the self within the Symbolic or, in other words, the behavior of the

signifying chain within language. This behavior is structural because it is formed in relation to that which resists and yet instigates the signifying chain: the *objet a*, the surplus of the Real. For this reason, Lacan understands the *tuché* to be the encounter: "The real is beyond the automaton, the coming-back, the insistence of the signs by which we see ourselves governed by the pleasure principle.... The function of the *tuché*, of the real as encounter—the encounter insofar as it may be missed, insofar as it is essentially the missed encounter [is] that of the trauma" (1973, pp. 53–54, 55). Here we see how Lacan reinscribes Freud's notion of the pleasure principle. Lacan explains that Freud's system demonstrates how human beings are always kept just shy of pleasure; there is no pleasure as such because it is never attained. Lacan, however, argues that what we desire is the very structure of **desire**: the frisson between the *automaton* and the *tuché*, the pleasure derived from the chance encounter that interrupts and undermines the very ground on which we stand.

As mentioned above, the unconscious is formed at the same time as the self/ego. It is an after-effect of the repression that takes place during subjection. Ego formation requires repression of whatever does not fit the image of the self constructed within the Symbolic. The unconscious is the "censored chapter" in the history of psychic life ("The Function and Field of Speech and Language in Psychoanalysis," 1956, p. 50). Alterity resides at the heart of the self, manifesting itself in and through language, often as interruption—misspeakings, slips, and forgetting names. But also in the curious linguistic constructions to which Lacan pays close attention. Constructions like *ne* in French or *but* in English: as in "I couldn't help but overhear." The agent of this statement is indeterminate. It is Lacan's position that when statements like this are made they indicate the presence of the Real in the Symbolic, which suggests the troubling and illusory nature of specular and linguistic identity. In other words, the intervention of the unconscious within conscious existence reveals the fact that the self is a tentative construct, by no means entirely stable, permanent, or discrete. In Lacan's words, "the unconscious is that part of the concrete discourse ... that is not at the disposal of the subject in re-establishing the continuity of his conscious discourse" (p. 49). This interruption or encounter indexes the presence of the Real within language, the immanent plane in which the subject is defined through a structure of desire.

The emphasis on the encounter with the Real, although thoroughly Lacanian, bears some similarity to the Surrealists' notion of the poetic "encounter": the sublation of the fantastic and the quotidian into a "surreality." This affinity between Lacan's work and the Surrealists has a long background. Early in his career Lacan was a participant in the Surrealist circle in Paris. In fact, he published some early works in the Surrealist journal *Minotaure* in the 1930s. These works show an affinity with the work of Georges **Bataille** and Salvador Dalì.

But Lacan's work helps the study of art history in a more decisive manner. In *Seminar VII: The Ethics of Psychoanalysis* Lacan discusses art as one of the primary means by which we take up a relation to the Real. He aligns art with the Freudian concept of repression (*Verdrängung*) by arguing that art represses the Real through sublimation. By developing his idea of art in relation to Kantian sublimation, Lacan tethers his discourse on art not only to that of Kant, but also to the thought of Plato and Martin **Heidegger**. Sublimation, he argues, is a change in status of the object that "raises an object to the dignity of the Thing" (1986, p. 112). The "Thing" in question here is the Freudian Thing or *das Ding*, that which is completely other or alien and therefore an index of the Real. (In his later work, Lacan denotes *das Ding* with the idea of the *objet a* discussed above.) A sublimated object, by being elevated to the status of *das Ding*, exerts a power of fascination and anxiety. This is one of the reasons why Lacan also links art, via repression, to hysteria. Art represses the Real and yet, through that very act, simultaneously acknowledges it by attempting to represent it.

In addition, Lacan spends nearly the entirety of his eleventh seminar on the **gaze**. This allows him the opportunity to survey Western painting from the advent of perspective in the Renaissance to Cézanne. The gaze, for Lacan, indicates a split with the eye/sight. Drawing on the phenomenological work of Jean-Paul Sartre and Maurice **Merleau-Ponty**, Lacan argues that sight examines the object, but that the gaze comes from the object; there is an asymmetry between the sight of the self and the gaze of the thing that looks back. In summarizing this point, Lacan states: "When ... I solicit a look, what is profoundly unsatisfying and always missing is that—*You never look at me from the place from which I see you*" (1973, p. 103). This schism between sight and the gaze is another indication of the fundamental "misrecognition"

of the self, the distinction that grounds all of Lacan's work: the subject within the self.

Beginning from Lacan's astute explication of Hans Holbein's sixteenth-century anamorphic painting *The Ambassadors* (1933), art and film historians have elaborated on the concept of the gaze. One of the most important of these subsequent readings is Laura Mulvey's "Visual Pleasure and Narrative Cinema" (1975). This essay provides a feminist reading of Lacan while simultaneously utilizing his theory of the gaze to interrogate the psychic and social interpellation of gender in cinema.

To conclude, Lacan's emphasis on the gaze as a lure, as a proleptic gesture of the act of traversing the fantasy that marks the end of analysis in his system, also provides him the opportunity to elaborate on some intriguing comments he makes in *Seminar VII*. The most pressing of these is his contention that "at a given moment one arrives at illusion. Around it one finds a sensitive spot, a lesion, a locus of pain, a point of reversal of the whole history, insofar as it is the history of art and insofar as we are implicated in it … [therefore] the expression 'history of art' is highly misleading" (1986, pp. 140–141). This comment clearly demarcates the difference between Lacan and Freud's positions regarding art. Freud values art in a classical liberal humanist sense. He champions artistic creation and the imagination of "the great artist." Freud reads sublimation as a process by which sexual libido is redirected into nonsexual, socially acceptable outlets. This understanding of sublimation intersects with his diagnosis of Western society in *Civilization and Its Discontents* (1930). For this reason, Freud spends considerable time on the biographies or "pathographies" of artists and writers (cf. his essays "Creative Writers and Day-Dreaming" [1907] and "The Moses of Michelangelo" [1914]).

Lacan, as we have seen, also takes up the idea of sublimation, but in a much different vein. The key distinction is Lacan's complete rejection of "psychobiography" (his term) when it comes to art history. This is why in *Seminar XI*, when explaining his interest in Edvard Munch, James Ensor, and other painters, he declares: "This is not the occasion to begin a psychoanalysis on the painter.… Nor is it a question of art criticism … [it] is not to enter into the shifting, historical game of criticism, which tries to grasp what is the function of painting at a particular moment, for a particular author at a particular time. For me, it is at the radical

192 THEORY FOR ART HISTORY

principle of the function of this fine art that I am trying to place myself" (pp. 109, 110). Lacan's interest in art and literature stems from his desire to explain the intimate connections between how we represent ourselves vis-à-vis desire. It is the gaze that fractures our relation to the work of art; a gaze that implicates us in a larger, de-limited structure of individual and social identity construction. Lacan's work sets art historians and art critics two tasks. The first is not to disavow the desire of the viewer. One's reading of an artwork is determined in large part by one's subject position. Second, Lacan's explications of painting and literature are meant to serve as allegories for the training of analysts: to show them how to listen, read, and interpret the analysand's discourse. Lacan is emphatic when he instructs his audience to "please give more attention to text than to the psychology of the author—the entire orientation of my teaching is that" (1978, p. 153). But he is equally emphatic when he derides what he calls "applied psychoanalysis." Rather than merely applying the insights Lacan's thought provides, the ethic of that very thought demands a radical redefinition of what we traditionally refer to as art history and aesthetics. The goal of Lacan's work is to change discourses, to interrupt the fantasy of "misrecognition." Any application of his work that refuses this ethical call misses the point.

Further Reading

By Lacan

1949. "Mirror Stage as Formative of the I Function, as Revealed in Psychoanalytic Experience." In *Ecrits: A Selection*, translated by Bruce Fink. New York: W.W. Norton, 2002.

1956. "The Freudian Thing, or the Meaning of the Return to Freud in Psychoanalysis." In *Ecrits: A Selection*, translated by Bruce Fink. New York: W.W. Norton, 2002.

1956. "The Function and Field of Speech and Language in Psychoanalysis" In *Ecrits: A Selection*, translated by Bruce Fink. New York: W.W. Norton, 2002.

1973. *The Seminar of Jacques Lacan Book XI: The Four Fundamental Concepts of Psychoanalysis*, translated by Alan Sheridan. New York: W.W. Norton, 1978.

1978. *The Seminar of Jacques Lacan Book II: The Ego in Freud's Theory and in the Technique of Psychoanalysis: 1954–1955*, translated by Sylvana Tomaselli. New York: W.W. Norton, 1988.

1986. *The Seminar of Jacques Lacan Book VII: The Ethics of Psychoanalysis: 1959–1960*, translated by Dennis Porter. New York: W.W. Norton, 1992.

About Lacan

Adams, Parveen, ed. *Art: Sublimation or Symptom*. New York: Other Press, 2003.

Brennan, Teresa, ed. *Between Feminism and Psychoanalysis*. London and New York: Routledge, 1989.

Conley, Tom. "The Wit of the Letter: Holbein's Lacan." In *Vision in Context: Historical and Contemporary Perspectives on Sight*, edited by Teresa Brennan and Martin Jay. London and New York: Routledge, 1996.

Copjec, Joan. *Read My Desire: Lacan against the Historicists*. Cambridge, MA: MIT Press, 1994.

Evans, Dylan. *An Introductory Dictionary of Lacanian Psychoanalysis*. London and New York: Routledge, 1996.

Feldstein, Richard, Bruce Fink, and Maire Jannus, eds. *Reading Seminar XI: Lacan's Four Fundamental Concepts of Psychoanalysis*. Albany: State Univ. of New York Press, 1995.

Fink, Bruce. *The Lacanian Subject: Between Language and Jouissance*. Princeton, NJ: Princeton Univ. Press, 1995.

Mulvey, Laura. "Visual Pleasure and Narrative Cinema." In *Visual and Other Pleasures*. Bloomington: Indiana Univ. Press, 1989.

Regnault, François. "Art After Lacan." *lacanian ink* 19 (Fall 2001): 48–69.

Silverman, Kaja. *The Subject of Semiotics*. Oxford: Oxford Univ. Press, 1983.

Žižek, Slavoj. *Looking Awry: An Introduction to Jacques Lacan through Popular Culture*. Cambridge, MA: MIT Press, 1992.

EMMANUEL LEVINAS

Key Concepts

- ethics as first philosophy
- otherness (alterity)
- face-to-face encounter
- transcendence

Emmanuel Levinas (1906–1995) was born in Kovno, Lithuania, where his parents were part of a distinguished Jewish community. In 1923 he moved to Strasbourg, where he studied philosophy. From 1928 to 1929 he studied phenomenology with Edmund Husserl in Freiburg. It was there that he met Martin **HEIDEGGER**, one of the primary figures in Levinas's thought. Levinas's doctoral thesis was entitled *The Theory of Intuition in Husserl's Phenomenology* (1930). Before World War II, Levinas moved to Paris and began teaching at the École Normale Israélite Orientale. In 1935, he published "On Escape" (1935) in *Recherches philosophiques*, an essay that evinces his desire to move beyond a discussion of phenomenological being. During the war, Levinas volunteered for the French military, serving as a translator of German and Russian. He was captured by the Nazis and spent the remainder of the war in a prisoner-of-war camp. Many members of his family, including his parents, were murdered by the Nazis. Fortunately, however, his wife and daughter survived in France. Levinas has described his life as dominated by the memory of exile and the Holocaust. After the war, he was reunited with his wife and daughter in Paris, where

he participated in Talmudic studies with the famous Monsieur Chouchani (who was then also teaching the young Holocaust survivor Elie Wiesel, another Lithuanian). Levinas became director of the Alliance Israélite universelle, but did not begin his university career until the publication of his first major work, *Totality and Infinity*, in 1961. He was appointed professor of philosophy at Poitiers, before moving on to the University of Paris-Nanterre in 1967, and finally to the Sorbonne, from where he retired in 1976.

For most of his career, Levinas remained a relatively obscure philosopher, known primarily for his essays on the Talmud and interpretations of Husserl and Heidegger. The latter, especially his work on Husserl, exerted a strong influence on Jean-Paul Sartre and Simone de Beauvoir in their construction of Existentialism. Much attention was drawn to his work in 1963 by Jacques **DERRIDA**'s famous essay on *Totality and Infinity* entitled "Violence and Metaphysics in the Thought of Emmanuel Levinas." Derrida's essay, although critical of some of Levinas's major points, demonstrates how Levinas's articulation of responsibility and alterity provides further possibilities for ethics. Throughout his life, Derrida remained a primary interlocutor for Levinas's work, calling his thought "an immense event of this century" (Derrida, 1963, p. 153). Subsequent to the publication of Derrida's essay Levinas's influence has grown immensely. His work on Jewish experience and philosophy (Talmudic readings and interpretations of thinkers like Franz Rosenzweig and Martin Buber) as well as how he employs the premises of phenomenology to reinscribe its discourse, plays a central role in any discussion of critical theory. Levinas died in 1995, but his legacy has yet to be fully established.

Central to his philosophy is the claim that ethics and not ontology is the basis of philosophy (i.e., first philosophy). **Ethics as first philosophy**—one's responsibility for and obligation to the other—is what makes metaphysics possible. Because philosophy posits ontology as first philosophy, Levinas's contention challenges the very foundations of Western metaphysics. This leads to his examination of what he terms "prephilosophical" texts (primarily Russian literature and the Bible). The central theme of an inescapable obligation to care for the other differs from the subject–object relation as discussed by Sartre. In Sartre's work the subject–object relation is one fraught with antagonism and alienation. For

Levinas, the dictum of the Oracle at Delphi to "know yourself" is impossible without the other. **Otherness (alterity)** is the not-me, that which is beyond or exterior to my own self-understanding and sense of the world. This other is not an abstraction, but a radical exterior tied directly to another human being. Levinas grounds his argument that we are always responsible for and to the other in a rigorous discussion of phenomenology and ethics.

The condition of the "self" or "me" (*L'même*, the same) in this relation is one of passivity because in the face-to-face encounter with the absolute other (*Autrui*) one is required to respond: to recognize the other without any mediating factors such as religion, law, or philosophy. Ethics is first philosophy because there are no meditating factors in the primal need to respond to the other. The **face-to-face encounter** with the other is one in which the traditional subject does not exist except in its obligation to this other face whose presence calls to mind the biblical injunction "Thou shall not kill." This prohibition is both literal and metaphorical for Levinas, who argues that to deny the other's existence by reducing alterity to sameness constitutes "killing." If the subject "makes sense" of the other according to a preexisting system of thought, explains the other away, or regards the other as a means to an end, then alterity is killed. The face-to-face encounter with alterity is the "ultimate situation" because it is "present in its refusal to be contained" (1961, pp. 81, 194). It obliges "me" to open myself to it, thereby sacrificing my own sense of self-contained identity and any sense of security.

This relation with alterity is the primal encounter from which all language and communication are made possible. In the face of the other we must acknowledge a responsibility for the other. In this dialogical I–thou relation that Levinas adapts from Buber's famous text *I and Thou* (*Ich und Du*, 1923) to look into the face of the other is not only to hear the injunction not to kill, but also to experience responsibility for the other. This inescapable responsibility is not the result of a sovereign decision on the part of an autonomous subject, but rather it is the condition which preexists and founds any notion of a subject. With a term borrowed from Heidegger, one could discuss Levinas's thesis as one in which we are "thrown" into responsibility: it is an unconditional demand that is made upon me. For this reason the face-to-face encounter is an exposure

without moralism or pathos; to recognize the other exceeds even cognition. Levinasian ethics represent an alternative to the concept of being that grounds Western metaphysics. In this condition of responsibility one does not know what to do or what is expected of one. This is precisely the in-between of ethics as first philosophy.

Levinas's critique of phenomenology, especially Heidegger's ontology of *Dasein*, is a critique of Western philosophy as a philosophy of "totality." Rather than thinking "totality," the same, or being, Levinas thinks ethics and alterity. The stakes of his critique are high, but the consequences of the idealism of "totality"—the dream/nightmare of Western philosophy—are much worse. In "On Escape" (1935) Levinas's words are pointed and direct:

> [T]he value of European civilization consists incontestably in the aspirations of idealism, if not in its path: in its primary inspiration idealism seeks to surpass being. Every civilization that accepts being—with the tragic despair it contains and the crimes it justifies—merits the name "barbarian"....It is a matter of getting out of being by a new path, at the risk of overturning certain notions that to common sense and the wisdom of the nations seemed the most evident. (p. 73)

One can read the trajectory of Levinas's work *in toto* in this early statement. To find "new paths" in order to "get out of being" is a call for nothing less than an escape from the very confines of Western philosophy as such. This is evident in his concept of **transcendence**. The face-to-face encounter with alterity is a form of religious experience, albeit not the kind of religious experience that affirms the foundations of religious certainty. In one's responsibility for the other, an awareness arises of the wholly other. Levinas often discusses the individual face of the other—that singularity—as the trace of God. Thus, the encounter with the other is one of responsibility that is simultaneously an encounter with transcendence. Transcendence is the experience of the "trace of the other," completely outside of the self, what is beyond exterior, and yet that which remains the most intimate relation. For Levinas, transcendence is not the totality of the same that he sees as the barbaric foundation of Western metaphysics and politics.

Levinas's ethics has been subjected to several critiques, not only by Derrida, but also by Alain Badiou in his polemical text *Ethics: An Essay on the Understanding of Evil* (1998). But the intersection of Judeo-Christian thought and modern European philosophy has made Levinas's work central to a variety of disciplines, including literary studies. In terms of art history, there has been very little written on the implications of Levinas's concept of ethics and responsibility. There remains much work to be done.

One place to begin is Levinas's essay "Reality and Its Shadow," which appeared in a 1948 issue of the famous journal *Les Temps Modernes*. Interestingly, it appeared in the issue that followed the appearance of Sartre's "What Is Writing?" and it bears on Sartre's conception of "committed" art. Levinas argues that our "confrontation" with works of art raises questions about the fundamental face-to-face encounter. He argues that art opens an "interval" or "meanwhile" between representation and reality. In an argument that cites Plato as well as Heidegger, Levinas argues that art shadows reality. This "doubling" allows art to be a mode of escape (*l'evasion*) from the responsibility we have to others because by focusing on the play of appearance—the shadow of reality—we forget our obligation to the face-to-face (authentic) encounter that precedes any discussion of being and through which a just world is created. Challenging the position of art for art's sake, or "artistic idolatry" as he calls it, Levinas asserts that the "world to be built is replaced by the essential completion of its shadow. This is not the disinterestedness of contemplation but of irresponsibility" (p. 126).

To counter this mode of escape, Levinas calls for an art criticism that can redirect our attention on the art object back to the sphere of human interaction and ethical responsibility. "If art originally were neither language nor knowledge, if it were therefore situated outside of 'being in the world' which is coextensive with truth, criticism would be rehabilitated. It would represent the intervention of the understanding necessary for integrating the inhumanity and inversion of art into human life and into the mind" (1948, p. 118). The task of art criticism here is to undermine the privileged and atemporal realm in which an artwork is said to exist. Rather than discussing the "eternal duration of the interval" (Levinas uses the enigmatic smile of Leonardo's *Mona Lisa* as an example), which is

the "sad value" of the beautiful in modernity, art criticism should focus on the "eternity of a concept" which is "the meanwhile, never finished, still enduring—something inhuman and monstrous" (p. 125). Levinas calls for an art criticism of the "interval" to deny the "essentially disengaged" position of art, which "constitutes, in a world of initiative and responsibility, a dimension of evasion" (p. 126). The "aesthetic event," which is obscured by art criticism and art history, must become the center of any exegesis even though it eludes simple cognition. Too often the experience of the interval becomes reified as myth, rather than disclosing philosophical truth. Levinas calls for art historians to be silent *and* to interpret the artwork: "the immobile statue has to be put into movement and made to speak" (p. 127). The key here is that this concept of "being made to speak" is not ventriloquism, but an ethical responsibility for alterity. The artwork face-to-face opens us to an encounter and, therefore, we must not simply enfold this experience into the preexisting narrative of our lives. This concept has been at the center of many discussions of art history and critical theory, especially postcolonial theory. But those calls, while ethical, remain within a dimension of politics. With Levinas, the ethical turn is not what remains to be done, but what will have been done if there is to be any discourse between subjects and objects that is not merely the totality of the same.

Further Reading

By Levinas

1935. *On Escape*, translated by Bettina Bergo. Stanford, CA: Stanford Univ. Press, 2003.

1948. "Reality and Its Shadow." In *The Continental Aesthetics Reader*, edited by Clive Cazeaux. London and New York: Routledge, 2000.

1961. *Totality and Infinity: An Essay on Exteriority*, translated by Alfonso Lingis. Pittsburgh: Dusquesne Univ. Press, 1969.

1981. *Otherwise than Being or Beyond Essence*, translated by Alphonso Lingis. Pittsburgh: Duquesne Univ. Press, 1998.

1983. *Difficult Freedom: Essays on Judaism*, translated by Seán Hand. Baltimore: The Johns Hopkins Univ. Press, 1997.

1983. *Ethics and Infinity: Conversations with Philippe Nemo*, translated by Richard A. Cohen. Pittsburgh: Dusquesne Univ. Press, 1985.

1983. *The Levinas Reader*, edited by Seán Hand. Oxford: Blackwell, 1990.

About Levinas

Blooechl, Jeffrey, ed. *The Face of the Other & the Trace of God: Essays on the Philosophy of Emmanuel Levinas*. New York: Fordham Univ. Press, 2000.

Caygill, Howard. *Levinas and the Political*. London and New York: Routledge, 2002.

Cornell, Drucilla. *The Philosophy of the Limit*. New York and London: Routledge, 1992.

Critchley, Simon, and Robert Bernasioni, eds. *The Cambridge Companion to Emmanuel Levinas*. Cambridge, UK: Cambridge Univ. Press, 2002.

Derrida, Jacques. 1963. "Violence and Metaphysics: An Essay on the Thought of Emmanuel Levinas." In *Writing and Difference*, translated by Alan Bass. Chicago: Univ. of Chicago Press, 1978.

Derrida, Jacques. *Adieu to Emmanuel Levinas*, translated by Pascale-Anne Brault and Michael Nass. Stanford, CA: Stanford Univ. Press, 1999.

Hand, Seán, "Shadowing Ethics: Levinas' View of Art and Aesthetics." In *Facing the Other: The Ethics of Emmanuel Levinas*, edited by Sean Hand. Richmond, Surrey: Curzon, 1996.

Hollander, Dana, "Levinas, Emmanuel." In *The Johns Hopkins Guide to Literary Theory and Criticism*, 2nd ed., edited by Michael Groden, Martin Kreiswirth, and Imre Szeman. Baltimore: The Johns Hopkins Univ. Press, 2004.

Hutchens, B.C. *Levinas: A Guide for the Perplexed*. New York and London: Continuum, 2004.

Jay, Martin. "The Ethics of Blindness and the Postmodern Sublime: Levinas and Lyotard." In *Downcast Eyes: The Denigration of Vision in Twentieth-Century French Thought*. Berkeley: Univ. of California Press, 1993.

van de Vall, Renée. "Touching the Face: The Ethics of Visuality between Levinas and a Rembrandt Self-Portrait." In *Compelling Visuality: The Work of Art in and out of History*, edited by Claire Farago and Robert Zwijnenberg. Minneapolis: Univ. of Minnesota Press, 2003.

Wall, Thomas Carl. *Radical Passivity: Levinas, Blanchot, and Agamben*. Albany: State Univ. of New York Press, 1999.

JEAN-FRANÇOIS LYOTARD

Key Concepts

- metanarrative
- postmodern condition
- petits récits
- differend
- event
- figure
- aesthetics of the sublime
- avant-garde

Jean-François Lyotard (1924–1998) was born in Versailles, France. He studied phenomenology under Maurice **MERLEAU-PONTY**. His doctoral work was entitled *Discours, figure* (1954). Lyotard began his academic career as a secondary school teacher in Algeria. It was there that he witnessed firsthand the brutality and oppression of colonialism. Throughout his life, Lyotard was politically active. He played a primary role in several leftist political groups, including one called *Socialisme ou barbarie*, from 1953 to 1963, which was comprised of intellectuals (Jean Laplanche and Claude Lefort, among others) and workers. This group wrote critical pieces about the French presence in Algeria and served as a kind of political model for many of the groups formed in the aftermath of May 1968 in Paris. Lyotard taught at the University of Nanterre and the University of Paris, in addition to holding posts at several American universities such as Yale, Emory, and the University of California,

Irvine. Besides being closely associated with postmodernism and a philosophy of desire, Lyotard's work is wide ranging, covering topics as diverse as linguistic and political philosophy, aesthetics, and literature. His interest in art and art history led to his role as the curator of a 1985 exhibition, *Les Immatériaux*, at the Centre Georges Pompidou in Paris.

From his earliest work, Lyotard resisted the structuralist "linguistic turn" that emphasized the way language shapes experience, and which was so influential among his contemporaries in France during the 1950s and 1960s (for example, LACAN and BARTHES). He insisted, rather, that there is always a gap between experience and language, and that one must not rule out extralinguistic experience. Language does not construct experience completely because there are events that language does not and cannot represent.

Lyotard's two most influential publications are *The Postmodern Condition: A Report on Knowledge* (1979), originally written as a report on the current state of knowledge for the government of Quebec, and *The Differend: Phrases in Dispute* (1982). The two texts are closely related and together provide a valuable introduction to Lyotard's philosophy.

A key concept in *The Postmodern Condition* is "**metanarrative**," or "grand narrative." Lyotard uses the term to refer to the overarching mythic narratives that individuals and societies use to structure knowledge and legitimate truth-claims. A metanarrative locates a current situation, whether individual or communal, within a larger narrative structure that plots movement toward some ultimate objective, such as progress, the triumph of reason, the victory of the proletariat, or redemption. These types of single, unified accounts of events are totalizing structures that claim to resolve difference.

The **postmodern condition**—ascribed to the contemporary West by Lyotard—is one in which there is an increasing "incredulity" and distrust toward metanarratives. Lyotard asserts that metanarratives are being replaced by a proliferation of *petits récits*, "little stories" or testimonies that draw attention to the particular as opposed to the universal, that is, to local events, individual experiences, heterodox ideas, and other practices and narratives that are not included in the predominant metanarratives (Christianity, Marxism, and so forth). Within the postmodern condition there is a newfound

interest in difference and dissension that challenges the drive toward homogeneity, which Lyotard describes as "totalitarian." Against this drive, he urges us to "wage war on totality; let us be witnesses to the unpresentable; let us activate the differences and save the honor of the name" (1979, p. 82).

Lyotard continues this line of thought, adding an ethical imperative, in *The Differend*. Here he uses the term "**differend**" to explain the silencing of particular differences that do not fit within larger conceptual or social totalities. It signifies that someone or something has been denied voice or visibility by the dominant ideological system, which deems what is and is not unacceptable. Such radical differences are suppressed because they cannot be subsumed under overarching universal concepts without undermining them. "Differend" means at once dispute, difference, and otherness (alterity).

To counter metanarratives, Lyotard forwards the indeterminacy of language games, linguistic play. The critical play of the *petit récits* is evident in his contention that they reveal the incommensurability between metanarratives and the singularity of the event. Metanarratives are unable to fully account for the event. Lyotard's argument here is explicitly poststructuralist and anti-Hegelian. The **event**, for Lyotard, is a singularity, an occurrence or a happening. (His usage here borrows from Martin **HEIDEGGER**'s concept of *Ereignis* and, later, it is taken up by Alain **BADIOU**.) Lyotard's position is that an event cannot be completely articulated or translated by discourse. It is here that his reliance upon the aesthetic arena becomes evident. For him, the aesthetic—the production and the reception of the work of art—offers an alternative to the conceits of any metanarrative while simultaneously transmitting the undisclosed aspect of the event. In other words, what discourse is unable to attend to, the work of art can represent as feeling, sensation, or desire. It is important to note that in Lyotard's thought the concept of truth is premised on the notion that sensibility and understanding occur before cognition. The artwork communicates preconceptual knowledge; it communicates a radical alterity prior to and independent of cognition. Therefore, an artwork's ability to communicate the incommunicable plays an ethical and political role in Lyotard's philosophy. Not only does the work of

art disclose the limitations of discourse—the hegemony of reason and metanarratives—Lyotard's conception of it renders the often facile appropriation of his work as the manifesto of postmodern artistic practice problematic. In referring to the event, he writes: "The occurrence, the *Ereignis*, has nothing to do with the *petit frisson*, the cheap thrill, the profitable pathos, that accompanies an innovation. Hidden in the cynicism of innovation is certainly the despair that nothing further will happen" ("The Sublime and the Avant-Garde," 1984, pp. 463–464). This fear that "nothing further will happen" is tethered to Lyotard's notion of the sublime, which grounds his myriad discussions of modern and contemporary art. One cannot fully understand Lyotard's ethical and political position without engaging his writings on aesthetics.

Art history has traditionally deployed metanarratives of style and historical development, alongside other interpretative frameworks, to explain its subject matter. Lyotard's aesthetics of the sublime—which at once possesses the logic of play and games as well as the experience of the event—is a theorization of the particular that erodes the conceits of the grand narratives. The aesthetics of the sublime is a form of judgment counter to established rules and values, a break with the consensus. He articulates this by distinguishing between discourse and the **figure**, the basic aesthetic form, which occurs prior to any meaning or representation. For Lyotard, there is no possibility of meaning without figure, which is never fully locatable in the semiotic. The figure is excessive; it is sublime and, as such, it leaves one at a loss for words. In discussing the figure, he relies on FREUD's work on desire and the libidinal economy, in which the communicative (discourse) is associated with the conscious and the libidinal (figure) is associated with the unconscious. Lyotard claims that the relation between discourse and the figure reveals that reality is irreducible to representation. There is no discourse without figures, yet the feelings and intense desire represented by figures delimit any discursive contextualization. The release of desire signaled by the figure does not communicate discursively, but rather it foregrounds precisely what is incommunicable and, thereby, what exceeds the boundaries of discourse as such. Lyotard develops this point in relation to Abstract Expressionism (especially the work of Barnett Newman, Marcel Duchamp, Daniel Buren, and Paul Cézanne).

His discussion of Cézanne centers on the way in which the intensity and tonality of Cézanne's use of color indicate his attempt to translate desire. This is the point that formalist art historians have missed in their desire to explicate Cézanne's revolt against traditional representation, Lyotard argues. His work on Cézanne resonates with that of DELEUZE and GUATTARI, but it also provides a counterpoint to Merleau-Ponty's essay "Cézanne's Doubt."

"The Sublime and the Avant-Garde," originally published in *Artforum* in 1984, offers a concise summary of the ethical and political importance Lyotard gives the art of the avant-garde through his use of the concept of the sublime (see also Jacques DERRIDA's *The Truth in Painting* [1978] for a related discussion of the sublime). Lyotard's interest in the sublime reinforces his contention about sensation preexisting cognition. The sublime is an event that transcends the limits of knowledge and discourse because it is an experience of pleasure and pain, joy and anxiety: the presence of the unknowable and the unrepresentable is felt in the experience of the sublime and inasmuch it indicates the presence of an insurmountable radical difference. Lyotard's **aesthetics of the sublime** seeks to theorize an aesthetic event that interrupts any narrative tradition of aesthetic experience as well as any residual claim to canonical representation. The sublime is inexorable alterity, a particular event that undermines the foundations of art history as a metanarrative and traditional aesthetics as a "science."

Although Immanuel Kant occupies a central place in Lyotard's later work (for example, *Lessons of the Analytic Sublime* [1991]), in "The Sublime and the Avant-Garde" Lyotard relies more on Edmund Burke's conception of the sublime as given in his *Philosophical Inquiry into the Origin of our Ideas of the Sublime and the Beautiful* (1757). Lyotard begins his essay with a reference to Barnett Newman, specifically to his painting *Vir Heroicus Sublimis* (1950–1951) and his essay "The Sublime is Now" (1948). In defining his notion of the sublime event—an instant of exultation and despair—in relation to Newman's work, Lyotard writes: "The event happens as a question mark 'before' happening as a question. *It happens* is rather 'in the first place', *is it happening, is this it, is it possible*" (1984, p. 454). He proceeds to define further this sublime event in terms that recall Samuel Beckett's plays *Waiting for Godot* and *Endgame*:

The possibility of nothing happening is often associated with a feeling of anxiety, a term with strong connotations in modern philosophies of existence and of the unconscious. It gives to waiting, if we really mean waiting, a predominantly negative value. But suspense can also be accompanied by pleasure, for instance pleasure in welcoming the unknown, and even by joy, to speak like Baruch Spinoza, the joy obtained by the intensification of being that the event brings with it. This is probably a contradictory feeling. It is at the very least a sign, the question mark itself, the way in which *it happens* is withheld and announced: *Is it happening?* (p. 455)

The sublime event demands that we bear witness to that which is irredeemably other and unrepresentable. This is the basic premise of Lyotard's ethical argument, which bears the influence of the work of Emmanuel LEVINAS. Moreover, the aesthetics of the sublime provides Lyotard with a means to discuss the indeterminacy present in the work of the avant-garde.

Lyotard locates the "germ" of avant-gardism in the sublime as privation, the "threat of nothing further happening" that he reads in Burke's notion of the sublime. The wager of art in the nineteenth and twentieth centuries, for Lyotard, is not a representation of resemblance, but an indissoluble indeterminacy as evidenced by the advent of Impressionism and abstract art. The **avant-garde** is central to Lyotard's thinking about aesthetics because it transcends the historicity of the term. Avant-garde modernist groups, such as the Italian Futurists and Russian Constructivists, engage in an artistic practice that combines formal innovation with an explicit political agenda; they aimed to shock their audiences, generating new thoughts about the nature of art and its role in society. Lyotard retains something of this understanding in his definition, but he abandons any reliance on a linear narrative of historical time. The desire to transgress the accepted canon, to present a bloc of feelings and sensations as the exception rather than the rule is aligned with the event, which itself exists outside of the usual sense of history as a linear teleology (see *The Differend* and *The Inhuman: Reflection on Time*). For him, avant-garde practice embodies the political and ethical dimensions of the aesthetics of the sublime. (The contradictory implications of this position and

charges of neoconservatism have been levied at Lyotard despite his leftist leanings.)

What piques Lyotard's interest in the connection between the avant-garde and the sublime is its appearance in Newman's work. "It remains to the art historian," Lyotard writes, "to explain how the word sublime reappeared in the language of a Jewish painter from New York during the forties" (1984, p. 455). It is the sublime, Lyotard asserts, that connects what has been termed the historical avant-garde and the neo–avant-garde (cf. Foster, 1996). He presents his thesis in the following:

> There are in general no direct influences, no empirically observable connections. Manet, Cézanne, Braque, and Picasso probably did not read Kant or Burke. It is more a matter of an irreversible deviation in the destination of art, a deviation affecting all the valences of the artistic condition. The artist attempts combinations allowing the event. The art-lover does not experience a simple pleasure, or derive some ethical benefit from his contact with art, but expects an intensification of his conceptual and emotional capacity, an ambivalent enjoyment. Intensity is associated with ontological dislocation. The art object no longer bends itself to models, but tries to present the fact that there is an unrepresentable; it no longer imitates nature, but is, in Burke, the actualization of a figure potentially there in language. The social community no longer recognizes itself in art objects, but ignores them, rejects them as incomprehensible, and only later allows the intellectual avant-garde to preserve them in museums as the traces of offensives that bear witness to power, and the privation, of the spirit. (p. 460)

Following this statement, one can see why Lyotard would be invested in the work of the French Conceptual artist Daniel Buren, who denies an effective relation between the artwork and the viewer so as to foreground the limitations of the discursive places of the gallery and the museum.

In conclusion, the task of postmodern art, for Lyotard, is to disorient the viewer in time and space. This is meant to blur the boundaries of discourse so as to allow for an aesthetics of the sublime: an ethical and political interruption of the normative

that demands we bear witness to an event—to the particular as such—which cannot be circumscribed within the present, but rather is deferred to the future. This is the logic of the differend, which undermines certainty and the myth of the transcendental subject because it is premised on an inhuman, radical alterity. The singularity of the event makes one attentive to the presence of multiplicity and subversion within language. The sublime is an experience of the limits of language within language itself that sets forth the ethical and political task of postmodern art: to change discourse, to destabilize the narrative structure of art and its history in order to present the aesthetics of the sublime.

Further Reading

By Lyotard

1954. *Discours, figure*. Paris: Klincksieck, 1971.

1954. *Phenomenology*, translated by Brian Beakley. Albany: State Univ. of New York Press, 1991.

1974. *Libidinal Economy*, translated by Ian Hamilton Grant. Bloomington: Univ. of Indiana Press, 1993.

1974. "Preliminary Notes on the Pragmatic of Works: Daniel Buren." *October* 10 (Fall 1979): 59–67.

1977. *Duchamp's Transformers*, translated by Ian McLeod. Venice, CA: Lapis Press, 1990.

1979. *The Postmodern Condition: A Report on Knowledge*, translated by Geoff Bennington and Brian Massumi. Minneapolis: Univ. of Minnesota Press, 1984.

1982. *The Differend: Phases in Dispute*, translated by Georges Van Den Abbeele. Minneapolis: Univ. of Minnesota Press, 1989.

1984. "Philosophy and Painting in the Age of Their Experimentation: Contribution to an Idea of Postmodernity," translated by Mária Minich Breuer and Daniel Breuer. In *The Lyotard Reader*, edited by Andrew Benjamin. Oxford: Blackwell, 1989.

1984. "The Sublime and the Avant-Garde." In *The Continental Aesthetics Reader*, edited by Clive Cazeaux. London and New York: Routledge, 2000.

1985. *The Inhuman: Reflection on Time*, translated by Geoffrey Bennington and Rachel Bowlby. Stanford, CA: Stanford Univ. Press, 1988.

1985. "Les Immatériaux." In *Thinking about Exhibitions*, edited by Reesa Greenberg, Bruce W. Ferguson, and Sandy Nairne. London and New York: Routledge, 1996.

1985. *Que peindre?* Adami Arakawa Buren, 2 vols. Paris: La Différence, 1987.

1991. *Lessons on the Analytic of the Sublime: Kant's Critique of Judgment*, translated by Elizabeth Rottenberg. Stanford, CA: Stanford Univ. Press, 1994.

1991. *Political Writings*, translated by Bill Readings and Kevin Paul Geiman. Minneapolis: Univ. of Minnesota Press, 1993.

About Lyotard

Benjamin, Andrew, ed. *Judging Lyotard*. London and New York: Routledge, 1992.

Bennington, Geoffrey. *Lyotard: Writing the Event*. Manchester: Manchester Univ. Press, 1988.

Carroll, David. *Paraesthetics: Foucault, Lyotard, Derrida*. London and New York: Routledge, 1987.

Foster, Hal. *The Return of the Real: The Avant-Garde at the End of the Century*. Cambridge, MA: MIT Press, 1996.

Jay, Martin. "The Ethics of Blindness and the Postmodern Sublime: Levinas and Lyotard." In *Downcast Eyes: The Denigration of Vision in Twentieth-Century French Thought*. Berkeley: Univ. of California Press, 1993.

Readings, Bill. *Introducing Lyotard: Art and Politics*. London and New York: Routledge, 1991.

MAURICE MERLEAU-PONTY

Key Concepts

- phenomenology
- lived experience
- primacy of perception
- embodiment

Maurice Merleau-Ponty (1908–1961) was a French philosopher particularly interested in the nature of human consciousness as embodied experience. He was born in Rochefort-sur-mer, France. As a student at the École normale supérieure, he became interested in phenomenology through the work of Edmund Husserl and Martin **HEIDEGGER**. After graduating in 1930, Merleau-Ponty taught at different high schools, but with the outbreak of World War II, he served as an officer in the French army. During the German occupation, while participating in the French Resistance, he taught in Paris and composed *Phenomenology of Perception* (1945), widely regarded as his most important work. Following the war, he cofounded the left-leaning cultural and political journal *Les Temps Moderne* with Jean-Paul Sartre. Although the journal itself was never tied to a particular political organization, after the war, Merleau-Ponty was an active member of the French Communist Party. His affiliation with the group and his relation with the political and institutional interpretation of **MARX**'s work became strained however, ultimately resulting in his 1955 work *Adventure of the Dialectic*. He resigned his position on the editorial board

of *Les Temps Modernes* after repeated disagreements with Sartre over the latter's support of North Korea during the Korean War. Merleau-Ponty's postwar academic career included positions at the Sorbonne and, from 1952 until his premature death in 1961, at the Collège de France.

Merleau-Ponty's thought centers on understanding the lived, embodied nature of human consciousness and perception. But what makes his work so compelling for subsequent scholars is his incorporation of SAUSSURE's structuralist ideas into a phenomenological context. Among noted theorists influenced by his work in this regard were Claude Lévi-Strauss, Michel FOUCAULT, Paul Ricoeur, and Louis ALTHUSSER. More recently, Merleau-Ponty's work has been pursued by social scientists interested in critiquing traditional assumptions about the relationship between body and mind, and the nature of human perceptual experience. Texts such as "Eye and Mind" (1961), which discuss visual perception and develop a phenomenology of color (see KRISTEVA), have figured prominently in art historical discourse. Art historians informed by Merleau-Ponty's work have been central to discussions on topics as varied as Leonardo da Vinci's drawing and Robert Morris's Minimalist practice. Merleau-Ponty's presence is strongly felt in the work of Michael Fried, Rosalind Krauss, Hubert Damisch, and Annette Michelson.

In order to understand Merleau-Ponty's philosophy, one needs first to consider phenomenology. As the name suggests, **phenomenology** explores phenomena (from *phainein* meaning "to show"; Greek for "appearance"), which are perceived directly by the senses. Husserl, the German founder of phenomenology, argues that human beings experience the external world as objects of consciousness. That is, knowledge of the world begins with **lived experience** (*Erlebnis*). Husserl's method aims at "bracketing out" (*epoche*) or suspending any and all a priori ideas and assumptions about the world. By "bracketing out" the scientific and philosophical conceptualization of the world, Husserl believes that pure or preconceptual perception can be identified. He contends that we can isolate the underlying sensual perceptions that constitute our experiences of ideas, images, emotions, objects, and other things that are perceived in consciousness. One of the main premises of phenomenology is the contention that human consciousness is intentional, that is, it is always directed at or toward

something; it is always an experience of something. Consciousness, therefore, is nothing without its relation to the world, to the environment (*Umwelt*) that is always already there. The concept of the transcendental consciousness that Husserl aims for with his epochal method is conceived of as what remains after this process of "bracketing out" has occurred; transcendental consciousness is immediate knowledge of the world or pure experience. In the work of Husserl's followers, including Merleau-Ponty, there is an extended critique of **FREUD** and psychoanalysis, especially his concept of the unconscious. Merleau-Ponty argues that phenomenology can already account for fragmented consciousness and for the types of experience Freud seeks to explain by positing the unconscious.

Merleau-Ponty contributes to phenomenology by extending Husserl's premises. The focus of Merleau-Ponty's work centers on the concepts of embodiment and perception. In the Husserlian view (itself indebted to Cartesian philosophy), human beings are conscious entities first and foremost. Against this view, Merleau-Ponty insists that human identity—our subjectivity—is informed significantly by our physicality, our bodies. He asserts the centrality of the body and the body's influence on our perception of the world. These issues are explored in *Phenomenology of Perception* where Merleau-Ponty critiques the Cartesian body/mind dichotomy. It is essential, he insists, to recognize that people are not disembodied thinking minds, but rather bodies connected to a material world. Bodies are, therefore, not abstract, but are concrete entities in the world through which perception occurs and subjectivity is formed (see also Luce **IRIGARAY** and Judith **BUTLER**). For Merleau-Ponty, the world is the ground of experience. His position, colored by Heidegger's concept of being-in-the-world, is that subjectivity is of the world, not separate or disconnected from it, and it is fueled by the "**primacy of perception**." Our access to the world is through the body and not through, or not only through, the mind. Contrary to Descartes's *cogito ergo sum* ("I think, therefore I am"), existence is not thinking but embodiment. Indeed, all thinking is embodied; it derives from consciousness, which itself develops from the subject's bodily perceptions.

This concept of **embodiment** is central to Merleau-Ponty's work. According to him, it is not just the mind, which perceives experiences, and represents the world; instead, embodiment signifies the role of the body in how one experiences the world.

In this schema, the world is not merely an external object that is thought, instead the external things we perceive as objects in the world are the result of how our bodies experience them, not simply the product of consciousness recognizing the object. In *The Visible and the Invisible* (1964) Merleau-Ponty writes:

> What there is then are not things first identical with themselves, which would offer themselves to the seer, nor is there a seer who is first empty and who, afterward, would open himself to them—but something to which we could not be closer than by palpitating it with our look, things we could not dream of seeing "all naked" because the gaze itself envelops them, clothes them with its own flesh. (p. 130)

Between consciousness and reality, there is "an inside of an outside"—the human body. (Merleau-Ponty's theory of the gaze is taken up by Jacques LACAN in *Seminar XI: The Four Fundamental Concepts of Psychoanalysis*.) What Merleau-Ponty posits in this quotation is that "colours, patterns, and textures of sensory experience, *before they are the qualities of objects*, are the thick interactions which manifest the disclosive, intentional structure of experience" (Cazeaux, 2000, p. 76).

The relation between bodily perception (especially of vision) of our environment helps to explain Merleau-Ponty's long-standing interest in aesthetics. For him, aesthetic experience challenges conceptual experience because it is a disclosive, projective experience by which the limitations of disembodied consciousness are revealed. Merleau-Ponty has written a number of fine essays on the ways in which painting, especially modernist painting, constructs such an aesthetic experience. He is particularly interested in the intersection between modernist painting and ontology (see LYOTARD) as well as how a phenomenological/structuralist reading of art history must reject the traditional notion of "style." In "Indirect Language and the Voice of Silence," originally published in *Les Temps Modernes* in 1952, Merleau-Ponty offers a sustained critique of André Malraux's psychological history of art entitled *The Voices of Silence* (1953). But the best example of Merleau-Ponty's thinking about artistic production in regards to the primacy of kinesthetic perception is to be found in his essay "Cézanne's Doubt" (1945).

In this essay Merleau-Ponty gives us a phenomenological interpretation of Cézanne's painting that focuses on the artist's

representation of the lived experience of the premodern (scientific) world. Unconcerned with the usual formalist discussions of Cézanne as a proto-Cubist, Merleau-Ponty focuses his attention on the manner in which Cézanne conceived of himself as being thrown into a landscape that is both constructed by his perception and yet radically other. (This interest in Cézanne is shared by **DELEUZE** and **GUATTARI**, who privilege Cézanne in their discussion of percept.) Merleau-Ponty reads the "thickness" of Cézanne's famous apples as that through which the visible world appears. The painter renders his experience of the world, thereby bringing our attention to the presence of the invisible within the visible. This phenomenological conception of "seeing" as predicated on a requisite "blindness" features in Jacques **DERRIDA**'s discussions of blindness in his reading of painting and drawing.

The significance of Merleau-Ponty's readings of aesthetics is evidenced by the ubiquitous role they play in the work of many subsequent art historians and philosophers. His thoughts on the primacy of perception, his insistence on an embodied lived experience in and of the world, and his assertion that painting is a preconceptual perception in and of the world, evince not only his attempt to formulate an ontology of art, but his lasting importance for art history and critical theory as well.

Further Reading

By Merleau-Ponty

1945. "Cézanne's Doubt." In *The Merleau-Ponty Aesthetics Reader: Philosophy and Painting*, edited by Galen A. Johnson, translated by Michael B. Smith. Evanston, IL: Northwestern Univ. Press, 1993.

1945. *Phenomenology of Perception*, translated by Colin Smith. London and New York: Routledge, 2002.

1952. "Indirect Language and the Voices of Silence." In The *Merleau-Ponty Aesthetics Reader: Philosophy and Painting*, edited by Galen A. Johnson, translated by Michael B. Smith. Evanston, IL: Northwestern Univ. Press, 1993.

1955. *Adventures of the Dialectic*, translated by Joseph Bien. Evanston, IL: Northwestern Univ. Press, 1973.

1961. "Eye and Mind." In *The Merleau-Ponty Aesthetics Reader: Philosophy and Painting*, edited by Galen A. Johnson, translated by Michael B. Smith. Evanston, IL: Northwestern Univ. Press, 1993.

1961. *The Primacy of Perception and Other Essays*, translated by James M. Edie. Evanston: Northwestern Univ. Press, 1964.

1964. *The Essential Writings of Merleau-Ponty*, edited by Alden L. Fisher. New York: Harcourt, Brace, & World, 1969.

1964. "The Film and New Psychology." In *The Merleau-Ponty Aesthetics Reader: Philosophy and Painting*, edited by Galen A. Johnson, translated by Michael B. Smith. Evanston, IL: Northwestern Univ. Press, 1993.

1964. *The Visible and the Invisible*, edited by Claude Lefort, translated by Alphonso Lingis. Evanston, IL: Northwestern Univ. Press, 1968.

About Merleau-Ponty

Barral, Mary Rose. *Merleau-Ponty: The Role of the Body-Subject in Interpersonal Relations*. Pittsburgh: Duquesne Univ. Press, 1965.

Cazeaux, Clive. "Merleau-Ponty." In *The Continental Aesthetics Reader*, edited by Clive Cazeaux. London and New York: Routledge, 2000.

Dillon, M.C. *Merleau-Ponty's Ontology*. 2nd ed. Evanston, IL: Northwestern Univ. Press, 1997.

Evans, Fred, and Leonard Lawlor, eds. *Chiasms: Merleau-Ponty's Notion of Flesh*. Albany: State Univ. of New York Press, 2000.

Fóti, Véronique, ed. *Merleau-Ponty: Difference, Materiality, Painting*. Atlantic Highlands, NJ: Humanities Press, 1996.

Jay, Martin. "Sartre, Merleau-Ponty, and the Search for a New Ontology of Sight." In *Downcast Eyes: The Denigration of Vision in Twentieth-Century French Thought*. Berkeley: Univ. of California Press,1993.

Langer, Monika M. *Merleau-Ponty's Phenomenology of Perception: A Guide and Commentary*. Tallahassee: Florida State Univ. Press, 1989.

Pietersma, Henry, ed. *Merleau-Ponty: Critical Essays*. Lanham, MD: Univ. Press of America, 1989.

Priest, Stephen. *Merleau-Ponty*. London and New York: Routledge, 1998.

Sartre, Jean-Paul. "Merleau-Ponty." In *Situations*, translated by Benita Eisler. New York: George Braziller, 1965.

Watson, Stephen. "Merleau-Ponty and Foucault: De-Aestheticization of the Work of Art." In *Philosophy Today* 28 (Summer 1984): 148–166.

EDWARD W. SAID

Key Concepts

- colonial discourse
- Orientialism
- imperialism
- postcolonial theory
- contrapunctal reading

Edward W. Said (1935–2003) was a literary critic and the Parr Professor of English and Comparative Literature at Columbia University. Born in Jerusalem, Said's Palestinian family became refugees in 1948 and moved to Egypt, where he attended British schools. During his youth, he also spent time in Lebanon and Jordan before immigrating to the United States. He earned his bachelor's degree from Princeton University in 1957 and his Ph.D. in literature from Harvard University in 1964. He spent his entire academic career as a professor at Columbia University. He died in 2003 after a long battle with leukemia.

Said's work combined intellectual and political pursuits. On the one hand, he is well-known for his engagements with literary criticism (he wrote a study of Joseph Conrad) and postcolonial theory, often drawing on the theoretical perspectives and methods developed by Michel FOUCAULT. On the other hand, he was politically active as an advocate of Palestinian independence and human rights (see his 1979 text *The Question of Palestine*). Critical of U.S. foreign policy, especially in the Middle East, he also spoke out against corruption within Palestine.

These intellectual and political agendas are inseparable for Said, who taught that the intellectual is political and vice versa. In his case, both Said's academic work and his political activism address the ways in which white Europeans and North Americans fail to understand—or to even try to understand—the differences between Western culture and non-Western cultures. The example Said sets of an engaged intellectual has been extraordinarily influential throughout the world. In terms of the discipline of art history, Said's work is invaluable because it foregrounds the very historical premise of the discipline: to subsume numerous non-Western areas of study under the banner of a putatively universal "art history," which, in light of Said's work, appears as one of the more problematic artifacts of post-Enlightenment Europe.

Said's work inaugurated the discourse of postcolonial theory. With the publication of his groundbreaking study *Orientalism* in 1978, Said focused attention on the issues of discourse and representation in the history of Western colonialism. He asks critical questions about how colonized cultures are represented, about the power of these representations to shape and control these cultures politically and economically, and about **colonial discourse**, that is, the discourse through which the subject positions of the colonized *and* the colonizer are constructed.

Following Foucault, Said understands discourse as a system of linguistic usage and codes that produces knowledge about particular conceptual fields, demarcating what can be known, said, or enacted in relation to this archive of knowledge. It is through discursive formations that knowledge of the world is possible. For Foucault, there are significant ramifications to the discursive process. In any cultural setting, there are dominant groups that establish what can and cannot be said and done; this discursive knowledge is wielded against others. Discursive knowledge is power. Those in control of a particular discourse have control over what can be known and hence they have power over others. In the end, however, both poles are subjected to and by this knowledge; everyone lives within the parameters discursive formations allow. What Said works to uncover is precisely how this knowledge attains the status or appearance of an independent reality, and how its origins as a social construct are forgotten.

Discourse, as a form of knowledge-power, is central to Said's concept of **Orientalism:** Western discourse about the East that

engenders and reproduces the oppressor–oppressed relationship that arises within colonial discourse. Said focuses on the ways in which discursive formations about the "Orient" exert power and control over those subjected to them. This concept has three dimensions: the discursive, the academic, and the imaginative. All three are interconnected, however, and should be understood as such. The discursive concerns the notion that "Orientalism can be discussed and analyzed as the corporate institution for dealing with the Orient—dealing with it by making statements about it, authorizing views of it, describing it, by teaching it, settling it, ruling over it: in short, Orientalism as a Western style for dominating, restructuring, and having authority over the Orient" (1978, p. 3). The academic refers to "[a]nyone who teaches, writes about, or researches the Orient—and this applies whether the person is an anthropologist, sociologist, historian, or philologist—either in its specific or its general aspects, is an Orientalist, and what he or she does is Orientalism" (p. 2). Finally, the imaginative refers to the idea that "Orientalism is a style of thought based upon an ontological and epistemological distinction made between 'the Orient' and (most of the time) 'the Occident'" (p. 2). Said refers to this culturally constructed space as an "imaginative geography" (p. 54).

The analysis undertaken in *Orientalism* centers on the nature of colonial discourse and the ways it is used to construct the colonizer/colonized, self/other relationship, and how this binary construction of identity both creates and is produced by a social hierarchy predicated on racist hegemonic power. Said's work here focuses especially on the Middle East as "Orient," but his thesis and methodology have been extended to other cultural contexts where colonization has occurred (and is still occurring).

Said critiques Eurocentric universalism for devising this binary opposition between the putative superiority of Western cultures and the inferiority of colonized, non-Western cultures. Moreover, he points out that colonial discourse has the pernicious effect of treating the colonized as an undifferentiated mass of people. Thus, "Orientals" are perceived not as freely choosing, autonomous individuals, but rather as homogenous, faceless populations identified only by the commonality of their values. In general, they are reduced to a few stereotypical and usually negative characteristics. The racism that pervades colonial discourse is glaringly evident.

In support of this position, Said provides numerous accounts of colonial administrators and travelers who describe and represent Arabs in dehumanizing ways. After citing one such example he remarks: "In such statements as these, we note immediately that 'the Arab' or 'Arabs' have an aura of apartness, definiteness, and collective self-consistency such as to wipe out any traces of individual Arabs with narratable life histories" (1978, p. 229).

Orientalism, Said effectively argues, makes possible "the enormous systematic discipline by which European culture was able to manage—and even produce—the Orient politically, sociologically, militarily, ideologically, scientifically, and imaginatively during the post-Enlightenment period" (p. 3). His aim is not to refute the often spurious truth-claims of this discourse, but to demonstrate how colonial discourse constructs the epistemological possibility of the West and how it continues to do so. "The Orient," Said insists, "was almost a European invention, and had been since antiquity a place of romance, exotic beings, haunting memories and landscapes, remarkable experiences" (p. 1). For Said, the issue is not whether this European representation is true, but rather how we read its effects in the world.

If colonial discourse oppresses the colonized subject, it also affects the colonizer because the concept of "the Orient has helped to define Europe (or the West) as its contrasting image, idea, personality, experience" (pp. 1–2). Thus, European identity is framed in terms of what it is not. The self-identity of Europe, one could argue, is only the antithetical construction of the "Orient." As the literary critic and cultural theorist Ali Behdad has argued: "Orientalism … is not divided into accepted discourses of domination and excluded discourses of opposition. Rather, such a discourse of power makes allowance for a circular system of exchange between stabilizing strategies and disorienting elements that can produce variant effects" (Behdad, 1994, p. 17). This is a key statement because Orientalism is a seductive, polyvalent discourse that not only coerces, but seduces and appropriates even its opposition. Resistance to Orientalism must begin with the idea that "Europe" is as much of a fiction as is the "Orient," but it must not end there.

In a later study entitled *Culture and Imperialism* (1993), Said draws a distinction between **imperialism** and colonialism. For him, "'imperialism' means the practice, the theory, and the

attitudes of a dominating metropolitan center ruling a distant territory; 'colonialism', which is almost always a consequence of imperialism, is the implanting of settlements on distant territory" (1993, p. 9). Imperialism is embedded in colonial discourse and serves as an important tool for creating the colonized subject. Said argues that any discourse that comments on a colonized culture cannot remain neutral or stand outside of a consideration of imperialism, because all such discourses are invested in how the view of the other is constructed. For instance, the debased depictions of the other found in the literature, history, and other cultural productions of a colonizing nation serve as alibis for political and psychological acts of violence. This insight informs the concepts of filiation/affiliation that Said discusses in *The World, The Text, and the Critic* (1983).

Said's *Orientalism* initiates the discourse of postcolonialism. **Postcolonial theory**, which became prominent in the 1990s, is concerned with analyzing the relationship between culture and colonial power, exploring the cultural products of societies that were once under colonial rule. It addresses the lingering effects of colonialism on identity, nationality, and the nature of resistance to colonial power. One goal of postcolonial theory is to question humanist claims about cultural products containing timeless and universal ideas and values. When, for instance, colonizing nations make universal claims, the colonized culture is by default seen as derivative, unoriginal, merely mimicking white colonizing culture. For example, Victorian British literature often claims to represent the universal human condition. In doing so, however, Indian culture is represented—whether consciously or unconsciously—as irremediably particular and hopelessly benighted. Postcolonial theory refutes this universalist conceit and, instead, seeks to give voice to local practices, ideas, and values. Eurocentrism, which marginalizes non-European cultures, is understood as a hegemonic power that must be acknowledged and resisted. Part of this resistance is a reclamation of the cultural past of colonized peoples and establishing its value. This also leads to problems within postcolonial theory regarding the inherent indignity of speaking for others (see **SPIVAK**).

One of the primary and most effective means of critiquing colonial discourse that Said bequeaths postcolonial theory is his notion of **contrapunctal reading**. Borrowing the concept of counterpoint from music, Said (a lifelong music lover) describes

a reading strategy that exposes elements of colonial discourse hidden within a text. Contrapunctal reading not only unveils the colonial perspective but, more importantly perhaps, it also tries to read for nuances of resistance (counterpoints) that are also present within the same narrative. Said declares that we need to "read the great canonical texts, and perhaps the entire archive of modern and pre-modern European and American culture, with an effort to draw out, extend, give emphasis and voice to what is silent or marginally present or ideologically represented" (1993, p. 66). In practice, reading contrapunctally "means reading a text with an understanding of what is involved when an author shows, for instance, that a colonial sugar plantation is seen as important to the process of maintaining a particular style of life in England" (p. 66).

Viewed from a postcolonial perspective, the very foundations of art history as a discipline as well as the scholarship it has produced are implicated in colonialist practices. The cover of Said's *Orientalism* bears a reproduction of a work by the French Orientalist painter Jean-Léon Gérôme titled *The Snake Charmer*. Works like this were enormously popular in nineteenth-century Europe, and a considerable amount of art historical work has been done on the works of Orientalist painters, focusing especially on their training at European art academies and their affiliations with extra-artistic institutions. Reading the Orientalist bias in Western painting and film has become a cornerstone of academic research in Europe and North America.

In addition, the role played by the modern museum in colonial discourse has also been moved into the foreground by Said's work. What was once naively believed to be an innocuous institution for the "disinterested" appreciation of art is now read as an aesthetic space laced with social and political discourse. Said's work makes possible a critique of the means by which the modern civic museums of Europe were used as instruments to justify and police their imperial gains, beginning with the Great Exhibition of the Arts and Manufactures of All Nations at the Crystal Palace in London in 1851 (cf., Preziosi, 2003).

In discussions of contemporary art, the issues of globalization and the strong political bent of much of Said's work have been of unparalleled importance. Said's call for a "secular humanist" criticism plays a key role in the advent of postmodernism. Within

art history, the inclusion of Said's essay "Opponents, Audiences, Constituencies and Community" (1982) in one of the *urtexts* of postmodern art history, *The Anti-Aesthetic: Essays on Postmodern Culture* edited by Hal Foster, has insured the presence of Said's critical project.

One cannot underestimate the importance and the influence of Said's work on contemporary critical theory and art history. In a 1968 obituary for Marcel Duchamp, Jasper Johns wrote that Duchamp "changed the condition of being here." The same should be said of Edward Said.

Further Reading

By Said

Joseph Conrad and the Fiction of Autobiography. Cambridge, MA: Harvard Univ. Press, 1966.

Orientalism. New York: Vintage Books, 1978.

1979. *The Question of Palestine.* New York: Vintage Books, 1992.

1982. "Opponents, Audiences, Constituencies and Community." In *The Anti-Aesthetic: Essays on Postmodern Culture*, edited by Hal Foster. Seattle, WA: Bay Press, 1983.

The World, the Text, and the Critic. Cambridge, MA: Harvard Univ. Press, 1983.

Culture and Imperialism. New York: Alfred A. Knopf, 1993.

Reflections on Exile and Other Essays. Cambridge, MA: Harvard Univ. Press, 2000.

"Invention, Memory, and Place." In *Landscape and Power*, edited by W.J.T. Mitchell. Chicago: Univ. of Chicago Press, 2002.

Freud and the Non-European. New York: Verso, 2003.

About Said

Araeen, Rasheed, Sean Cubitt, and Ziauddin Sardar, eds. *Third Text Reader: On Art, Culture, and Theory.* London and New York: Continuum, 2002.

Ashcroft, Bill, and Pal Ahluwalia. *Edward Said.* London and New York: Routledge, 2001.

Ashcroft, Bill, Gareth Griffiths, and Helen Tiffin, eds. *The Post-Colonial Studies Reader.* London and New York: Routledge, 1995.

Barringer, Tim, and Tom Flynn, eds. *Colonialism and the Object: Empire, Material Culture and the Museum.* London and New York: Routledge, 1998.

Behdad, Ali. *Belated Travelers: Orientalism in the Age of Colonial Dissolution.* Durham, NC: Duke Univ. Press, 1994.

Ferguson, Russell, ed. *Out There: Marginalization and Contemporary Cultures.* Cambridge, MA: MIT Press, 1990.

Parry, Benita. "Overlapping Territories and Intertwined Histories: Edward Said's Postcolonial Cosmopolitanism." In *Edward Said: A Critical Reader*, edited by Michael Spinker. Oxford: Blackwell, 1992.

Preziosi, Donald. "The Crystalline Veil and the Phallomorphic Imaginary." In *Brain of the Earth's Body: Art, Museums, and the Phantasms of Modernity*. Minneapolis: Univ. of Minnesota Press, 2003.

Sardar, Ziauddin. *Orientalism*. Buckingham, UK and Philadelphia: Open Univ. Press, 1999.

Young, Robert. "Disorienting Orientalism." In *White Mythologies: Writing History and the West*. London and New York: Routledge, 1990.

GAYATRI CHAKRAVORTY SPIVAK

Key Concepts

- subaltern
- othering
- worlding
- strategic essentialism

Gayatri Chakravorty Spivak (b. 1942) is a Bengali cultural and literary critic. Born in Calcutta, India, to a middle-class family during the waning years of British colonial rule, she attended Presidency College of the University of Calcutta, graduating in 1959 with a degree in English literature. She came to the United States in 1962 and attended graduate school at Cornell University, where she received her Ph.D. in comparative literature under the direction of Paul de Man, who introduced her to the work of Jacques **Derrida**. Her 1977 English translation of Derrida's *Of Grammatology* (1967) made Derrida's work available to a wider audience. She gained initial recognition from her outstanding introduction to that work, quickly becoming recognized among English-speaking academics as an authority on Derrida's thought. Spivak is currently Avalon Foundation Professor in the Humanities at Columbia University.

Spivak's work operates at the intersection of postcolonial theory, feminism, deconstruction, and Marxism. She rigorously interrogates

the binary oppositions that animate both postcolonial and feminist discourse by deconstructing concepts (such as nationhood, fixed identity, and the Third World) found in imperialist language. The numerous articles and interviews that comprise Spivak's scholarly production have been compiled into several books. *Other Worlds: Essays in Cultural Politics* (1987) is a collection of essays on a wide range of topics, from Virginia Woolf's *To the Lighthouse* to French feminism, to the concept of "value." *The Post-Colonial Critic: Interviews, Strategies, Dialogues* (1990) is a compilation of interviews that present Spivak's often inspiring yet difficult thinking in a more reader-friendly format. Her *Outside in the Teaching Machine* (1993) brings together her writings on higher education and globalization.

Fundamental to Spivak's work is the concept of the **subaltern**, a term meaning "of inferior rank." Spivak borrows the term from the Italian Marxist philosopher Antonio Gramsci, who used it to refer to social groups under the hegemonic control of the ruling elite. In this sense, the term can refer to any group that is collectively subordinated or disenfranchised, whether on the basis of race, ethnicity, sex, religion, or any other category of identity. Spivak, however, uses this term specifically to refer to the colonized and peripheral subject, especially with reference to those oppressed by British colonialism, such as segments of the Indian population prior to independence. She emphasizes how the female subaltern subject is even more marginalized than the male. In the essay, "Can the Subaltern Speak?" (1985), Spivak observes: "If in the context of colonial production, the subaltern has no history, and cannot speak, the subaltern as female is even more deeply in shadow" (p. 28). Spivak's notion of the subaltern is thus also implicated in feminist concerns. She discusses the ways that colonialism—and its patriarchy—silence subaltern voices to the extent that they have no conceptual space from which they can speak and be heard, unless, perhaps, they assume the discourse of the colonizer. "Can the Subaltern Speak?" has been enormously influential for postcolonial theory. But we should note that Spivak critically revised aspects of her theory of the subaltern in her 1999 book, *A Critique of Postcolonial Reason: Toward a History of the Vanishing Present.* Here she explores further the idea of the "native informant" and reconsiders her discussion of that figure in earlier texts (see especially the chapter on "History").

Another aspect of Western colonialism explored by Spivak is the way that colonial discourse participates in a process she refers to as **othering**, a term derived from a whole corpus of texts by Hegel, LACAN, Sartre, and others. Othering is an ideological process that isolates groups that are seen as different from the norm of the colonizers. For Spivak, othering is the way in which imperial discourse creates colonized, subaltern subjects. Like Edward SAID, she views othering dialectically: the colonizing subject is created in the same moment as the subaltern subject. Othering, therefore, expresses a hierarchical, unequal relationship. In her research into this process, Spivak utilizes British colonial office dispatches to reveal othering in a historical context. Yet she makes clear that othering is embedded in the discourse of various forms of colonial narrative, fiction as well as nonfiction.

Spivak's related concept of **worlding** is closely related to the dynamics of othering in colonial discourse. Her understanding of this concept begins with Martin HEIDEGGER's "The Origin of the Work of Art" (1935–1936). Worlding is the process whereby colonized space enters into the "world" as crafted by Eurocentric colonial discourse. She argues: "If ... we concentrated on documenting and theorizing the itinerary of the consolidation of Europe as sovereign subject, indeed sovereign and subject, then we would produce an alternative historical narrative of 'worlding' of what is today called 'the Third World'" ("The Rani of Sirmur," 1985, p. 247). A worlding narrative of a colonized space is a process of inscription whereby colonial discourse and hegemony are mapped onto the earth. This is a social construct because it is a "worlding of the world on uninscribed earth" (p. 253). Mapmaking is a practice of worlding. For instance, Spivak cites the example of an early nineteenth-century British soldier traveling across India, surveying the land and people: "He is actually engaged in consolidating the self of Europe by obliging the native to cathect the space of the Other on his home ground. He is worlding their own world, which is far from mere uninscribed earth, anew, by obliging them to domesticate the alien as Master" (p. 253). In effect, the colonized are made to experience their own land as belonging to the colonizer. Worlding and othering, then, are not simply carried out as matters of impersonal national policy but are enacted by colonizers in local ways, such as the soldier traveling through the countryside.

Spivak often makes reference to the highly problematic nature of terms like Third World, Orient, and Indian. For her, as for Said, these terms are essentialist categories whose meanings hinge on binary oppositions that are of dubious usefulness because of their history and arbitrary nature. Essentialist perspectives stress the idea that conceptual categories name eternal, unchangeable characteristics or identities that really exist in the external world. Hence, a category like "Orient" is essentialist because it conceits to name a real place inhabited by people with the same characteristics and personality traits that are eternal and unchanging, and, by extension, inescapable because they are "naturally" possessed. Classic essentialist categories include masculine/feminine and civilized/uncivilized. But essentialist categories are unstable because they are social constructions, not universal names for "real" entities in the world. Furthermore, the categories that Spivak discusses were constructed by a colonial discourse whose usage had significant hegemonic and ideological implications and effects. A label like "savage Indian" literally *others* its subject. That is, it forces the colonized into a subaltern subject position not of their own choosing. Once located in a particular subject position, the colonizing power can treat them accordingly, and the subjects often assume this role.

In her 1985 essay "Subaltern Studies: Deconstructing Historiography," Spivak posits that although essentialism is highly problematic for the knowledge it creates about an other, there is sometimes a political and social need for what she calls **strategic essentialism**. By this she means a "strategic use of positivist essentialism in a scrupulously visible political interest" (p. 205). She argues that it is necessary to assume an essentialist stand—for instance, speaking as a woman or speaking as an Asian—so that the hegemony of patriarchal colonial discourse can be disrupted and questioned. Spivak acknowledges that the application of essentialist categories can have a salutary effect on struggles against oppression and hegemonic power despite the problems inherent in essentialist discourse: "I think it's absolutely on target to take a stand against the discourses of essentialism … [b]ut strategically we cannot" (1990, p. 11). Spivak's position is that strategic essentialism is expedient, if only in the short term, because it can aid in the process of revitalizing the sense of personal and cultural value of the

dominated. One example of this is when postcolonial cultures essentialize their precolonial past in order to find a usable, strategic cultural identity.

The intersection of theory and social activism runs throughout Spivak's work. She has been critiqued for her view of strategic essentialism on the grounds that she has acquiesced to the very essentialist, universalist language which she so adamantly opposes. But for Spivak, the strategic use of essentialist categories is not a matter of violating some notion of theoretical "purity" but rather is necessary from the perspective of social and political exigencies that require, among other things, certain kinds of discursive tools in order to counter oppression and other ills. Spivak is also critical of Western feminists for sometimes ignoring the plight of women of color and, contrarily, for sometimes presuming to speak for non-Western women on issues about which Western feminists have no direct knowledge or experience. In this latter instance, speaking for non-Western women is to once again mute the voices that Western feminists are trying to assist on the geopolitical stage. Such Western feminist discourse creates non-Western women as subaltern subjects and subverts their attempts to speak for themselves into an echo of the same, rather than allowing for a voice of difference.

The importance of Spivak's work in postcolonial theory, cultural studies, and feminism has made it especially insightful for art history. In addition to the inflections her work has made in the study of art produced in a colonial context by both colonizers and the colonized, Spivak's work poses an ethical demand that art historians think the complexity of discourse as that which constructs identities, representations, and epistemology. This means that the imbrication of race, gender, and class should be taken as a complex whole, rather than as purportedly theoretical elements that can be portioned out and dealt with individually. Spivak's work exemplifies a critical practice that is able to address the complexities of cultural production and its histories. Perhaps the most impressive reading of these issues is given in the chapter "Culture" from *A Critique of Postcolonial Reason: Toward a History of the Vanishing Present*. This chapter is a virtuoso reading of cultural discourse and politics. While it covers a lot of distance, Spivak grounds her discussion in a rereading of Frederic Jameson's *Postmodernism; or the Cultural Logic of Late Capitalism* (1991).

During her rereading of Jameson's influential and controversial argument, Spivak constructs a stereoscopic reading between it and the Minimalist artist Robert Morris's essay "Aligned with Nazca" (1975), which Spivak calls a "definitive text of minimalism." She addresses how art, space, and cultural alterity are discussed in each text, concluding:

> The constitution of a radical elite alibi for political practice can dress cool. The comprehension of cultural signifiers such as "postmodernism" or "minimalism" is taken as a given here. This is of course one of the ways to perpetrate a kind of "wild" cultural pedagogy that establishes these terms as quick diagnostic fixes within whatever functions as a general elite culture (which also produces the unnamed subject of Jameson's postmodern cultural dominant). (1999, pp. 337–338)

In many ways this is Spivak at her best. Not only critical of her own former positions (such as the concept of the subaltern), her criticality extends to the inaugural texts of postmodernism (as both a system of thought and an artistic practice). This reveals the necessity for modern and contemporary art history to continually examine its theoretical and ideological premises. Spivak's work on art, literature, and politics demonstrates how indispensable self-reflexivity is for any discipline, which must address its own contradictions and aporias before it can understand its objects of study.

Further Reading

By Spivak

1985. "Can the Subaltern Speak?" In *The Post-Colonial Studies Reader*, edited by Bill Ashcroft, Gareth Griffiths, and Helen Tiffin. London and New York: Routledge, 1995.

1985. "Subaltern Studies: Deconstructing Historiography." In *In Other Worlds: Essays in Cultural Politics*. New York: Methuen, 1987.

"The Rani of Sirmur: An Essay in Reading the Archives." *History and Theory: Studies in the Philosophy of History* 24.3 (1985): 247–272.

"Three Women's Texts and a Critique of Imperialism." *Critical Inquiry* 12.1 (Autumn 1985): 243–261.

"Criticism, Feminism, and the Institution." In *The Post-Colonial Critic: Interviews, Strategies, Dialogues*, edited by Sarah Harasym. London and New York: Routledge, 1990.

The Spivak Reader: Selected Works of Gayatri Chakravorty Spivak, edited by Donna Landry and Gerald MacLean. London and New York: Routledge, 1996.

A Critique of Postcolonial Reason: Toward a History of the Vanishing Present. Cambridge, MA: Harvard Univ. Press, 1999.

Death of a Discipline. New York: Columbia Univ. Press, 2003.

About Spivak

Eagleton, Terry. "Gayatri Spivak." In *Figures of Dissent: Critical Essays on Fish, Spivak, Žižek, and Others.* London and New York: Verso, 2003.

Varadharajan, Asha. *Exotic Parodies: Subjectivity in Adorno, Said, and Spivak.* Minneapolis: Univ. of Minnesota Press, 1995.

Young, Robert. "Spivak: Decolonization, Deconstruction." In *White Mythologies: Writing History and the West.* London and New York: Routledge, 1990.

AFTERWORD

A RELATION OF IMMANENCE: THE AFTERLIFE OF ART HISTORY AND CRITICAL THEORY

I try to keep myself at the limit of philosophical discourse. I say limit and not death, for I do not believe in what today is so easily called the death of philosophy (nor, moreover, in the simple death of whatever—the book, man, or god, especially since, as we all know, what is dead wields a very specific power). (Derrida, *Positions*)[1]

A disciplinary practice that attends to all this—whether we name that art history or not—would itself be worth attending to. (Preziosi, "The End(s) of Art History")[2]

Theory for Art History is marked by two important events: the passing of Jacques Derrida in October 2004 and the publication of Donald Preziosi's controversial text *Rethinking Art History: Meditations on a Coy Science* (1989). Between the two lies the discursive threshold between art history and critical theory, precisely where we have returned.

With Derrida's death, an event felt by many throughout the world, a curious, but not unfamiliar, refrain has arisen in many of the obituaries and reflections on his life. This refrain all too excitedly

proclaims "the death of theory." Once again, announcements of the death of theory, the death of deconstruction, the death of psychoanalysis, the death of philosophy, the death of aesthetics, are being voiced by cultural historians, academics, and journalists. Why is there such a desire to witness the end of theory? Have the lessons of critical theory been learned if one can so confidently declare its death?

Declaring critical theory dead or, more insipidly, out of fashion reveals a fundamental misunderstanding of its primary lessons: critical thinking and self-reflexivity. To assert that critical theory is passé is to posit that those who study the humanities and the social sciences need not concern themselves with how they conceive of their objects of study or the sociopolitical effects their interpretative methods and bias may have. It is hoped that these statements on the death of theory are merely myopic and not symptomatic of some larger apolitical and naive conceit. What these statements fail to address is the very nature of theory as *contretemps*, which opposes the time of fashion and the marketplace in general. Rather than considering itself outside of this accelerated temporal logic, critical theory attempts to construct another time, a slower, inversive temporal logic, within it. It is in this light that one must come to understand how Derrida's performative, "writerly" texts enact an ethical–political project committed to the logic of the *contretemps*.

Despite this, or perhaps in spite of it, we are once again faced with the putative death of theory. This is problematic for several reasons, not least of which is the premise that critical theory somehow exists separate from the fields it supposedly critiques. It has reached a point where these hyperbolic, moribund proclamations seem less like statements on the current situation of the humanities and more and more like the proscriptive insinuations of a "cold society," one without events, without an ethos or historical bearing.[3] The temporality of the cold forecloses on the event, the interruption, that "flashes up in a moment of danger."[4]

Preziosi's *Rethinking Art History* maintains a fidelity to the event of critical theory. The pointed questions he poses lay bare the foundations of the discipline of art history. Exposing a discourse founded on a spurious historiography and implicated in the discourses of capitalism, colonialism, and imperialism, Preziosi rightly positions the discipline of art history within a larger discursive

field of subjection and the attendant dissolution of the sociopolitical sphere into a passive space of visual consumption.

This fidelity to the event of theory, the impossibility of acting as if the suspect historicism and epistemology of traditional art history were never interrupted, drives Preziosi's text. In its wake, a set of questions must be asked again, but this time the stakes are raised. What is art history's object of study? Is it art? Perhaps it is not an object at all, but a subject? What is an artist? Is it possible to practice art history in the absence of any criteria by which we may judge a work of art successful, beautiful, or even anti-aesthetic? Shall we forfeit any claim of the autonomy of art to the vagaries of capitalist exchange economy? This is only one side of the rift. The other is the domain of the viewer, the spectator or passive consumer of the work of art. How is this persona to be conceived, animated, and codified? Who or what is the audience of art? Issues of class, race, and gender surface, but so do ones of an implied versus ideal audience. It may very well be that the viewer as disparately conceived by thinkers from Kant to Hans Haacke is a fiction. (One can't help but wonder what Jacques Lacan could have meant when he claimed that fiction is the truth.)

Our ability to posit these questions anew, without presupposing their answers, owes much to what we have come to call critical theory. Its advent is colored by World War II and May 1968, both of which demonstrate the radical interruptive and reinscriptive power of the event, that is, its ability to create caesuras in time and thought. In this light, critical theory is as much a theorization of the event as a fidelity to it. It arises as a critique of aesthetics and epistemology fueled by a knowledge of the political consequences of representational strategies and mass spectacle. Part of the often willful miscomprehension of critical theory results from the reign of the signifier it helps usher in, but the contingent and structural impossibility of any representation—whether linguistic or visual— to signify its referent, is not merely complicit in the logic of the late capitalist exchange economy.

The reign of the signifier is the despotism of the question: "What does it mean?" Yet the poststructuralist conception of language and the psychoanalytic wager of the unconscious posit that neither language nor the unconscious "mean" anything. What was and is still needed is the formation and articulation of a new series of questions, not inquiries with a presupposed end,

but a radical and experimental interrogation of the premises of representation, interpretation, and even reflexivity as such.

What Preziosi's work has helped subsequent art historians and cultural theorists address is how the mantra of art history from its inception in the eighteenth century—*what does it mean?*—is really just the hysteria of the signifier. Critical theory, however, emboldens art historians not to answer. Or rather, critical theory *and* art history encourage each other to reconceive the work of art (its reception and its role in constituting a *socius*) as that which indexes and insures a becoming otherwise instead of positing a meaning or an essence. To the question, "what does it mean?" the art historian must answer with Bartleby's famous line: "I would prefer not to."[5] That is, prefer not to think structure, historicity, or even critical theory as some sort of second-order metalanguage, but to think the threshold between art history and critical theory as openness, as undecidable.

Furthermore, and it is important to dwell on this point, we must come to understand how and why critical theory is not a second-order discourse. It is neither foreign to art history, nor does it exist in a transcendent position of authority or mastery. Both critical theory (or continental philosophy) and art history exist in a relation of immanence. This is the relation of the hinge (*brisure*) that Derrida posits in *Of Grammatology* as that which simultaneously brings together and separates.[6] A relation of immanence operates across a threshold; it is a play of dislocation that never belongs entirely to either side. It is in Benjamin's work that this relation is best explained. In his early essay "Goethe's Elective Affinities" (1924–1925), he writes:

> Let us suppose that one makes the acquaintance of a person who is handsome and attractive but impenetrable, because he carries a secret with him. It would be reprehensible to want to pry. Still, it would surely be permissible to inquire whether he has any siblings and whether their nature could not perhaps explain somewhat the enigmatic character of the stranger. In just this way critique seeks to discover siblings in the work of art. And all genuine works have their siblings in the realm of philosophy. It is, after all, precisely these figures in which the ideal of philosophy's problem appears.... These are works of art. The work of art does not compete with philosophy itself—it merely enters into the most precise relation to philosophy through its affinity with the ideal of the problem.[7]

The conceptual language in which Benjamin couches his statement is somewhat problematic: especially the notion of "genuine" artworks and the conception of interpretation as getting at the work's "secret." However, Benjamin's reliance upon a notion of a "genuine" work of art is by no means unique. Thinkers as different as Louis Althusser, Martin Heidegger, and Jean-François Lyotard all offer the caveat that their thoughts on aesthetics apply only to "genuine" or "true" works of art. (The question we are still left with, of course, is how and by what criteria are we to decide whether or not a work of art is "genuine" or "true"?)

What is important here is that, for Benjamin, the "secret" of the work of art is not something as simple as an essence or a historical truth. His metaphor about how one can use the siblings art history and philosophy against each other does not disclose the "secret" the work of art harbors. Rather it reveals a silent secret, the "expressionless" (*das Ausdruckslose*) of the work of art. In other words, Benjamin's focus shifts from the work of art to the interpretative modalities of art history and philosophy, and back again. What he constructs in this movement or rhythm is a way to account for the subject-position of the historian/critic in any reading by abandoning a posture of empathy and appreciation. Empathy and appreciation only lead to ventriloquism, the indignity of speaking for others, whether they are artworks or people. Benjamin insists that any presupposed viewer or reader of a work of art is an illegitimate effect of ideology. There is something dire in Benjamin's thoughts on the radical alterity of the work of art and his calls for the "emergence of an ethical and aesthetic critique" that we have abandoned at an as yet undetermined cost.[8]

Extending Benjamin's metaphor, art history and critical theory are embroiled not in a play for mastery, but merely in a bitter sibling rivalry. The reliance of each upon the other can account for the anxiety that arises whenever their relation is discussed. It is in the threshold between the two that the "origin" of each is to be found. Simply put, art history is always already theory.

We have asked after the nature of the "art" in art history, but what does the concept "theory" signify in critical theory? More than a proper name, theory (*theōria*) in Western cultural discourse from Plato to Hannah Arendt designates not a discourse of mastery, but rather a praxis, an interruption, an exception to the rule, a caesura that allows for a rethinking. In his *Nicomachean Ethics*, Aristotle

insists that *theōria* is the "highest human praxis."[9] Thus, and Heidegger strove to make this clear, there is no distinction between theory and practice: theory is (re-)thinking; it is an activity that constructs an interruption of any reified, unexamined conception of an entity's very being. Rethinking is the praxis that allows art history and philosophy to assert their relation *and* their distinct "lines of flight."

This theoretical rethinking of art history is not a work of mourning. What I am proposing here, on the contrary, is a *recollection* of art history and critical theory that is not an interpretation so much as an experience of the work of art predicated on its alterity, on its impersonal address. It is the experience of art that art historical discourse has overwritten and choreographed into farce. *To recollect is to rethink the experience of art.* Since the end of World War II, critical theory has shadowed art history, always calling for reflexivity, for a recollection, a rethinking. This concept of thinking owes much to Heidegger, who in "The Thinker as Poet" writes: "That is why thinking holds to the coming of what has been, and is remembrance."[10] A recollection of art history, therefore, must acknowledge the undisclosed potentiality of an art history to come. "It is not," Gilles Deleuze has argued, "a work of mourning; non-mourning takes even more work."[11] This current recollection of art history is an "untimely meditation"—coming as it does right after critical theory's eulogy. Yet, it is precisely the "untimely" which marks the emergence of another actuality, another becoming.

To conclude, a recollection. What is art history the "history" of? Put another way, what is the "history" of art history? This signifies the Janus-face of our current predicament. We remain fundamentally nonplussed not only about the criteria for criticism, but also about an even more basic question about what constitutes a work of art. This has resulted in ongoing attempts—which are very much needed—to reconceive the audience of art. But because these attempts overlook the work of art itself, they are ultimately dissatisfying. The emphasis on *aisthesis*—the sensory involvement of the viewer—that has dominated aesthetic thought since Kant continues with very little consideration of the production of art (like two estranged siblings). The ethical and political consequences of this state of affairs are expressed by Giorgio Agamben in *The Man Without Content* (1994):

The original structure of the work of art is now obscured. At the extreme point of its metaphysical destiny, art, now a nihilistic power, a "self-annihilating nothing," wanders in the desert of *terra aesthetica* and eternally circles the split that cuts through it. Its alienation is the fundamental alienation, since it points to the alienation of nothing less than man's original historical space. In the work of art man risks losing not simply a piece of cultural wealth, however precious, and not even the privileged expression of his creative energy: it is the very space of his world, in which and only in which he can find himself as man and as capable of action and knowledge.[12]

This predicament emphasizes even more how the "history" we are all supposedly writing either remains ignorant or overdetermined. Echoing Agamben's position, it is Deleuze again who offers us the crucial comment: "History, in short, is what separates us from ourselves and what we have to go through and beyond in order to think what we are."[13]

The praxis of art history will benefit from a consideration of critical theory not as a foreign body, but rather as a gift— *Theory* for *Art History*. It is a gift of recollection that allows us to bear witness, to preserve not what has been but what will have been. To receive this gift, art history must take as its task a radical passivity: an *ekphrasis* of the work of art that resists giving it a meaning and instead attempts to think the event, the interruption of the same, another relation between subjects and objects—an ethics of the self.

Theory is an attempt to construct another experience of art. The death of aesthetics wields a "very specific power," one that recollects the threshold in which survival is affirmed. As such, our ethical task must come to comprehend Emmanuel Levinas's contention that "knowledge is precisely that which remains to be done when everything is completed."[14]

Endnotes

1. Jacques Derrida. *Positions*, translated and annotated by Alan Bass (Chicago: Univ. of Chicago Press, 1981), 6.

2. See the final chapter of *Rethinking Art History: Meditations on a Coy Science* (New Haven: Yale Univ. Press, 1989), 179.

3. A "cold society" is a concept put forth by the structuralist anthropologist Claude Lévi-Strauss. For a discussion of this concept in an art historical context see Jean Baudrillard's "Hot Painting: The Inevitable Fate of the Image" in *Reconstructing Modernism: Art in New York, Paris, and Montreal 1945–1964*, edited by Serge Guilbaut (Cambridge, MA: MIT Press, 1990).

4. This phrase is from Walter Benjamin's "Theses on the Philosophy of History" in *Illuminations*, translated by Harry Zohn (New York: Schocken Books, 1968), 255.

5. Giorgio Agamben and Gilles Deleuze have both written on Herman Melville's enigmatic short story "Bartleby, the Scrivener" in *Bartleby: La formula della creazione* (Macerta: Quodlibet, 1993). In his essay, "Bartleby, or On Contingency," Agamben writes that "one could say of Bartleby that he succeeds in being able (and not being able) absolutely without wanting it. Hence the irreducibility of his 'I would prefer not to'. It is not that he does not want to copy or that he does not want to leave the office; he simply would prefer not to. The formula that he so obstinately repeats destroys all possibility of constructing a relation between being able and willing.... It is the formula of potentiality" (*Potentialities: Collected Essays in Philosophy*, edited by Daniel Heller-Roazen. Stanford, CA: Stanford Univ. Press, 1999), 255.

6. See Derrida, *Of Grammatology*, translated by Gayatri Chakravorty Spivak (Baltimore: The Johns Hopkins Univ. Press, 1974), 69–73.

7. Benjamin, "Goethe's Elective Affinities" in *Selected Writings*, edited by Marcus Bullock and Michael W. Jennings (Cambridge, MA: Belknap Press/ Harvard Univ. Press, 1996), 1: 833–834.

8. This phrase is from a fragment Benjamin wrote titled "The Theory of Criticism" while working on "Goethe's Elective Affinities." See *Selected Writings*, 1: 219.

9. See Book 10 of *Nicomachean Ethics*, translated by Sarah Broadie and Christopher Rowe (Oxford: Oxford Univ. Press, 2002), 241–258.

10. Heidegger, *Poetry, Language, Thought*, translated by Albert Hofstadter (New York: HarperCollins, 1971), 10.

11. Deleuze, "Breaking Things Open, Breaking Words Open" in *Negotiations 1972–1990*, translated by Martin Joughin. (New York: Columbia Univ. Press, 1995), 84.

12. Agamben, *The Man Without Content*, translated by Georgia Albert (Stanford, CA: Stanford Univ. Press, 1999), 102.

13. Deleuze, *Negotiations*, 95.

14. Levinas, *On Escape*, translated by Bettina Bergo (Stanford, CA: Stanford Univ. Press, 2003), 72.